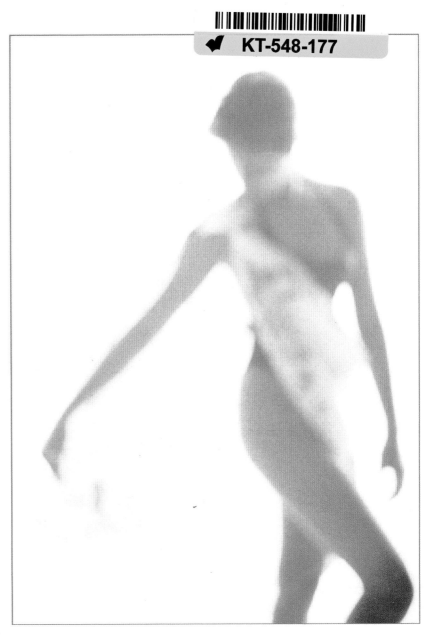

PHOTO ART

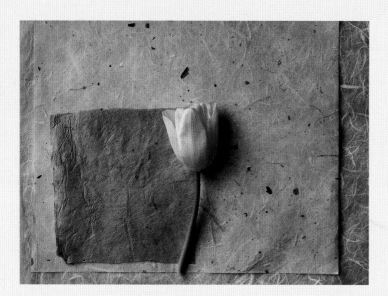
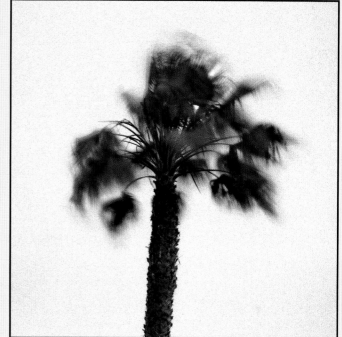

PHOTO

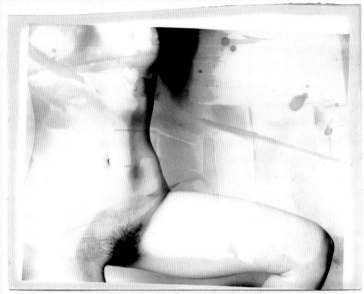

ART

In-Camera | Darkroom | Digital | Mixed Media

TONY WOROBIEC AND RAY SPENCE

Amphoto Books
An imprint of Watson-Guptill Publications
New York

First published in the USA in 2003 by
Amphoto Books
An imprint of
Watson-Guptill Publications,
A division of VNU Business Media, Inc.,
770 Broadway,
New York, NY 10003
www.watsonguptill.com

First published in the UK in 2003 by
Collins & Brown Limited,
64 Brewery Road, London

A member of Chrysalis Books plc

1 3 5 7 9 8 6 4 2

Library of Congress Control
Number: 2002115285

ISBN 0-8174-5372-5

Publisher: Roger Bristow
Photography by Tony Worobiec &
 Ray Spence
Project managed by Emma Baxter
Designed by Roger Hammond
Copyedited by Ian Kearey

Reproduction by Classicscan PTE Ltd,
 Singapore
Printed and bound in Singapore
 by Imago

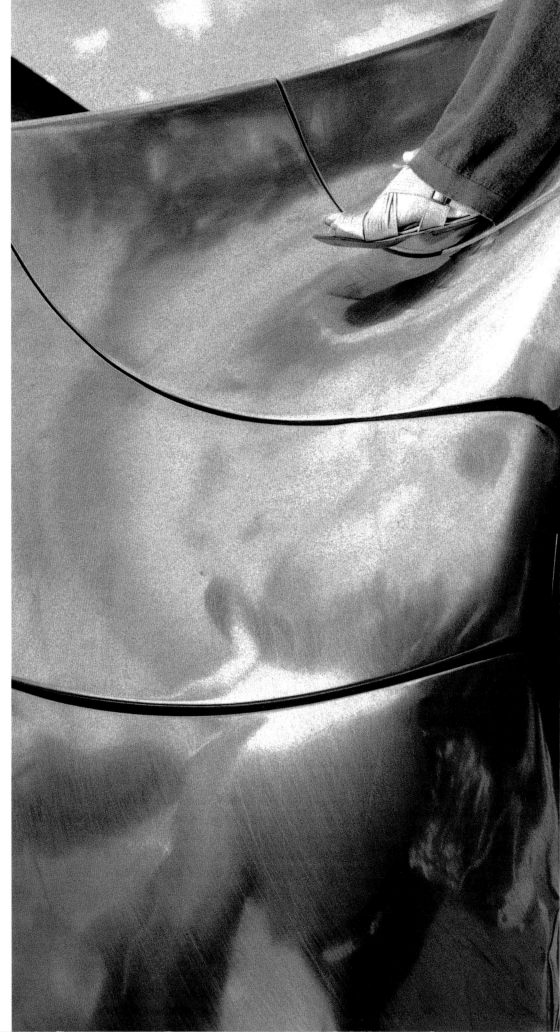

CONTENTS

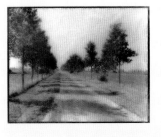

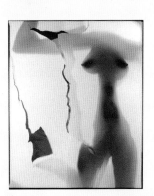

INTRODUCTION

SOME MAY VIEW the overlap between art and photography as a fairly recent phenomenon, but it is a relationship that goes back to the beginning of photography. The earliest cameras were slow, so even exposures taken in strong daylight required several seconds or more; this resulted in photographs featuring blurred figures and moving trees. Whilst they were always keen to deny this, many of the French Impressionist painters were greatly influenced by these early photographs, and there is considerable evidence to suggest that they had a close connection with a group of photographers working in the Forest of Fontainbleau, and this consequently influenced the way they painted.

This relationship worked both ways. Once photographers had learned how to overcome their technical difficulties, they immediately wanted to compose their work, and, not unnaturally, they looked to painting for inspiration. An interesting symbiotic relationship between art and photography evolved and has remained ever since.

While it is easy to see similarities between these two activities, in general terms they have each assumed quite different roles. Prior to photography, it had been the duty of the painter to record portraits and events, but because of the cost, portraiture remained the preserve of the wealthy. With the advent of photography this changed, and photographers now do many of tasks once done by artists. By way of contrast, this proved to be a seminal point within the development of art, and at last artists felt liberated. The aesthetics underpinning all great painting are fundamentally abstract, and once the artist lost the role of visual-recorder, he was free to explore this.

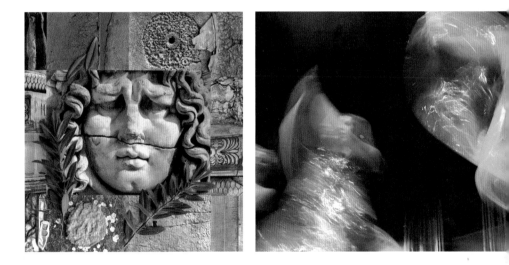

As technology improved photography became increasingly concerned with accuracy and detail, to such an extent that it was in danger of losing sight of its affinity with this changing role of art. Fortunately, an interesting tradition survived amongst a minority of "artistic" workers who developed some exciting techniques, including gum-bichromate, silk-screen printing, photo-etching, and collage. These continue to evolve, as photographers and artists are often among the first to recognize the potential of developing technologies.

Our principal aim is to show how easily you can apply different procedures to purposefully explore your own ideas and responses to the visual world. We cover a variety of techniques, some of which can be done in the darkroom as well as others that can be achieved digitally.

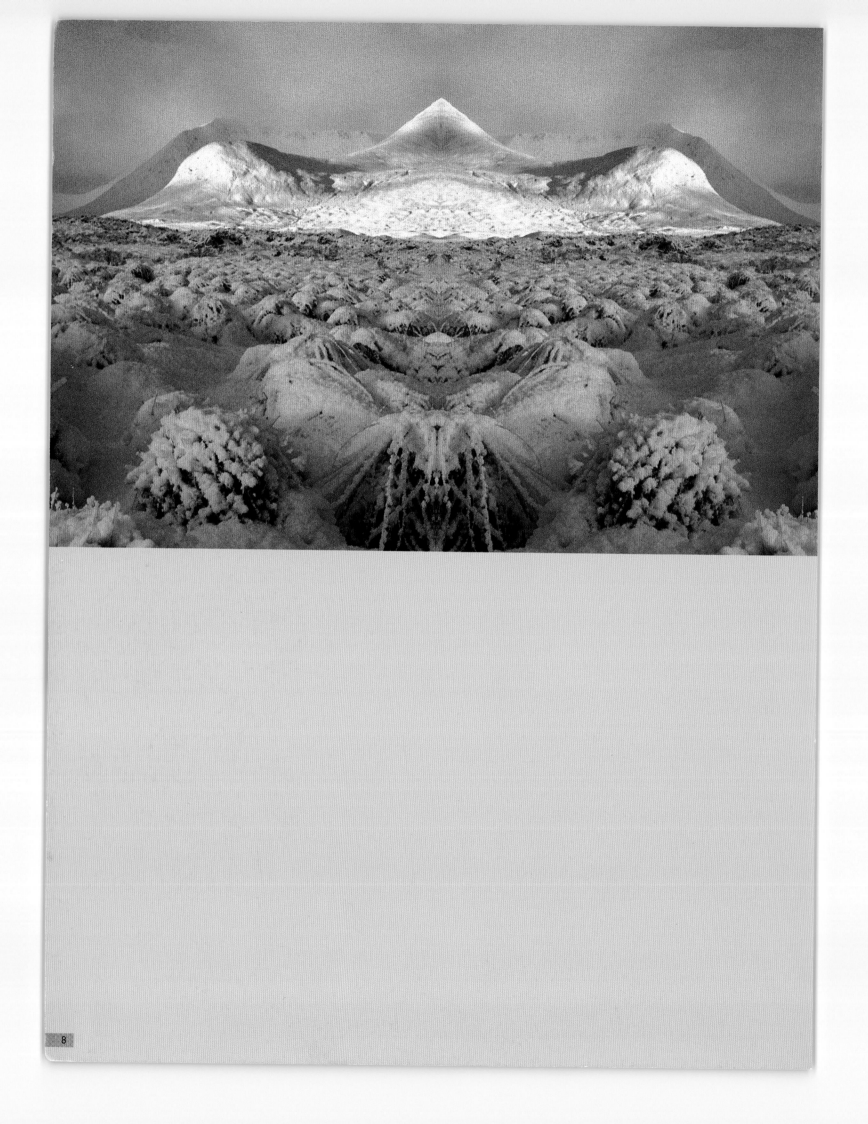

PART I

Exploring the Conventions

Multi-Exposure

Photography records and preserves a fraction of a second in time. This is a strength of the medium and at the same time a weakness. However, there are a multitude of ways in which time and place have been extended and transposed by relatively simple photographic processes. The technique of multi-exposure in camera has been important in exerting creative control over the photographer's interpretation of the world.

MULTI-EXPOSURE IS the technique of exposing more than one image on the same frame or sheet of film in camera. At one time, of course, most cameras had this facility, and double or multi-exposures were often achieved more by accident than design. Modern camera design prevents such accidents from happening, but fortunately there are still many ways to achieve the same result.

Multi-exposure facility in camera

Some manufacturers had the foresight to realize that multi-exposure was a creative tool that many photographers desired. Among other older 35mm cameras still in use is the Canon T90, which has a wonderful multi-exposure facility that allows you to re-expose up to nine frames at one setting. Most medium-format systems, such as the Mamiya RB67, have a multi-exposure lever that allows you to take as many exposures as you like on the same frame. Of course, moving up to any large-format camera such as Sinar, Horseman, or MPP, there is no film advance, so the shutter can be cocked and the same sheet of film re-exposed as many times as required.

Multi-exposure using rewind button

Many older manual cameras, such as the Pentax K1000 (now sadly discontinued), have no automatic multi-exposure facility. When you re-cock the shutter, the film advances as it is mechanically linked. However, the film advance mechanism can be disconnected by pushing in the rewind button on the base of the camera. Now when the shutter is cocked, the film remains stationary.

Exposing and re-exposing film

A rather interesting technique is to expose a whole roll of film, rewind it, and re-expose it.

Self-portrait 1987

Here, the studio was set up for the first of two exposures on the same frame. A 24mm lens on a 35mm camera was used to emphasize distance. A single tungsten light was placed behind one of the flats to illuminate the face as it looked in the mirror. The photographer then changed clothes and moved the light to the front for the second image. The trail of photographs links the two figures.

Self-portrait 2 (OPPOSITE)

This was the result of several exposures using a slow shutter speed on a Canon T90. Depending upon whether the photographer is moving or stationary, the level of blur is altered. Both full face and profile are shown within the same image.

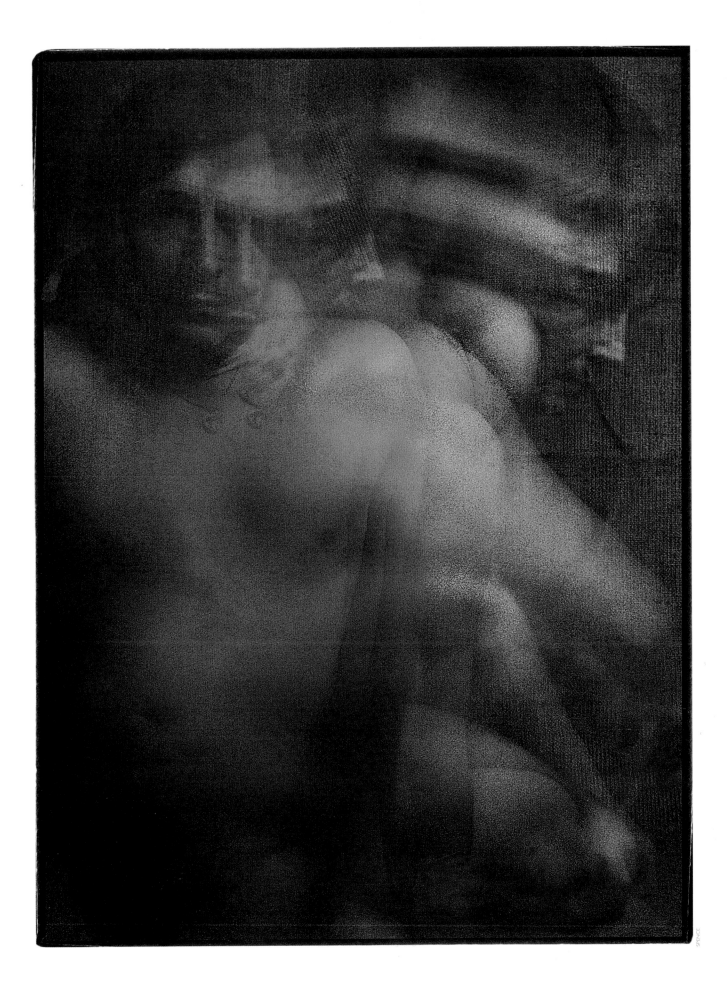

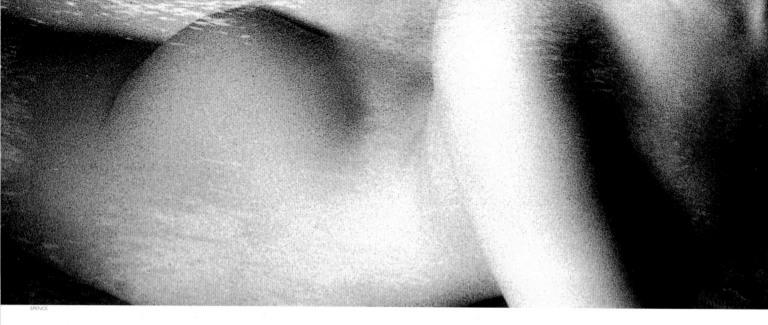

SPENCE

Water nymph

This is the result of running the film through the camera (a Canon A1) twice. Using Kodak Infrared film with a red filter, the model was photographed in the studio against a black background. Normal exposure was given. The film was then reloaded, and the second exposure was of the surface of the water in a local river, along with the plants growing by the edge. The garland of leaves around the model's head was a lucky accident, linking the two images.

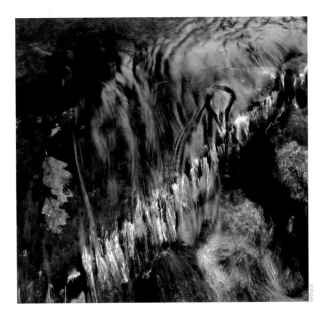

Water

By dividing a 1-second exposure into 15 separate exposures of ¹/15 second, the highlights of the water were changed into moving patterns of light, while the still images of the submerged leaves were retained. A tripod was placed in the moving water. The camera was a Mamiya RB67, with standard lens and Ilford FP4 film.

Arum lilies (BELOW)

Using an oblique light and a Mamiya RB67 on a tripod, the film was first exposed with the flowers on a rusty metal plate. Then the flowers were removed, and a second exposure, of the plate only, was made. This flattened the forms slightly and provided some translucency to the flowers, allowing the metal texture to show through.

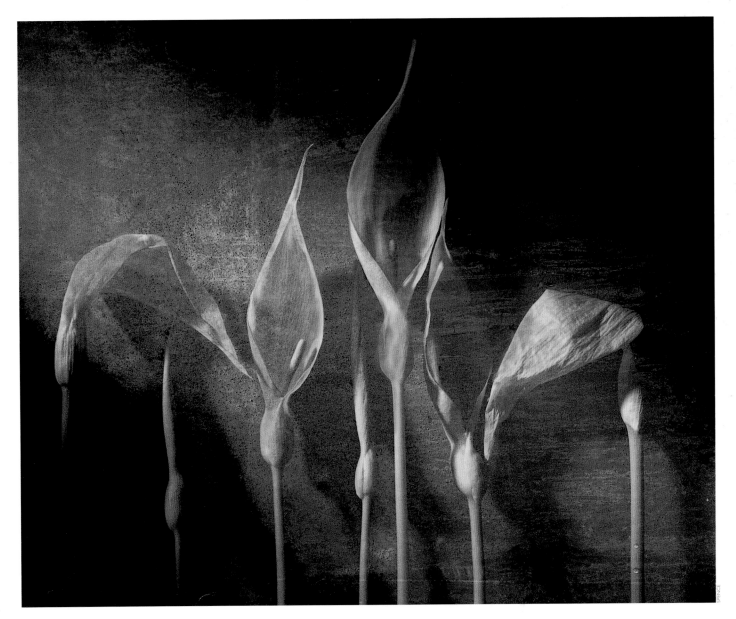

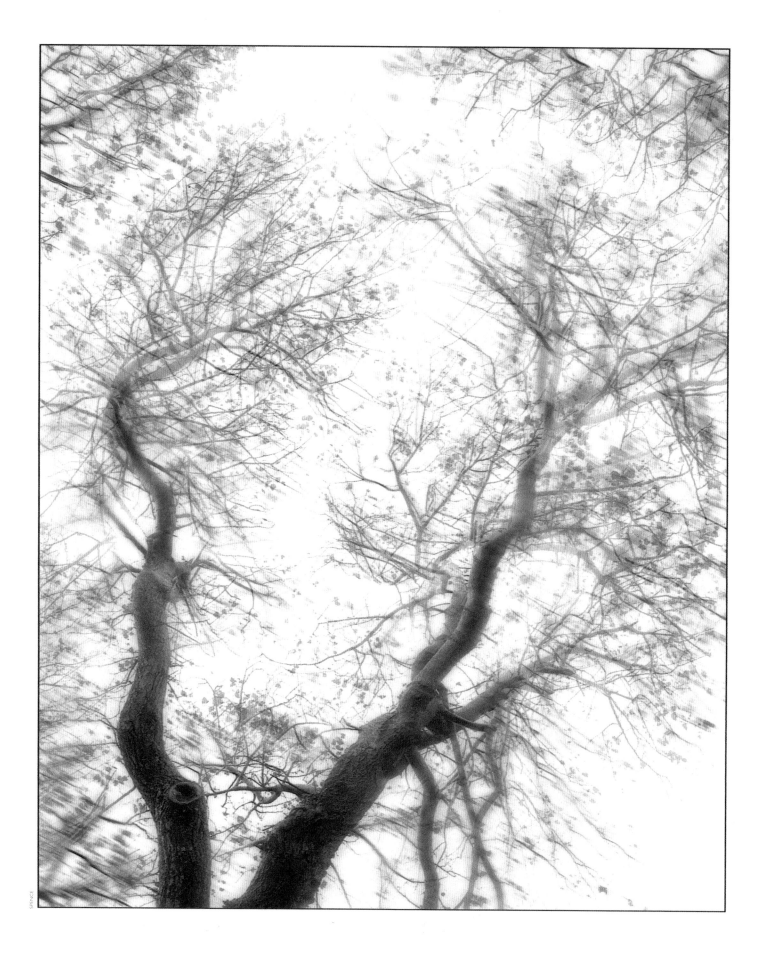

SPENCE

This requires planning if the results are to be predictable, but even so, there is an element of chance. This can throw up interesting surprises, and if you are not too stingy with your film, it is certainly worth trying. The problem with this technique is aligning the original frames that were taken with the re-exposed frames.

The way to do this is to use a permanent marker to make a mark on the inside of the camera above the film guide rails. Then make sure the film is tight in the cassette, and load the film. Now mark the back of the film with the marker at the same position as the previous mark, aligning the two. When you reload the film for the second exposure, just make sure these two marks are once again aligned. It is fair to say that this is not always totally accurate, so some allowances for mismatched frame edges must be made. Beware of modern cameras that

rewind the film totally into the cassette. Manual rewinding is best so that you don't lose the leader film. If you can't manually rewind, stop shooting a frame or so before the end of the film. Go into the darkroom, open the back of the camera, remove the film, and rewind it.

Layers

Multi-exposure allows one image to show through another. Depending upon the subject and number of exposures, very simple or very complex layers of image can be produced. The success of your images will depend upon how you select subject matter, their tonality, and the relative "weight" given to each exposure. In a number of these images, many more than two exposures were made. Aperture can be changed between exposures to give more or less prominence to individual parts of the image.

Trees in the wind

(OPPOSITE)

These emerging leaves in springtime were at a stage where the structure of the branches could still be seen against the sky. The effect seen here could have been created by using two exposures in a slow exposure (about $^1/8$ second) while the wind moved the branches. In fact the tree was not moving at all, and the image was manipulated digitally. The effect was created by copying and moving part of the image, and applying Radial Blur to simulate the movement.

Using layers in Photoshop to create multi-exposure

Déjà vu

Created using a Nikon Coolpix 995 camera, this recent self-portrait was created by combining two images digitally. The back of the figure was blended with the background using Soft Light blending. There are a range of blending modes in Photoshop that are invaluable when combining one or more layers, especially if some translucency is required.

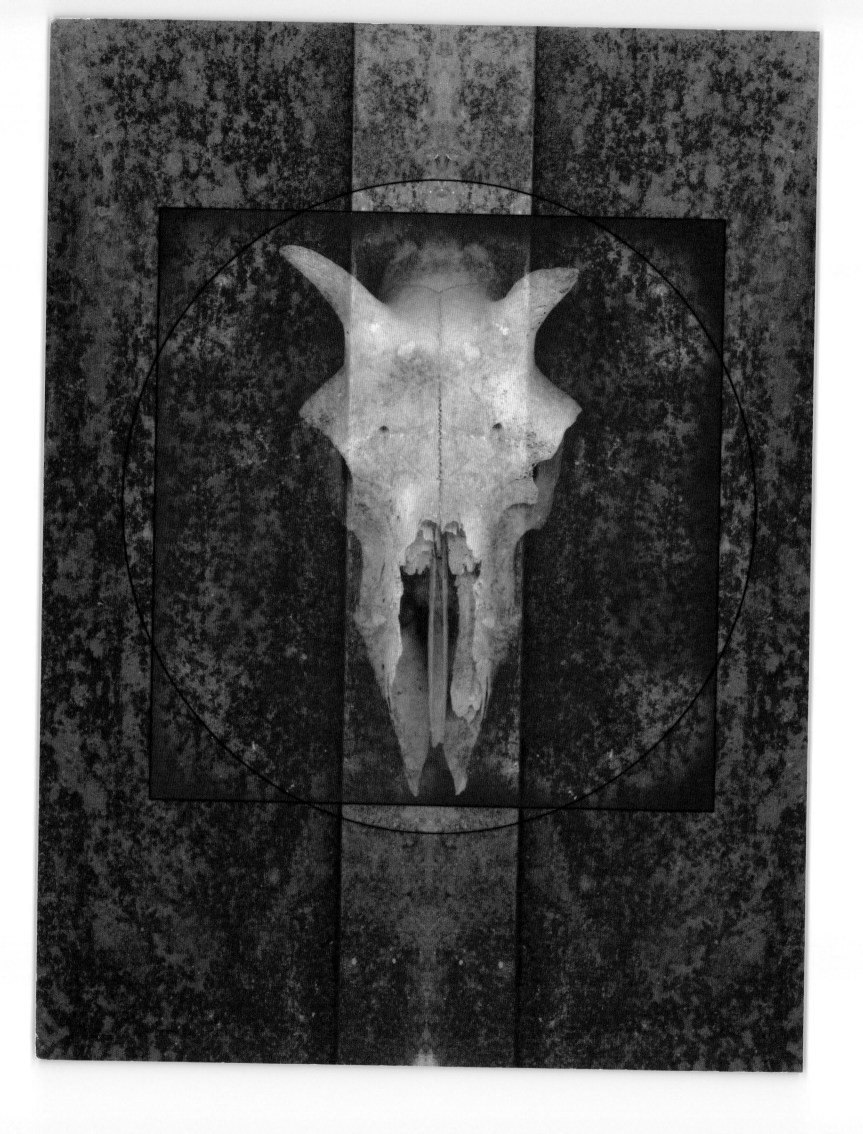

Skull (OPPOSITE)

Here, digital technology has been used to achieve a multi-exposure image in a way that would have been far more difficult—if not impossible—by conventional means. The background is a rusty saw that was scanned, flipped horizontally, and pasted together. The skull was put on a new layer, and selectively erased to show the texture. The geometric shapes were selected, and Curves was used to adjust tonality and color. Finally, the shapes were stroked with a black line to delineate them.

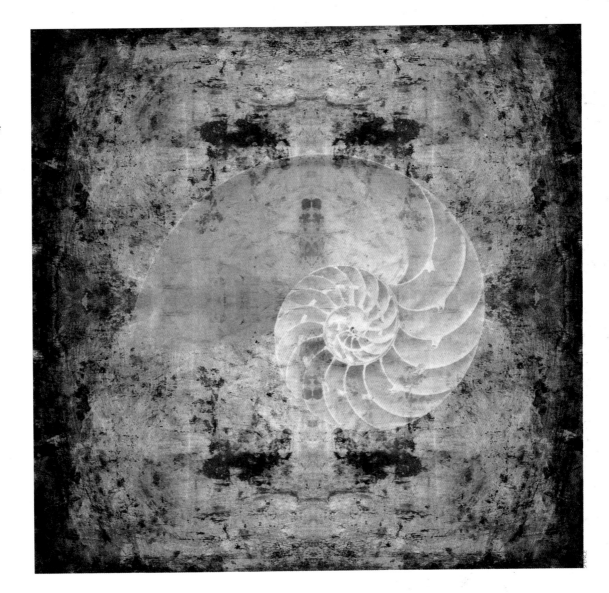

Nautilus shell

In this case, both the background and the shell image were captured by a flatbed scanner, and the resulting scanned images were merged together in Photoshop using Layers and Opacity Control.

With such still-life tableaux, objects can be removed or added between each exposure, thus producing the layered effect.

Multi-exposure and movement

Movement can be shown in a photographic image by using slow shutter speeds and allowing the moving subject to blur its own image. Such a technique is fine, but by using multi-exposure of a moving object, we produce a different interpretation of movement. This is elegantly shown in the work of such photographers as Ralph Eugene Meatyard and John Blakemore. With a camera set up on a sturdy tripod, a number of exposures are taken on the same sheet of film—maybe twenty or more. Anything that stays stationary will look normal, but anything that moves will produce an image in a slightly different place at each exposure, for example, grasses in a field as they are blown by

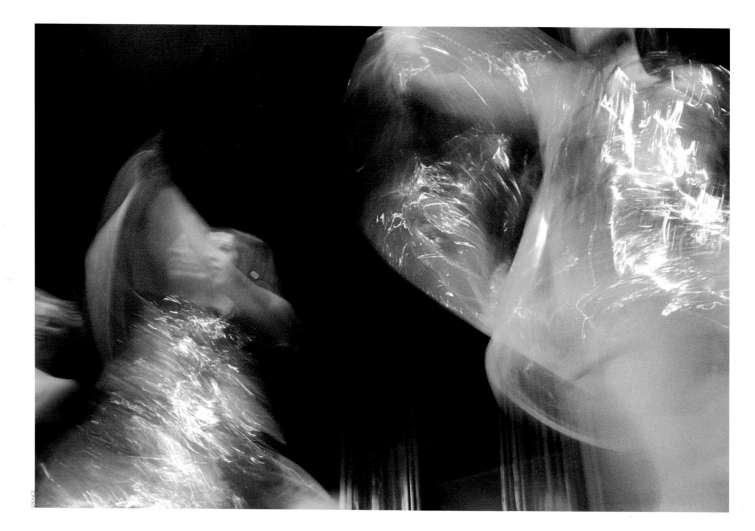

Fashion

The energy and swirling colors at this fashion show are emphasized by the use of slow shutter speed and flash. A low viewpoint was chosen, and a shutter speed of $1/8$ second with fill-in flash via a 28mm lens on a Canon T90 produced a combined image that has some sharp detail and movement.

Two sisters (OPPOSITE)

In this image, a slow shutter speed of $1/8$ second was combined with flash, and the camera was moved during the exposure. This resulted in a sharp image of the girls in the foreground, lit by the flash, and a blurred background lit by ambient light.

the wind. Light on moving water appears as dancing lines, and the water seems in turmoil.

The effect will obviously depend on the number of exposures you take, and the amount of subject movement. Exposure is determined by simply dividing the total exposure by the number of exposures used, so a subject that requires 1 second at $f/16$ would require fifteen exposures at $1/15$ second, plus an extra one or two for reciprocity.

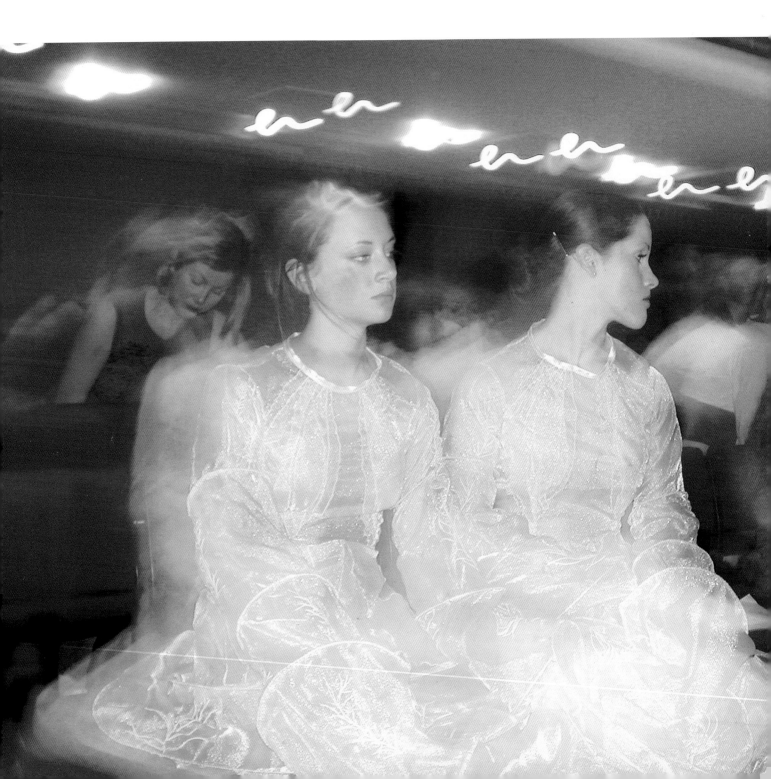

Multiple Printing

During World War II, images were deliberately doctored for propaganda purposes. Their key to success was that the visual lies were always highly plausible. There is a well-established tradition for altering an image during the printing stage, and it is not unusual for photographers to use two, three, or even more negatives. The final image should be credible, but integrity need not be restricted to naturalism.

POSSIBLY THE MOST common example of multiple printing is when the photographer prints a landscape but chooses to "drop in a sky." This is easy to do, although a little thought is required when selecting the negative.

It is important to retain some measure of consistency and to consider the direction of light in both negatives. If your landscape is backlit, you should consider using

Selecting images to combine

a similarly backlit sky. Mistakes are often made when using landscapes that have been lit from one side, and it is important to examine your test strips carefully.

If you notice an inconsistency, you always have the option of reversing one or other of the negatives. Another possible pitfall is to use a landscape that has a light feature (such as a building, figure, or vehicle) that breaks the horizon. Unless you exercise great care, unwanted sky detail could appear in these lighter parts, so choosing the right negatives clearly is important.

Plan your work carefully

Once you have your elements, it is essential that you make clear and precise test strips, both of the landscape and the sky. Make accurate notes, because even a relatively straightforward multiple print requires exacting sequences.

When making notes, tabulate each part of the sequence—you must decide which part of the final print is the most important and then ensure that the supporting negative is printed sympathetically. There is little point in printing a subtle, high-key landscape and then adding a dark and aggressive sky. One needs to

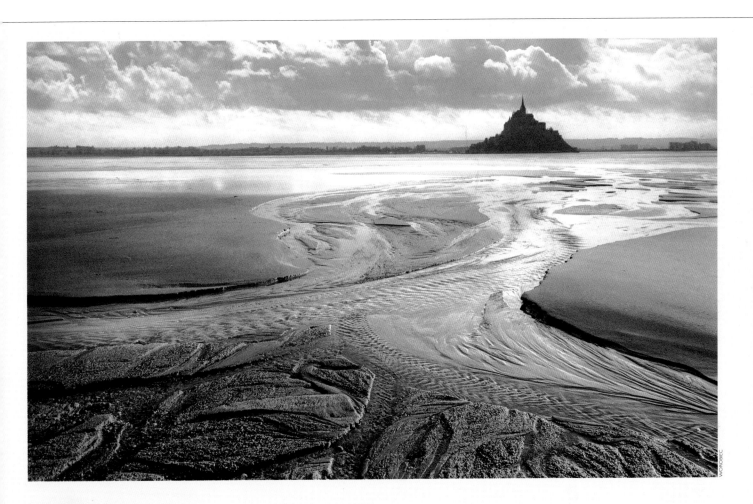

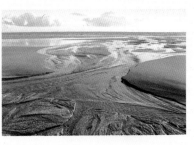

Mont St Michel 2

Here, image A was joined to image B. This was easily achieved because they both shared a common feature, a large expanse of wet sand that was backlit slightly to the right. In order to retain consistency, negative B was reversed so it also appeared to be illuminated from the right.

"Dropping in" a sky

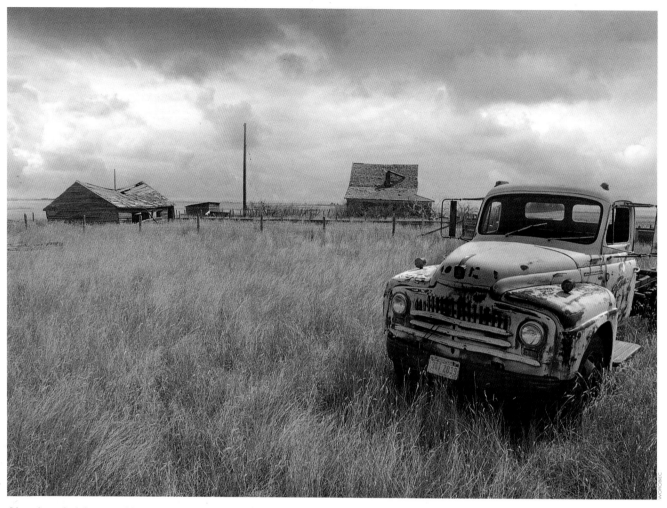

Abandoned pick up on Montana homestead

In this photograph, the image needed a more threatening sky than existed on the negative. Once again, there are buildings above the horizon, although in this case, they are light in tone. If you were to try and simply print in another sky without masking the buildings in some way, some unwanted and unnecessary detail would appear. It is possible to overcome this by masking the buildings using card or acetate masks.

Card mask

Place markers precisely in line with the horizon

Acetate mask

Place markers precisely in line with the horizon

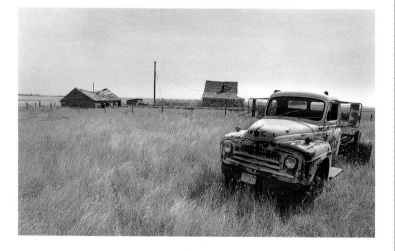

complement the other. It is also important, especially if you are varying the enlargement of the negatives, to take note of where the lamp-house is relative to the column.

The technique

The technique is a simple one. Cut two little triangular markers out of masking tape, and place them on the inside edge of the enlarging easel so they correspond with the two edges of the horizon. It is worth adding at this point that it is important to use a good-quality, heavy-duty easel, however much it costs.

Before putting the paper in the easel, pencil in a small cross on the reverse side, top right, so you know which is top and bottom when retrieving the paper later on. Print the image negative as normal, taking care to mask the sky with a piece of card during part of the exposure. If you mask for too long, you risk losing parts of the image. Carefully remove the paper and return it to your paper safe. Now insert the sky negative into the carrier, ensuring that the horizon matches up to the markers. Return your paper to the easel, making sure that it has been accurately placed, and then make your second exposure. With a little bit of luck, all should work out well.

In principle, that is all you need to know about multiple printing, except, of course, that there are numerous variations on this method, which should enable you to overcome most technical difficulties.

Making masks.

1 Project the landscape onto a piece of card. Draw the outline as carefully as possible, and then cut a mask (see figure 1 on page 22). It helps if your cardboard mask is significantly smaller than the intended image to allow for more subtle blending—an 8-by-10-inch mask for a 12-by-16-inch print generally works well. When using this method, it is essential that at the printing stage, you keep your piece of card moving. This will help you avoid tell-tale lines.

This method has many advantages—it is

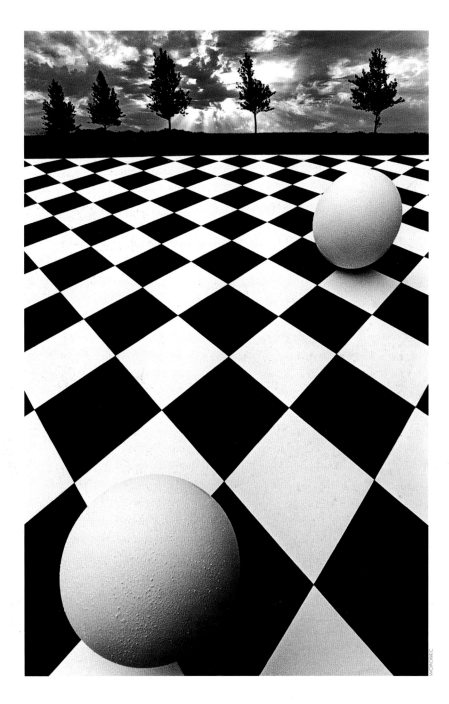

Counterchange

Two negatives were required to produce this highly graphic image—negative 1, which contains the checkered board, and negative 2, which contains the sky and line of trees. The checkered surface was originally a 4-by-4-foot piece of hardboard on which the design was painted. When it was shot, the photographer ensured that there was a piece of black material at the top, then took the sky negative with its corresponding dark area and blended negative 1 into negative 2.

relatively easy to achieve and is generally effective in most situations. However, as you will have noted in the drawing of figure 1, some fine detail has to be omitted.

2 Produce a mask using a sheet of acetate. Ideally, you should start with a sheet identical in size with the intended print. Place the sheet of acetate in the easel and project the negative image onto it. Then paint those areas you wish to mask using a photo-opaque solution—this can prove laborious but is nevertheless fairly accurate (see figure 2 on page 22). If

absolute accuracy is essential, then a rather sophisticated development of this principle is to produce a lith mask, which again should be the same size as the intended print. If you do not have the facilities to make one, they can be made up commercially. These masks are much more accurate than using cardboard masks, making it important to achieve a very accurate registration at the printing stage.

3 Another interesting way of producing a mask is to use your computer and a film scanner. If you are using Photoshop, scan in your negative, go to Brightness/Contrast, and produce a dark yet contrasty image. Once you have achieved this, then it is just a simple matter of printing out the final image onto an OHP inkjet transparency, which again can serve as your mask. Your only restriction is that the final size of your print will be determined by the size of your printer.

Blending images

An alternative option is to blend an area of common value, thereby avoiding any need for specially made masks. For example, it is possible to blend the details of the sky from one negative with the sky from another.

Once you have accepted that cloud can be blended into cloud, why not sand into sea? Any two landscapes can be successfully blended, providing they share certain key characteristics, such as lighting, texture, tone, and topography.

Doing it digitally

Many darkroom workers avoid multiple printing because they feel it is outside their competence—however, nobody ought to feel this about multiple printing digitally. There are various software packages that will do this, although Photoshop now appears to be the industry standard. Not only does it match what can be achieved in the darkroom, in many respects it supersedes it.

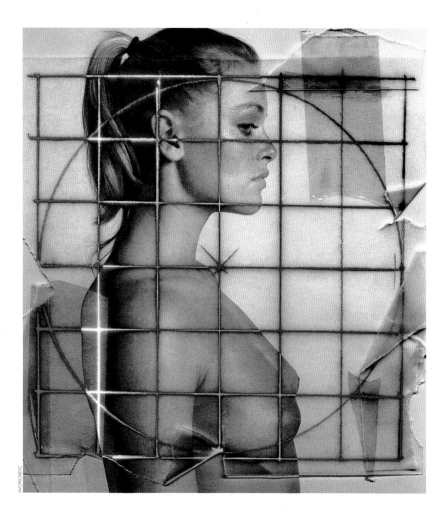

Model seen in profile

The method used to create this image is explained in detail on page 26. It would have been impossible to create this image in the darkroom; the original black and white image was scanned as a color negative and each layer was independently manipulated in Photoshop.

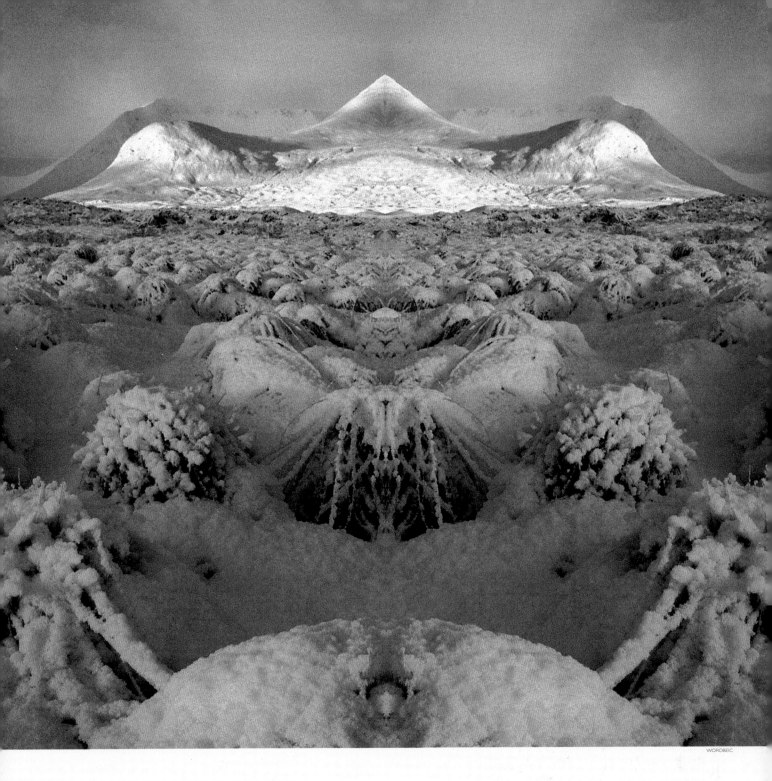

WOROBEIC

Winter in Middle Earth

One of the most impressive features of working digitally is its unerring accuracy. This example was made by selecting half the landscape, flipping it, and then joining the two parts, resulting in this visual palindrome. This is virtually impossible to achieve in the darkroom.

The advantages of working digitally

■ While blending one negative into another is relatively easy to do in the darkroom, superimposing one negative over another is a little trickier. It is difficult to predict which areas will come to the fore, and often the results can appear rather muddled. With Photoshop you have the Layers option, which allows you to work with considerable control. Being able to determine the opacity of each negative and see the outcome prior to printing offers the printer immense scope.

■ Unless you wish to hand-tint your print, it is impossible to merge monochrome and color into the final image when working in the darkroom—but this is easily achieved digitally.

■ Unlike working in the darkroom, there is no need to make test strips prior to printing.

■ Because you are able to control the opacity and tones at each stage of the process, and also to review what you have done, you are less likely to make mistakes.

Model seen in profile. How was it done?

Initially the black and white image of the model was scanned as if it were a color negative, as one is able to establish a far more tonally accurate scan in this way. All the tonal adjustments were made using curves and also a few further localized adjustments were made with the Dodging tool. Finally the image was resized up to the desired scale and then saved.

Next a piece of tracing paper was deliberately distressed by tearing, crumpling and taping and then a circle and grid was drawn onto it. As the tracing paper was much larger than a standard piece of film it was scanned using a flatbed scanner, ensuring that the resolution matched the final outcome. The aim was to disguise the identity of the second layer, so it seemed appropriate to negativize this part— this was easily achieved by going to Image > Adjust > Invert. Minimal tonal adjustment was required at this stage, so the new element was then resized to match the negative of the portrait and saved.

The real beauty of using a program such as Photoshop is that it is so easy to overlay one image over another in a controlled way. It is as if you have two sheets of acetate, one over the other and either can be changed or removed at any time.

Firstly the portrait negative was called up and established as the first layer. A second layer was then created with the drawn grid. It is important at this stage to keep the layers independent of one another to allow for changes of position and tone to be made. If you wish you could add further layers.

After experimentation with the layer options it was decided that the Difference mode best suited this particular image as it introduced a slightly quirky solarized effect. Finally the image was flattened and then colored using Saturation/Hue.

Blending non-photographic images

Whilst many digital workers recognize the creative opportunities of merging one negative into another, few appreciate how easily photographic and non-photographic elements can be merged. This is a well established tradition pioneered by such eminent artists such as Robert Rauschenberg and Olivia Parker. If you have access to a flat-bed scanner, why not try introducing drawings, paintings, collages, letters, maps, leaves, flowers; it may well open entirely new creative channels for you to explore.

Merging two negatives together

Kimmeridge 1
While the movement of the water over the rocks is good, the bald sky tends to draw the eye.

Kimmeridge 2
Although the sky in this example is much more interesting, the rocks are visually less attractive than in the first print.

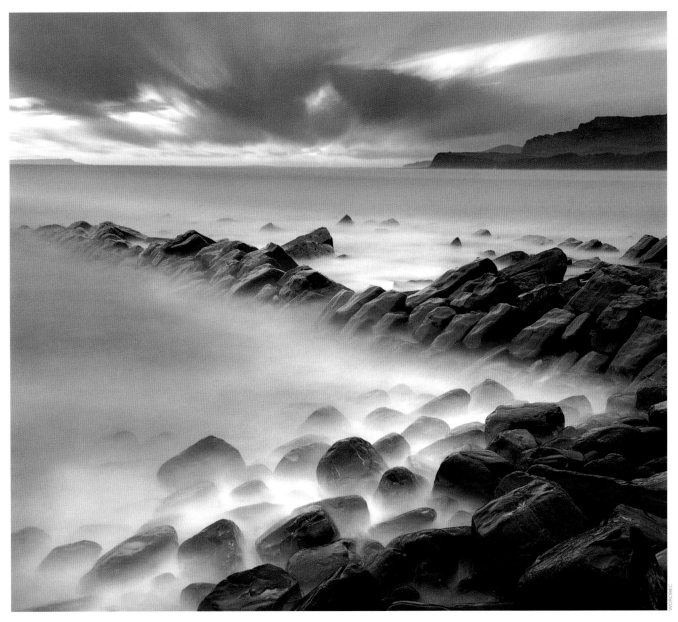

Kimmeridge 3
To achieve an amalgam of the best from both negatives, the area between the rocks and the headland was joined together.

Photomontage

Cutting out and reassembling photographs was a popular pastime in the early part of the twentieth century. It was developed as a serious art form by the Dada movement, which used photographs, drawings, and newspaper cuttings to produce witty and ironic images with a social or political message. Photomontage is the art of combining elements from various sources into one final image that is then rephotographed. It can be blatant or extremely plausible.

Because the final outcome needs to be rephotographed, it is important that the individual elements are taken on at least a medium-format camera. Always ensure that the paste-up is copied onto medium or large format—images from 35mm film lack detail and clarity.

Developing an idea

For photomontage to work, you need an idea. The best ones are planned, with the photographer drafting out a design and then taking negatives specifically for the task. It helps enormously to sketch out your initial idea so that problems of scale and proportion can be resolved at the shooting stage. If you want your final picture to look plausible, it is important to consider the viewpoint and direction of light.

Establishing a scenario

In most montages, it is important to decide upon a scenario or background, which the other elements fit into, such as a landscape or interior. Try and keep it as simple as possible, or you may end up with conflicting elements. Ensure that the initial montage is as large as possible (most are no smaller than 12-by-16), otherwise the joins may become too obvious in the final negative.

Printing the montage elements

This is an important part of the process—all the information you require in the final print hinges on these prints. Print on low-contrast paper: it is easier to retain shadow and highlight detail but also because the contrast will be increased at the copying stage. Anything that reduces this will prove to be beneficial. It also helps to use matte or semi-matte paper; glossy can cause problems at the copying stage. The

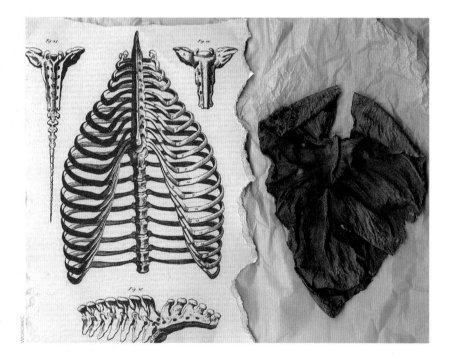

Rib cage and dead leaf
In order to be successful with montage work, you need to adopt an open-ended approach. In this example, I was struck by how much the diagram of the rib cage echoed the shape of the dead leaf. By carefully positioning them together, the comparison is made more obvious.

Antiquity I (OPPOSITE)
This montage uses elements from a variety of sources. While it may not be immediately obvious how all the parts link up, the viewer's imagination can quickly compensate, creating a new level of understanding.

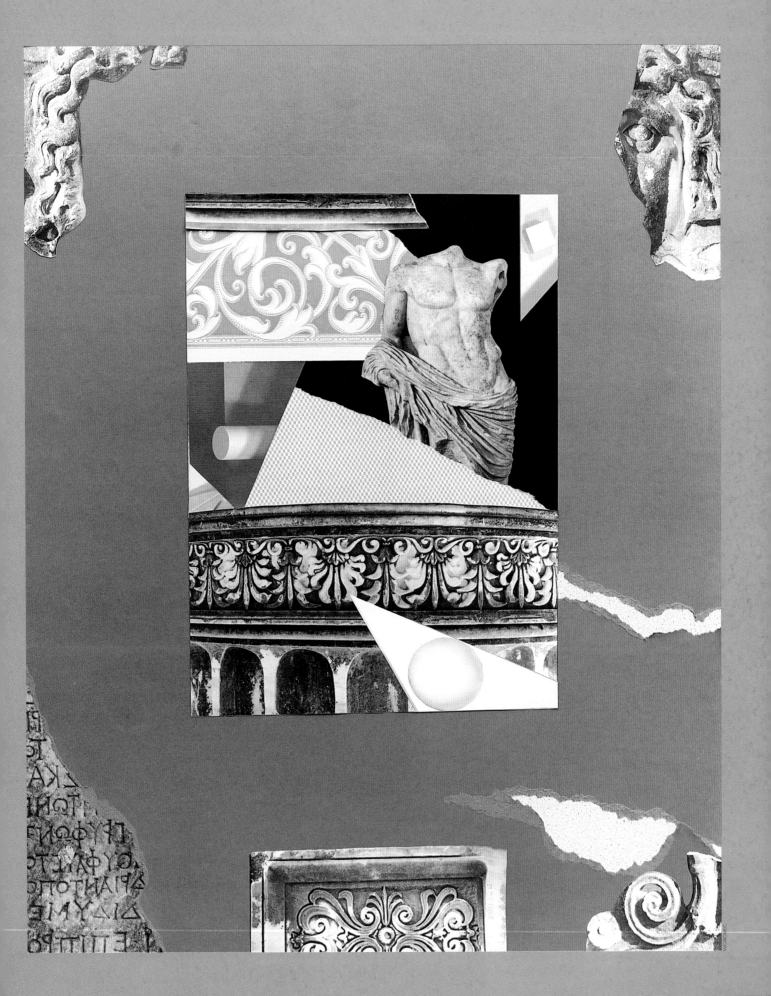

Considering the elements for the final montage

Danny

The three elements of this photomontage are shown in the smaller prints. This is an example of photomontage where it is a good idea to first sketch the elements, both to determine the correct printing sizes and to achieve the desired perspective. Seen together, the three elements appear far more menacing.

Cutting out the elements

The lines radiating outward from the subject indicate the "darts" used for cutting out the image. For the outline of the subject, try not to cut right through the paper (see text below). The edges are gently sanded from the back of the print, working outward from the center of the cutout.

Element A

The sky that the rest of the montage is pasted to.

Element B

The oil drum.

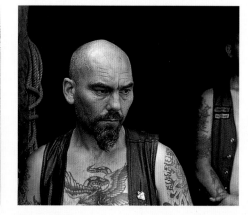

Element C

The subject has a shaved head, making it easier to cut him out.

real difficulty comes when you are trying to assess scale, so an accurate line drawing can be invaluable. Increasing and decreasing the scale of the elements relative to each other is an essential part of the process.

Cutting out the elements

Cutting is the most demanding of skills, and it is essential to use a good-quality craft knife or scalpel with a fresh blade. The real secret is not to cut out the part you want but to merely score the line. You should not be able to see the cut from the other side. Then carefully cut "darts" up to the part you wish to retain, and rip away the excess paper in the direction of the piece you want to keep (see line drawings above). It helps to work with resin-coated paper at this stage, because the plastic coating is far more robust than traditional papers.

If all goes well, your remaining portion of the photograph should be feathery at the edges. Use a very fine grade of abrasive paper to make the edges even thinner, but always make sure that you rub the back of the paper, from the center out. If this is done properly, the edges will become so thin that they appear almost translucent.

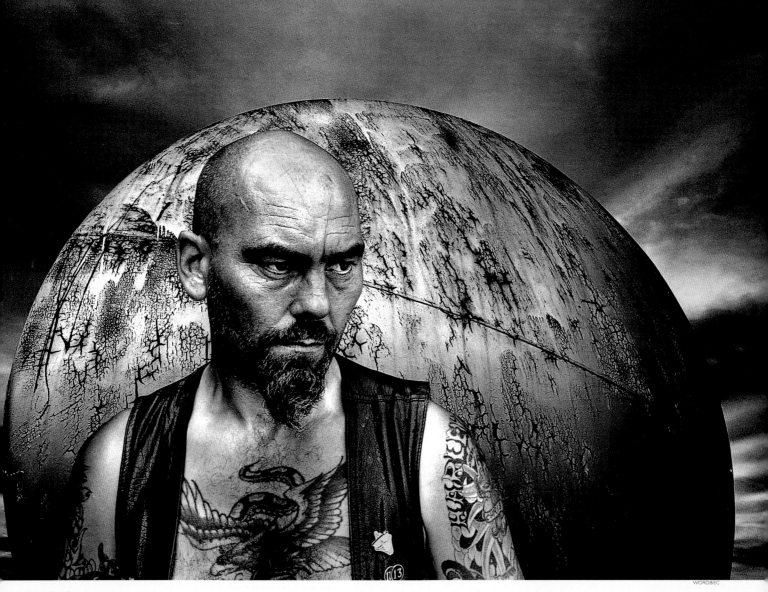

The final montage

When viewed separately, each of the elements looks quite ordinary, but assembled

together, they become altogether different.

Assembling the montage

Assembling the final elements onto the background is relatively easy. Use Spray Mount to adhere the montage onto a clean sheet of board—laminate has a very smooth surface, and the montage can easily be peeled off once copied. Remove any grit or debris from the parts you wish to stick down and from the board. If Spray Mount has seeped onto the surface of the montage, wipe off with nail-polish remover.

Copying

Some photographers make quite a drama out of copying, using two evenly illuminated lights to ensure that the lighting is balanced and shadowless. Why bother? You cannot beat daylight. Try copying outside, on a dull day and, if necessary, use a polarizing filter.

When copying, try to use the finest film possible with a medium- or large-format camera. Use a good-quality lens hood, and if you still detect flare, construct a "tent" around your montage. Contrast is the biggest problem, but this can be overcome by overexposing and underdeveloping your film. Alternatively, try a two-bath development process. It should be possible to get most of your negative to print onto grade 2 paper.

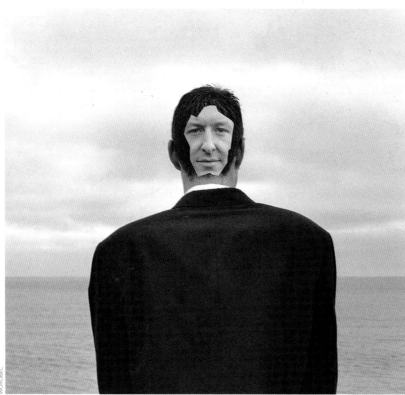

WOROBIEC

Portrait in the style of René Magritte

This is a photographic parody of Magritte's painting *La Maison de Verre*. It was easily constructed, requiring only one negative showing the model's back, and a second featuring his portrait.

While all the prints in this section are black and white, there is no reason why this technique could not be applied to color. In any process that relies on cutting and pasting there are limitations, but if you choose to montage traditionally, you are able to use conventional papers, with all the advantages this brings, not least the ability to archivally tone your work. Even once you have printed your image, you can still apply a little brushwork to introduce detail beyond the scope of cutting and pasting.

Montage challenges tradition

Have you ever moved around apparently unrelated prints or images, only to discover that they suddenly seem to work together? Montage is an extremely worthwhile means of creating an image that could prove to be more interesting than other, traditional modes of photography.

When photography emerged in the mid-nineteenth century, it freed art from its role of recording portraits and events, resulting in the varied schools of twentieth-century art in which the focus was on the aesthetic issues that

underpin all good art. Photographers, however, steadfastly stuck to their role as visual recorders. Recently, they've realized that, like artists, they can extend the boundaries of their craft.

So what is it that concerned the painters of the twentieth century? In short, a personal, visual language. Through the manipulation of line, form, color, texture, and composition, a much-heightened visual expression could be achieved. Moreover, images did not need to conform to the rules of proportion or the laws of perspective.

The key is to establish an idea. You may decide to group images that have obvious links, such as natural shapes, mechanical parts, or elements of the human form. More interesting examples often emerge when dealing with concepts such as time, political values, or human relationships.

What you create may appear to be random, but as soon as you engage in choices—which element goes with which—either consciously or subliminally, you become aware of relationships and how the elements can work together. Often what results is a visually dynamic statement that transcends the glibness of more traditionally crafted montages.

Do not always use photography as your only point of reference—the world of art is full of exciting and challenging imagery. An exercise that often crops up in photography classes requires students to produce a piece of photography that mimics examples of twentieth-century art. By dipping into another visual world, they emerge motivated, enlightened, and capable of breaking out of the conformity that blights so much photography.

Choosing your elements

This is where you are really required to be receptive to new ideas. While much of your imagery may well be photographic in nature, not all of it needs to be. Part of the art is to see the potential of discarded leaves, insignificant scraps of paper, or other material and see how they can be woven into a challenging and new

reality. Artists who seriously indulge in this kind of work have enormous collections of scrap that they use as the ideas begin to develop. They are eclectic hoarders who seem incapable of throwing anything away, because they are aware of the design potential in every discarded piece. The American Pop artist, Joseph Cornell, exemplifies this tradition and has constructed some of the most beautiful and original montaged sculptures.

There is no reason why you cannot amalgamate real and photographic sources into the same montage, providing it improves the final statement. You may find it difficult adhering some elements onto your final montage at the beginning, but there is no reason why you cannot place them over your design, and then photograph your completed montage from above.

Keeping the design simple

Good design should always maintain a balance—the more disparate the elements, the more clear-cut the design needs to be. Photography and all other aspects of the visual arts are fundamentally about communication, so the more varied the pieces you introduce, the greater the need for an overall simplicity. A good way to start a design is to sketch out a few basic thumbnail sketches so that you have a clear idea of how you wish your montage to develop.

Creating a montage digitally

Abandoned Cadillac

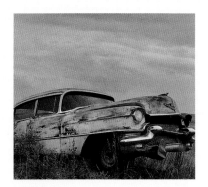

Element A

An interesting vehicle. However, even when printed in, the sky lacks interest.

Element B

This sky was chosen because of its potential to add drama to the final image.

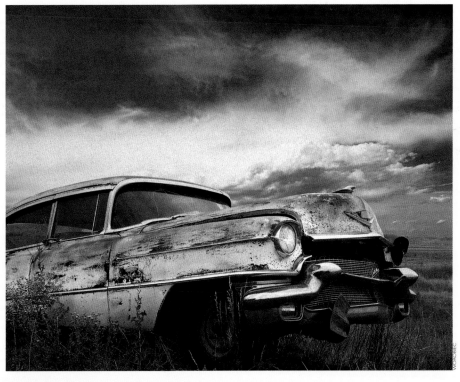

The final montage

There is a mistaken belief that creating a digital montage is easier than doing it traditionally. Both methods require skill and patience, but the advantage with digital montage is that you are able to work on it further without having to go back to square one. This example was toned blue, using Hue/Saturation.

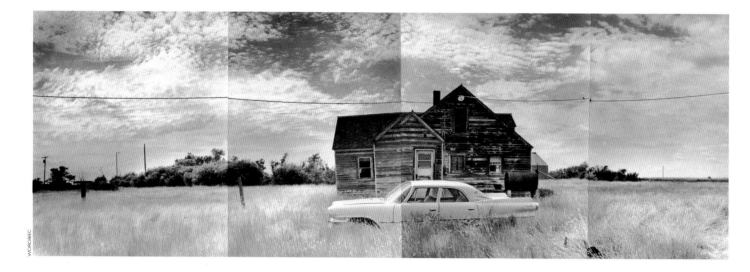

Madoc

Joiners can prove to be a rather ephemeral aspect of photography, unless you are prepared to rephotograph them.

Andy as a cubist portrait

One of the great pleasures of teaching is that you are constantly encountering students with bright and imaginative ideas. One of them was examining the Cubist movement, and he quickly appreciated that the Cubists created their distortions by viewing an object from not just one but from various viewpoints. In order to illustrate his point, he took various photographs of himself and then cut parts out, creating lattices which he then overlapped, creating a new and more interesting portrait. This study works along similar lines—it would have been relatively easy to disguise the joins, but they were part of the process.

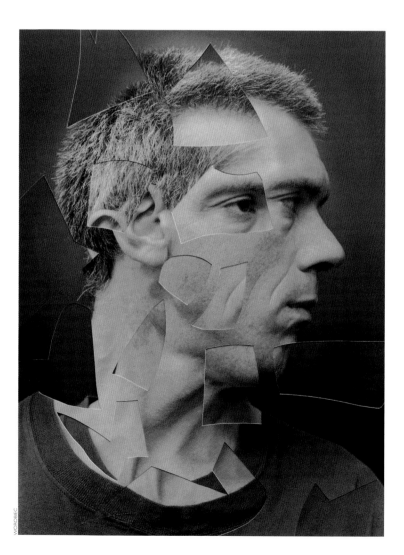

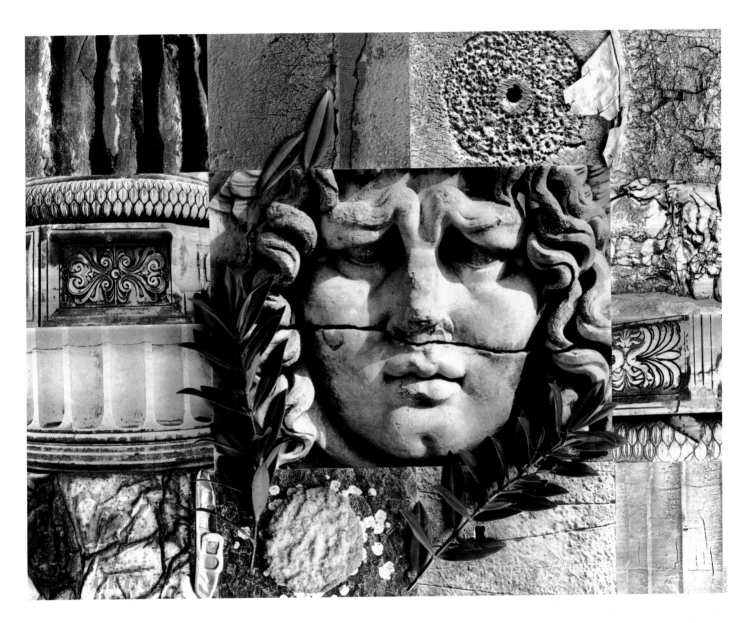

Antiquity 2

This is a very deliberately constructed montage that does not seek to create any sense of realism. Using images that illustrate fragments of ancient architecture, a rich sense of texture is introduced.

Planning your work carefully

While much of this kind of work appears informal, the best examples are extremely well constructed, which requires a great deal of planning. One way of doing this is to start with cheap photocopies that you can easily overlap and cut, tear, and paste until the design is fully resolved.

Working in this way you will quickly figure out the order in which to paste the constituent parts, and whether any elements need to be increased or decreased in size. Scaling up and down is a critical part of the process, and failure to observe this could prove to be costly, both in terms of time and materials, unless you already have a clear idea of what you want.

Working informally

When working conventionally, it is important that the joins do not show, but with this more contemporary approach to montage, you can afford to be far more liberal. Rips, cuts, and heavy overlaps can often enhance this kind of work, and should not be disguised. Remember that you are not trying to create a false illusion but rather to celebrate the unusual juxtaposition of a variety of visual elements.

Joiners

Joiners are increasingly popular way of exploring photography although the final results can often appear ephemeral. One excellent way of resolving this is to photograph them precisely in the same way as a montage. The overall shape of the montage and the background it is pasted onto are clearly important aspects of the design and should be carefully considered.

Using distressed photographs

An interesting convention many contemporary graphic designers are currently exploring is using images that have been deliberately distressed. Crumpling, tearing, aging, and staining photographs before you work them into the montage adds a new dimension of interest. We have become accustomed to viewing pristine images, and, as soon as they are presented in this unconventional way, we are encouraged to see them with fresh meaning.

Working digitally

The decision to work traditionally or digitally is a personal one, and it is important to understand that each method has its own unique characteristics. One compelling reason

Constructing montages using a flatbed scanner

Element A: single tulip

This was scanned using a flatbed scanner, so the detail is very sharp indeed. The flower was carefully suspended to ensure that the weight of the flower did not spread over the glass screen. Despite using a white background, unnecessary detail appeared in the background— this was removed by selecting the background and "airbrushing" out the detail.

Element B: background for tulips

This was created by using various layers of silk paper that were also scanned using a flatbed scanner.

for working digitally is that you are able to work from 35mm negatives; another is that there is no need to copy your work, so there is no reduction in quality. The many options offered by Photoshop are immense, and problems concerning scale, opacity, and composition are very easily handled when working digitally—so easy, in fact, that it is possible to lose the character of a montage if you are not too careful.

The digital process

Surprisingly, this is very similar to working in the darkroom—it is important to start with negatives that will work together and that share the same directional lighting. It is also helpful to establish a scenario. Scan each of the elements in turn, making tonal adjustments as you go along, in order to make selections easier.

How you choose to select will vary depending on the negative used and your own style, but the quick mask is an easy and effective way of cutting out the parts you need. This is possibly the most difficult part of the process.

The old phrase "there's more than one way to skin a cat" certainly applies to working in Photoshop because there are so many alternatives you can use to achieve the same

task. A preferred method for selecting is to use the lasso tool to crudely select the area you wish to cut, and then to apply the Quick Mask.

If you are selecting from a complex negative, it does help to precisely see what you are cutting, so always set the opacity between 20–30, then refine your selection using the pencil tool. Because this is usually achieved when this image is magnified, use a graphics pad, which allows you to to work with far greater accuracy. Once this part of the task is complete, a feather of 1 pixel will help to soften the edge.

Using a flatbed scanner as a camera

While many photographers view flatbed scanners as a means of scanning in prints, they are also a superb way of developing montages. Obviously you will be restricted by the size of your scanner, and of course you will need to choose your elements with care to ensure that you do not damage the platen, but, if you use a clear sheet of polyacetate for protection, this should reduce the risk. Beyond that, there is an enormous potential in this sort of work, which will be considered later.

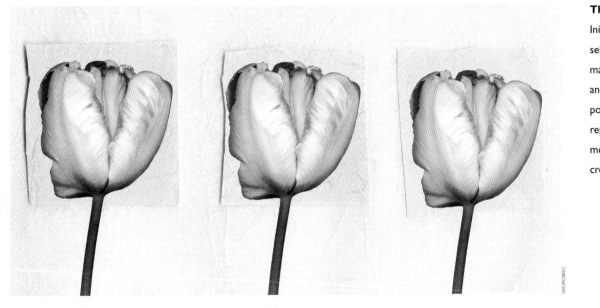

Three tulips

Initially the tulip was selected using the magic tool, cut out, and moved into position. This was repeated twice more, in order to create the montage.

Infrared photography

Our eyes are sensitive to the visible light spectrum—the colors from red through violet—and the monochromatic tones into which they translate. However, the world is observed in a completely different way by many animals—a butterfly detects the position of nectar in a flower by guidelines invisible to man; a snake detects a mouse in the undergrowth by the heat of the animal's body. These facets are invisible to our eyes. However, there are many ways of entering this unseen world.

THE VISIBLE LIGHT spectrum can be split into its component parts by a prism and the energy of each wavelength measured. There exists a band of energy beyond that of human vision—infrared. We cannot see it, but infrared film makes visible the invisible.

So what does infrared film see, and how does it interpret the world around us? The answer is complex and depends upon a number of variable factors, such as film type, development, use of filters, and the time of the year.

Monochrome infrared

There are currently four monochrome films, which are sensitive to infrared to a greater or lesser extent:

- Kodak High-Speed Infrared
- Konica 750 Infrared
- Maco IR 820C
- Ilford SFX

Generally speaking, objects that reflect a lot of infrared will appear very light, and those that absorb infrared will appear dark. In typical landscapes, foliage will be light, blue skies and water almost black. In portraits, flesh tones are smooth and white, while eyes (particularly blue) are deep, black, mysterious pools. Highlights often show signs of flare or halation, giving images an ethereal look.

Infrared films are also sensitive to visible light, so to produce the greatest infrared effect filters are used to block out visible light. Pure infrared filters are available (Nos. 87 or 72), but as they filter all visible light, they make viewing through an SLR impossible. They can be used on rangefinders, or you can put the filter on an SLR after composing the shot. They are also useful if placed over a flashgun to light with "invisible light" at night, or in darkness.

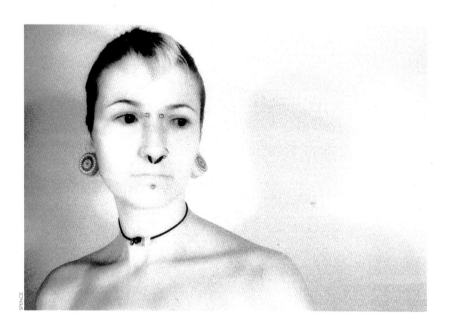

Cressida

This portrait emphasizes the effect of infrared film on the skin and the eyes. The film was Kodak High-Speed infrared film rated at 200 ISO and developed in Kodak HC110 at 1:31 for 6 minutes. A red filter and two tungsten lights were used to produce a rather stark image.

Dancer (OPPOSITE)

The grandeur of the tiles and columns of the room suggested a theatrical setting and make an ideal backdrop. The lighting was natural sunlight, and the film was Kodak High-Speed infrared. A wide-angle lens 28mm was used to emphasize the foreground.

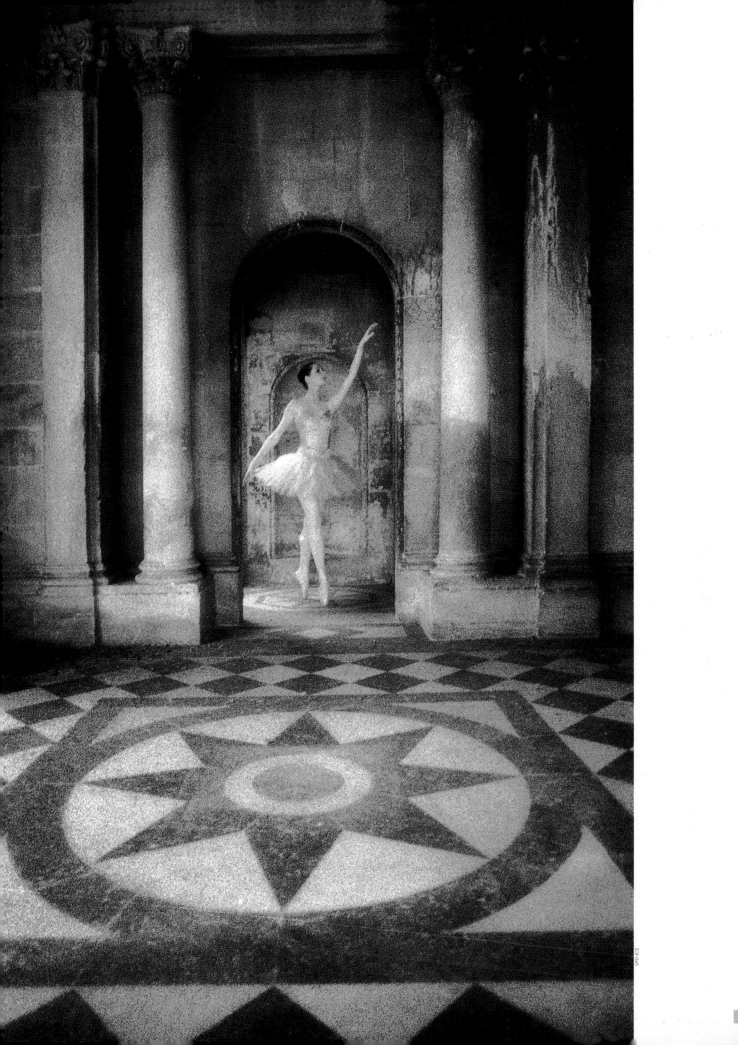

More useful in most cases are red (No. 29 deep red, or No. 25 red) or orange filters. These block out some of the visible light, but it is still possible to see through the viewfinder.

Infrared focuses at a slightly different point than visible light. Most lenses have an infrared mark on the lens barrel, and after visibly focusing, the lens has to be moved to this mark for accurate focusing. In reality, if the subject is not too close and a small aperture is chosen, this usually takes care of the problem.

Infrared film is easily fogged by visible light, so be prepared always to load and unload film in darkness. If a darkroom is not available—such as when working on location—it is worthwhile investing in a good changing bag.

Kodak High-Speed Infrared

This gives the most pronounced infrared effect, particularly when used with a red filter. With a No. 25 red filter in place, set the TTL meter to 400 ISO and meter through the filter. In

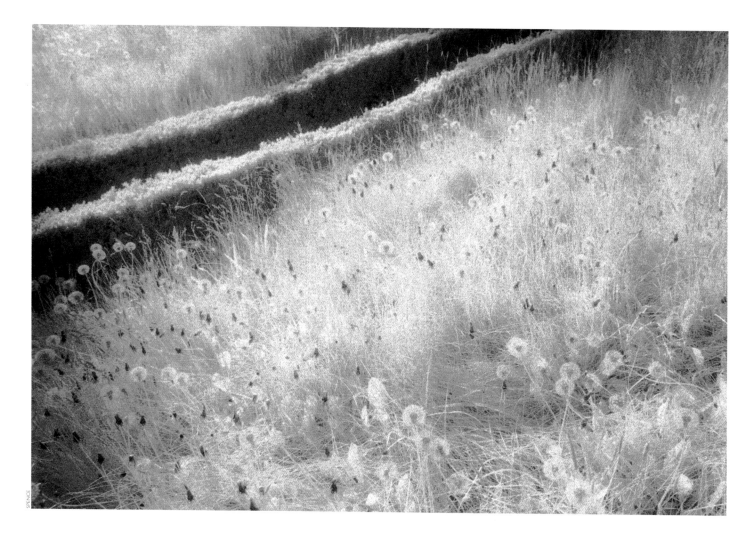

Dandelion lawn

On initial viewing, this overgrown lawn in an otherwise formal garden did not look promising. However, the direction of the sun meant that from a different viewpoint, the sun would backlight the formal hedge and seeding dandelions. Kodak High Speed Infrared film added to the ethereal quality of the scene.

difficult situations it pays to bracket one stop up and down. Under good light it is possible to select a small aperture and allow depth of field to take care of focusing abnormalities. However, if working close up, or with wide apertures, refocus using the red "ir" mark on the lens barrel. Always load and unload this film in total darkness—don't even take it out of the plastic film canister in light or it will fog! Care has to be taken with this film, especially when processing, because it has a thin, flexible film base and twists and curls easily. It is a grainy film, which is part of its charm, and because it has no antihalation backing, it can allow highlights to spread, giving such shots the ethereal feel found in bright sunshine.

Konica 750 Infrared

This is a finer-grain film and is ideal for landscape detail. It is a slower film, so a tripod may be necessary. With a red filter attached, set the camera meter at 50 ISO. It has an antihal-

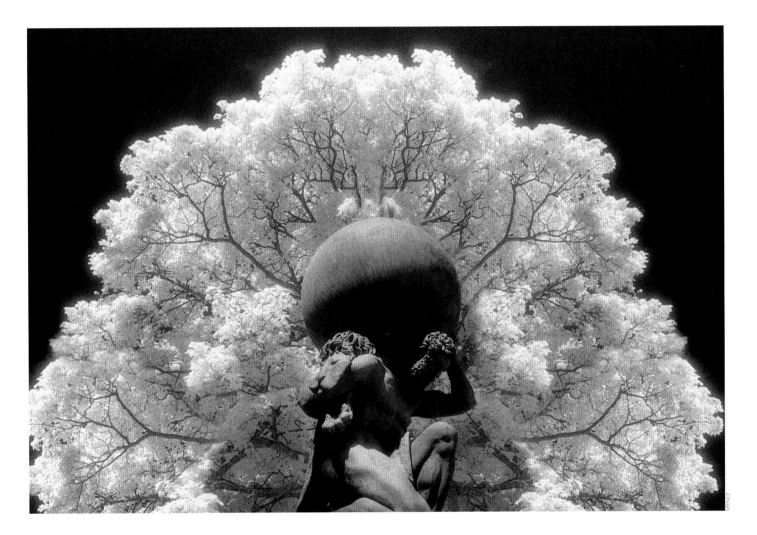

Atlas

Infrared film lightens foliage and darkens blue skies. The effect on foliage is clearest when the leaves are young. Using Kodak High Speed infrared film and a red filter, the tree stands out strongly. The negative was scanned, and some of the left side of the tree was copied and flipped horizontally in Photoshop, to add symmetry to the shot.

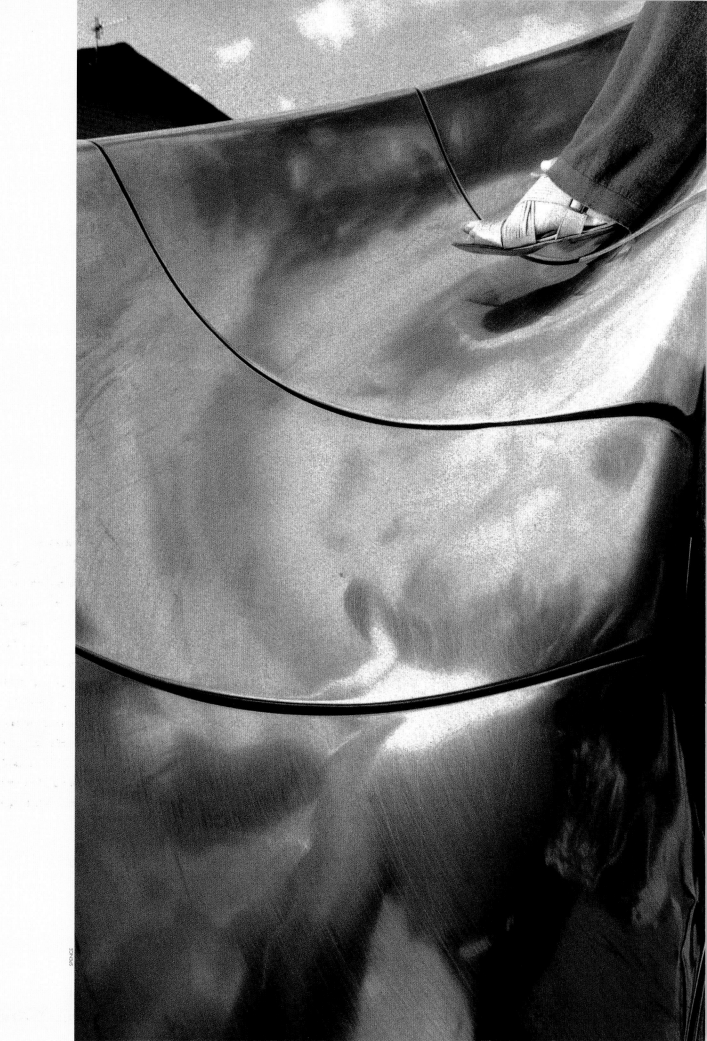

Slide (OPPOSITE)

Even family trips to the playground can be sources of interesting images. Here, the photographer's wife is about to descend a metal slide. The reflective surface and graphic shapes have been emphasized using Ilford SFX film, which has heightened the contrast without producing the grain and halation of Kodak infrared film.

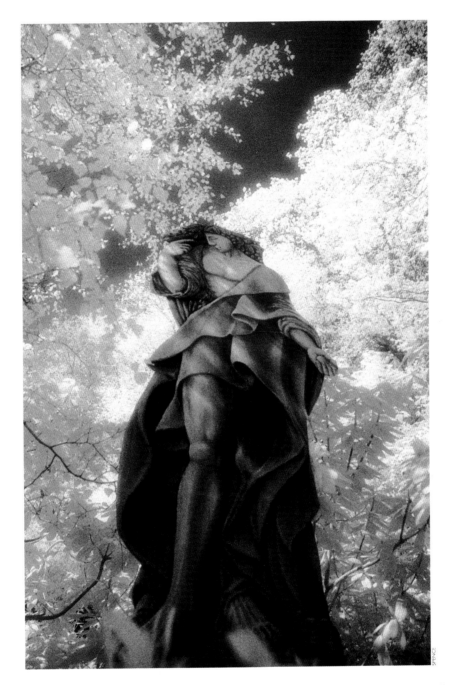

Portmeirion

The Welsh village of Portmeirion is full of illusion—a photographer's paradise. This "statue" is in fact a flat, painted piece of hardboard set in among the trees. A 24mm lens on a Canon A1 has further enhanced the illusion of scale. Kodak infrared film was used to lighten the foliage that contrasts with the figure.

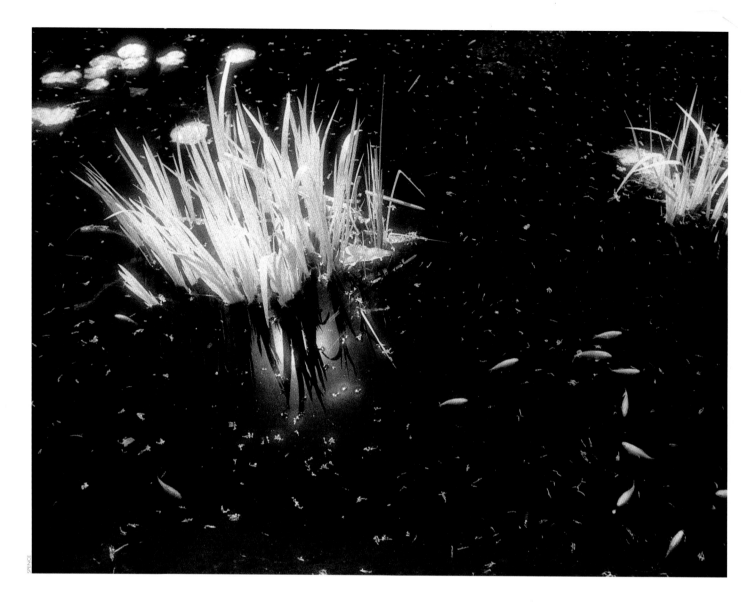

Pond

Water seems to absorb infrared and so usually appears black in a photograph. Here, this contrasted well with the water plants and the goldfish, which had formed a sinuous curve, reminiscent of the Big Dipper in the night sky.

ation layer, so does not give that glow seen with Kodak HIE (High Speed Infrared). It is less sensitive to the infrared end of the spectrum and can be loaded and unloaded in subdued light.

Maco IR 820C

This is a relatively new film with characteristics similar to Konica 750 but with greater infrared sensitivity; so it must also be handled in darkness. It is relatively slow—with a red filter, try about 32 ISO on the TTL meter. Interestingly, the film has a clear, polyester base so is suitable for reversal processing and projection.

Ilford SFX

This is probably the easiest of the infrared films to use. It does not give such a dramatic infrared

effect as the other films, but it can be loaded in subdued light and is rated at 200 ISO with a red filter. Ilford also produces a specific SFX filter, which enhances the infrared effect.

Processing

Infrared film can be developed in most normal film developers, but changes in grain and contrast are achieved by careful selection. What works for you will be a matter of personal

Film	Developer	Dilution	Time (mins @ 70°F)
Kodak HIE	Kodak HC110	1:31	6.5
	Rodinal	1:50	8.0
Konica 750	Rodinal	1:50	6.0
Maco IR 820C	Rodinal	1:40	8.0
Ilford SFX	ID 11	stock	10.0

experimentation. Contrary to popular belief, both stainless steel and plastic tanks can be successfully used for processing.

As a starting point, try the film/developer combinations listed opposite.

Color Infrared—Kodak Ektachrome EIR

This is a strange film that probably has more use in scientific photography than pictorial work. It is a color-reversal film available in 35mm. It produces a color shift that is, to say the least, not very subtle. However, as with any material, it can have its place when used carefully. It is usual to use filters, and depending on which one is chosen, the color will vary. It is usual to use a red or yellow filter, but it is worth experimenting with others.

Tree

A combination of a wide angle lens and Kodak infrared film separated the massive branches of this tree from the rest of the forest. Careful exposure retained detail in the tree, allowing the background to fade into the highlights.

Color infrared film records infrared as red, red as green, and green as blue. Blue can be removed by using red or yellow filters, though the color dyes in the film still record the absence of yellow as blue—leading to the appearance of blue in the final image.

Using a filter and TTL, the film should be rated at about 200 ISO. As with any reversal film, however, exposure can be critical. It is easy to overexpose, so it is best to bracket and avoid conditions that are too contrasty.

Processing used to take place using the E4 process, but this is hard to find—for pictorial purposes, the film can be processed in E6.

Digital infrared effects

The development of digital technology has provided a marvelous tool for manipulating images and creating effects in seconds that took many hours in the darkroom. Both color and monochrome images can be manipulated in the computer to give the effect of infrared. It has to

Monochrome infrared from a color image

Adjusting tonality

■ Start with a color image—either a scan from a slide or negative, or a digital capture.
■ Make a copy layer, which means you can use the original color layer at a later stage for reintroducing color.
■ Create a New Adjustment Layer (Adjustment layers allow you to see the effect of change without altering your original pixels and returning to fine tune at a later time).
■ Select Channel Mixer. Change the settings to Red—100 Green + 190 Blue +10. These are only starting points, so fine-tune as necessary.
■ Check the Monochrome box.

Creating halation

■ Highlight the Background Copy layer, and

Color original

This was taken on a Nikon Coolpix 995 digital camera. An image with simple lines with natural, light areas is a good choice as a starting image.

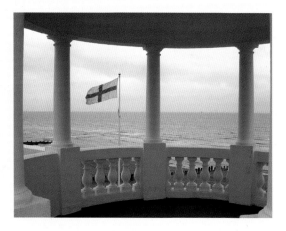

apply Gaussian Blur at about 20–30 pixels.
■ Set Blend Mode to Lighten.
■ A new Curves Adjustment Layer can be created at this stage to refine the highlight and shadow contrast. This is not always necessary, but again it allows fine-tuning of tonality and contrast. By altering the opacity of the layer, the effects can be made even subtler.

Creating grain

■ Create a new layer and label it Grain. Select Edit>Fill and fill with 50% Gray, making sure that the preserve transparency box is not checked. The image will now disappear and be replaced by a gray screen. Don't panic—select Blend option Overlay, and the image will return.
■ Add grain to this layer using Filter> Noise> Add Noise. Check the Monochromatic box and Gaussian distribution. Use the distribution slider until it looks right—possibly 10–20%.

Adding color

■ Toning effects can be introduced by using a new Adjustment Layer for Hue and Saturation, or some of the original color of the scene can be re-introduced by lowering the opacity of the Channel Mixer Adjustment Layer.
■ Finally, a little Unsharp Mask can be used to sharpen up the grain.

be said that it is not the same as using true infrared film, because we are dealing only with the visible light spectrum. However, if we understand how infrared radiation is translated into a visible image on infrared film, we can produce results that are remarkably similar. Effects such as halation, lightening of foliage, darkening skies, and characteristic grain structure can all be created. Depending on the desired effect, there are many approaches you can take.

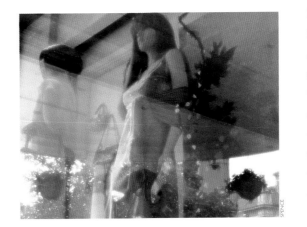

Digital color infrared effects
A normal color photograph taken on a Nikon Coolpix 995 was converted to a pseudo-color infrared image by shifting the Hue slider in the Hue and Saturation controls in Photoshop.

Monochrome image
The original color image has been converted into monochrome with a Channel Mixer adjustment layer.

To create an infrared effect from a monochrome negative, convert to RGB, desaturate, make a copy layer, and work from the fourth bullet point above.

Color infrared

Bearing in mind that Ektachrome infrared film basically translates colors by a color shift (as outlined above), it is a relatively easy task to achieve a similar effect digitally.

Using a normal color image, select Image> Adjust>Hue/Saturation. Using the Hue slider (at about +100), red can be replaced by green, and green by blue. However, because we are trying to create false color, almost any Hue setting will give more or less color shift.

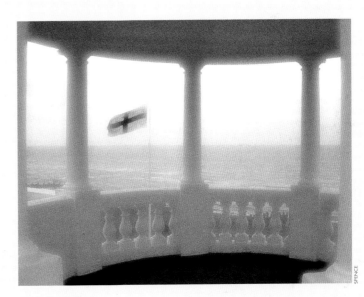

Gaussian Blur
A copy layer has been subjected to Gaussian Blur, and grain has been added.

Printing in Edges

Henri Cartier-Bresson saw it as a point of honor always to print the entire negative, and to prove this, he would include the film rebate in his photographs. But he was part of the photo-journalist tradition that values truth and integrity above all else—practitioners of art photography have an entirely different agenda, and few have qualms about constructing edges if it adds interest to their work.

AS PHOTOGRAPHERS WE are confined to set formats, be they 35mm, 645, 6-by-6, or whatever. In areas other than photojournalism this can prove to be rather restrictive, but by cropping our work and giving due consideration to the edges, we can introduce further options. Highly constructed edges can be specially made for a print, which then becomes a legitimate part of the composition. While there may often be sound aesthetic reasons for constructing edges within the print, avoid using frames as frivolous affectation.

Printing in the film rebate

The most common way to add edges is to print in the film rebate. This is easy to do, providing you have an adjustable negative carrier—slide the blades so that a bit more than the printable part of the negative is visible. If you choose this route—and it is only a matter of choice—keep the black rebate a consistent thickness throughout the print.

Some carriers, especially 35mm negatives, are not adjustable, so you are unable to do this. One solution is to file all four edges of your negative carrier so you will always have a printed rebate with your own, unique hallmark. The downside is that the process is irreversible with that particular negative carrier, so it may prove worthwhile having a spare for more conventionally produced prints.

Some photographers might be put off by having "Ilford" or "Kodak" embedded in their print, but this can be seen as part of the idiom.

Using a cardboard mask

There are occasions when you do not want to print in the entire negative, and in these cases printing the rebate is not an option. Instead, make a cardboard mask and place it over the photographic paper to achieve a definite black border as thin or as thick as you like. Frame your negative in the negative carrier as normal, and

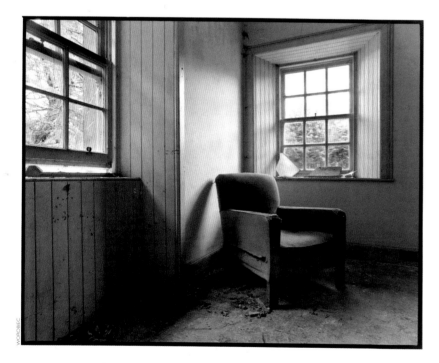

Abandoned interior, Argyll

One of the simplest ways of creating a black border is to print the entire image, including the film rebate. The outcome will be determined by the film stock you use, and the format.

Model holding white material (OPPOSITE)

It is relatively easy to create a Polaroid border by using a discarded Polaroid photograph and the Layers facility in Photoshop. If the two images do not fit, the Polaroid edge can simply be resized.

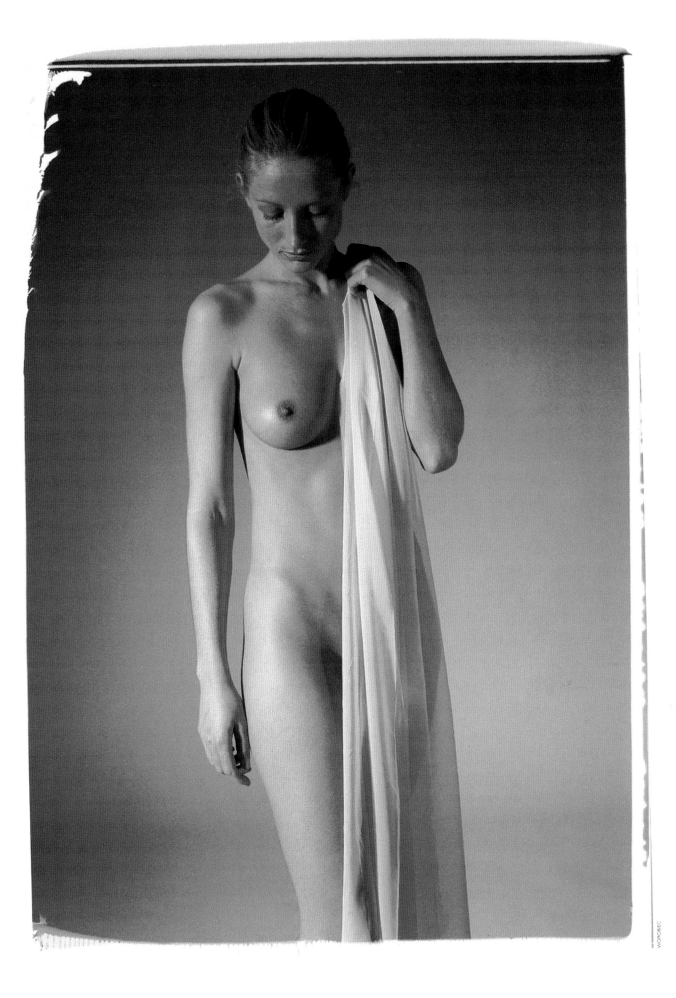

Irregular white border

Christmas tree decoration

The dramatic brushstroke effects, characteristic of liquid emulsion prints, can quite easily be simulated using conventional photographic paper.

1. Roughly paint a rectangle about the same proportions of the film format you are using onto a piece of white copy paper, and photograph it. You can be as liberal as you like with the brushstrokes, providing you do not leave any gaps in the center.

2. Once you have photographed your rectangle, your negative will look like this. When you sandwich this with another negative, the dark areas on the edge will prevent any light from the enlarger affecting the paper, hence the irregular white border.

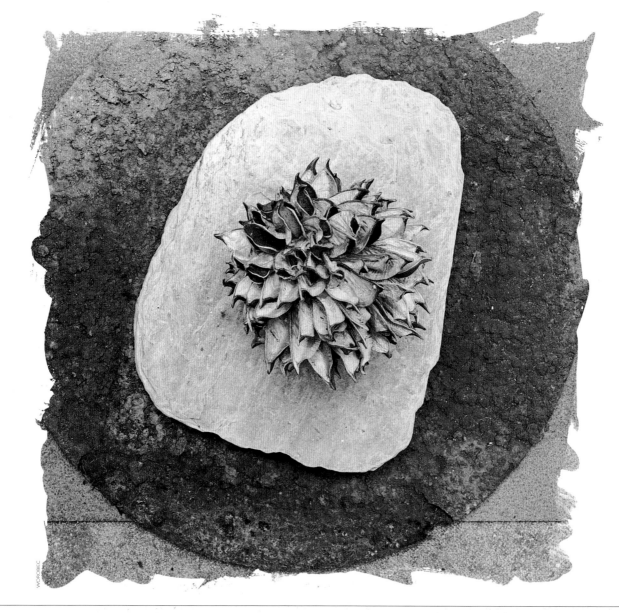

WOROBIEC

crop the image as required using the easel. Cut a mask from a lightproof piece of paper or card that is smaller than the intended image—for example, if your print is going to be 11 x 14in, (275 x 350mm) cut a piece of card that is 10¾ x 13¾in (270 x 340mm) to ensure a uniform border of quarter of an inch. Expose your print as normal, but before removing the paper, take the negative out of the carrier and open up your aperture. Place your mask carefully onto your printing paper, ensuring that the gap from the edge is uniform.

Do not move the paper. If you think the mask is likely to bend, weigh down the corners. Finally, switch your enlarger lamp on again, although this time the entire print except the edges will be shielded from the light. When you finally develop your print, you will have a razor-sharp black border.

An interesting variation is to use a piece of card that has been cut with a beveled edge. In this way it is possible to create a softer line that appears to bleed into the print. Another alternative is to roughly tear or cut your mask, creating a more informal black border.

Torn edges on a white border

An easy way of producing an attractive, ragged, white edge is to make a mask from a thin piece of card or paper that has been cut or torn from the center. Once you have established the size of your intended print in the easel, place a sheet of thin card in the easel in lieu of the photographic paper. Draw in where you wish the edge to be, remove, and then cut roughly with a pair of scissors. Place the printing paper in the easel, together with the mask, and print normally. Instead of thin card, you may wish to try water-color paper. If you dampen around the area where you wish the edge of the frame to be, you can tear the paper in a controlled way.

Painting in the edges of the negative

A more radical way of creating a white border is to paint photo-opaque liquid directly onto the negative. The results can be quite dramatic, but

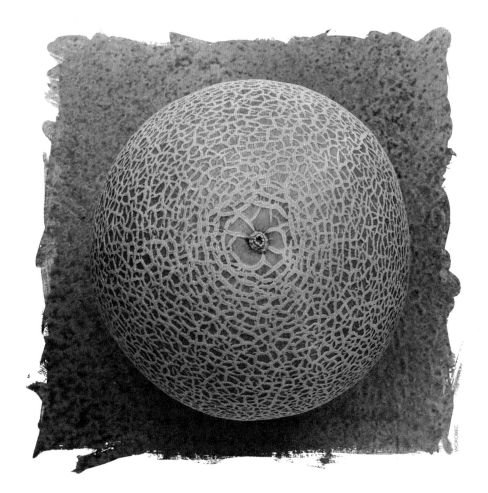

the process is irreversible, so use a negative that has a back-up copy. The size of the brush depends on the negative format you are using and the final effect you are after. It is important that you can see the extent of the border you are creating, therefore working on a lightbox does help. For best results, work quickly but surely.

To achieve the negative of this, try taking a clear piece of film that has not been exposed. (These can often be found at the beginning or end of a reel of film.) In order to establish the parameters of the format, place a normally exposed film and the clear film on a lightbox. Having established your edges, paint in the clear piece of film with photo-opaque liquid, taking care not to go up to the edges. When dry, you can use this as a mask to create an informal black border, after you have exposed the first.

The liquid emulsion effect

One effect many photographers want to create in their photographs is the irregular edges

Melon

The surface of melons is extremely interesting, not dissimilar to a thumb-print. Although a highly minimalist approach was adopted with the photography, the image needed just a little more—which this interesting edging seems to have provided.

created by brushing liquid emulsion onto paper. This cannot be done using conventional papers, but the effects can easily be simulated.

First, establish proportions that match the film format you commonly use. If you use 6-by-6, then paint in a square, using black ink on copy paper (see page 50). Avoid using a paper with a strong texture, which might appear in the final print. Once you have completed your painted black rectangles, photograph them, but aim to increase contrast at the processing stage. Slight underexposure and overdevelopment works wonders to ensure that whites are truly white and blacks are totally without detail.

Once you have your negatives, it is simply a matter of sandwiching the negative with the one you want to print. To get accurate registration when you sandwich the negatives, work on a lightbox, and if necessary use a small piece of cellophane tape to lock the negatives in place. To ensure that everything is truly sharp, sandwich them emulsion to emulsion. Finally, you may well be required to double your exposure in order to get a satisfactory print. Even though you are sandwiching clear acetate over the original negative, the additional density does absorb quite a lot of the projected light.

Allium (OPPOSITE)
Polaroid 55 is a wonderful film for fine-art photography. Not only do you have the advantage of instant results, but a negative is produced that can be printed in a variety of ways later. One characteristic of this film is the edge effect that is produced from the adhesion between the negative and positive sheets.

Still life with thistles
It is possible to work on the border at the photography stage. In this example, the still life was set onto a white sheet of card, so that the edges of the rusting pieces of metal had a bearing on the final design.

Soft-Focus and Blur

As an optical instrument, the human eye is rather limited. The light-sensitive surface, the retina, has only a small area where a high degree of resolution occurs. It also has a totally blind spot, and much of the retina is unable to discern color. As we age, the lens of the eye becomes yellow and loses elasticity, thus coloring the way we see and how much detail we perceive. Nevertheless, with the help of the brain we rarely notice these defects.

Lilies (OPPOSITE) Creative use of aperture control is one of the most important ways for a photographer to convey an individual vision of a subject. With a subject such as this lily, critical focus throughout the image would have caused too much confusion. By using a wide aperture and careful focusing, the attention has been placed on the flowers, and the leaves have formed a secondary interest. The photograph was taken on a Horseman 5-by-4-inch camera at ƒ5.6 on Polaroid Type 55 film, which produces an instant negative and gives the characteristic edge effect seen here.

WHEN WE USE a camera and film the familiar light-perception roles are somewhat reversed. Film is purely the recording medium (though the film type affects the way it is recorded), but the camera and lens can greatly affect the way an image is recorded. One important aspect is focus. Most cameras are designed so that the lens focuses an image in the same plane as the film. There is a very narrow plane of focus, but decreasing the aperture of the lens increases the depth of field or acceptable sharpness.

An image that stays sharp from near to far distance is a very artificial way of observing the world. Our eyes cannot achieve this depth of field. The way we perceive such sharpness throughout a scene is by constantly changing our plane of focus by rapid changes in the shape of the lens of the eye. Creative camera controls and printing techniques can make changes in focus to impose a personal view of the world.

Camera

Plane of focus

Cameras with fixed-lens planes (and this includes most 35mm SLRs and medium-format cameras) have the plane of focus parallel to the film plane. However, some medium-format, and virtually all large-format, cameras allow the lens plane to be tilted. This has the effect of putting the plane of focus at an angle to the film plane.

Usually this technique is used to increase the amount of the image in focus without having to appreciably stop down the lens. For example, a landscape photographer will use a forward tilt of the lens plane to increase sharpness of near and far ground. Studio photographers also make use of this focus control when photographing a range of still-life products on a table.

If we take this technique and use it in less conventional ways, however, it can create images that have a rather unsettling appearance. By using front lens-tilts in conjunction with wide apertures, it is possible to focus midway up an object, scene, or person, leaving the top and bottom of the image out of focus. Of course this point of focus can be placed anywhere in the image, allowing us to draw attention to a specific area. This type of differential focus is alien to our normal way of seeing, where focus tends to decrease with distance from the camera.

Defocusing

As part of good technique, we generally expect that our subject has some point of critical focus and is sharp. Modern, autofocus cameras ensure that if the camera is held steady, then sharpness is assured. This accurate representation of detail has always been both a strength and a weakness of photography. Pictorial photographers in particular have used many techniques to provide more of an impression of a scene, rather than recording all the detail. This leaves viewers to use their own interpretation of what they see.

A simple way to provide such an impression is to defocus the image. With SLR cameras the effect is easy to see. The effect of defocusing is greatest if you forward-focus—that is, if you focus on a point in front of the subject. As with diffusion in camera, light areas seem to spread, especially if the subject is backlit. For the most accurate of renditions—known as WYSIWYG, for "what you see is what you get"—it is best to

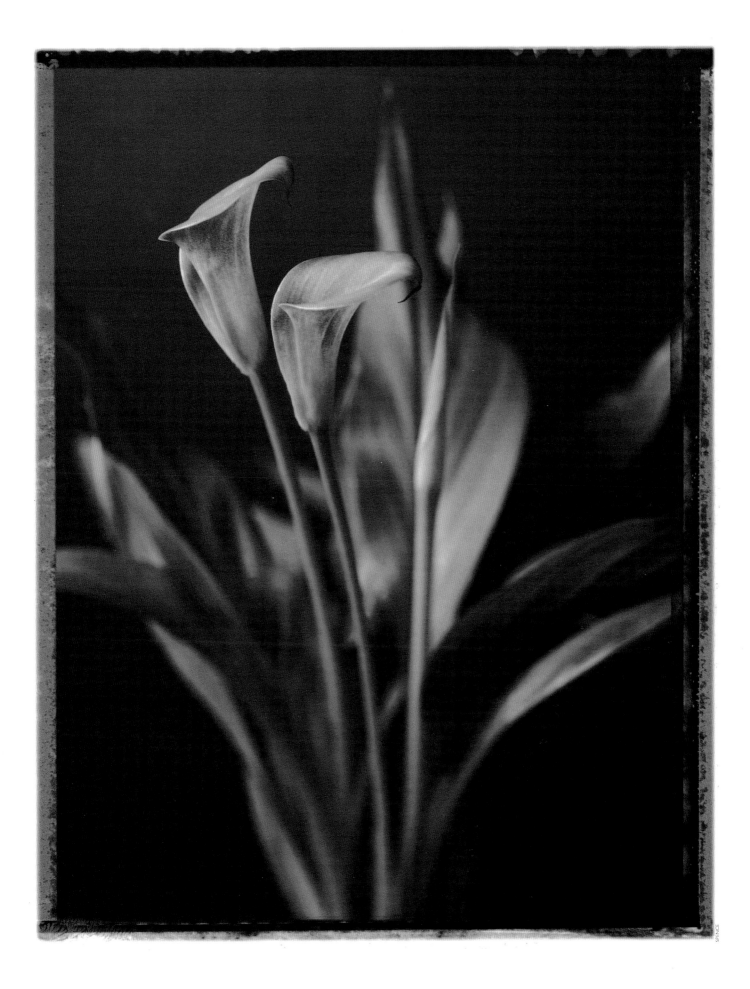

SPENCE

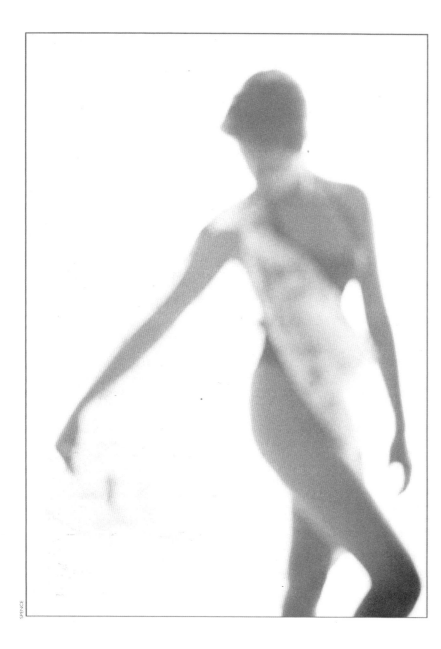

SPENCE

Draped figure

This figure was photographed in the studio against a white background using strong light from behind. By forward-focusing and overexposing slightly, an ethereal feeling has been captured. The effect of the narrowing of the limbs, seen particularly here in the arms and hands, is typical of this technique. Canon A1, 50mm lens, on Kodak Ektachrome film.

use the camera at its widest aperture, as this is the way a subject is normally viewed through the camera. Using smaller apertures necessitates the use of a depth-of-field preview button, which unfortunately is rare on modern cameras. The degree of out-of-focus is variable and very subjective. In most cases the viewer is most comfortable if the subject has a recognizable form, but throwing the subject completely out of focus can produce some interesting, abstract designs, particularly in color. Contemporary photographer Robert Stivers has made use of the defocused image to produce images of great mystery and beauty.

Defocusing can also be an effective way of producing soft focus during printing. Throwing the image slightly out of focus during part of the exposure time for printing will produce a soft-edged image, reminiscent of the effect of a subtle zoom. As the image is defocused it usually increases in size, so care has to be taken to observe the effect, and tests for different degrees of focus are worthwhile. Subtle differences can be made by balancing the degree of sharp and out-of-focus image.

Filters

There is a plethora of filters on the market that affect the focus of the image, mainly by diffusion of light. This has the effect of making light areas of an image spread into the darker areas, usually giving a soft effect and making highlights "glow." Traditionally this technique has been used with portraits to conceal defects of the skin or to romanticize scenes.

Such filters can be bought or, more interestingly, made. A common but effective technique is to stretch some black stocking material over the lens, which creates an overall softening effect. Partial softening, for example around the edges of an image, can be created by using a UV filter and very lightly smearing some Vaseline on the outer edges. Motion effects can be produced in a similar way—by smearing Vaseline on a filter in a well-defined direction.

Soft-focus in Photoshop

Josephine

This was a 4-by-5 black-and-white negative from a series of images of the torso. Unfortunately, the negative inadvertently fell into the footwell of a car, where it stayed for several days getting trampled underfoot. The damage meant that it was all but useless for conventional printing, so as a last resort it was scanned on a flatbed scanner and repaired in Photoshop. After the initial digitization and cleanup, the focus was softened, and some color was added by using Gaussian Blur and Curves.

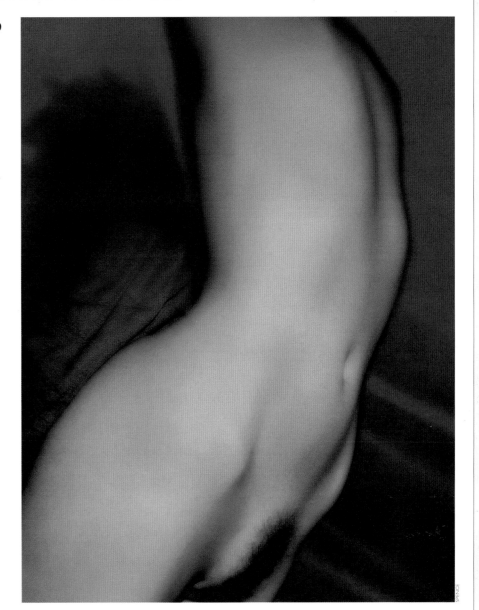

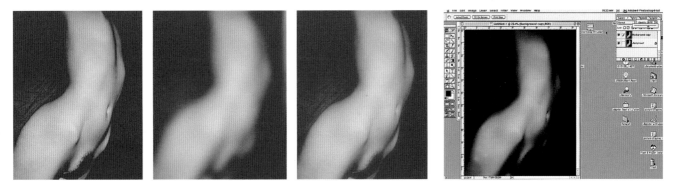

Stages in digital soft focus

The initial negative scan revealed a sharply focused image. A copy layer was created, to which Gaussian Blur was applied. The opacity of this layer was then reduced to allow some of the sharp image back, producing a controlled amount of soft focus. The screen shot on the right shows the Layers being created in Photoshop.

Darkroom

Diffusion under enlarger

Diffusion under the enlarger causes shadow areas to spread into highlights. The diffusing material is still diffracting light, but because we are working from a negative, the light is coming from the less dense areas of the negative—the shadows. At the printing stage, diffusion is highly controllable—exposures are lengthy, and they may be split into a number of parts. You can diffuse an image for the total printing time, or split exposures into two or more and diffuse for part of the time, allowing a degree of sharpness with diffusion of the shadows as an extra layer.

Almost any translucent material can be used to provide diffusion, from plastic wrap to tissue paper. The position of the diffusing material also

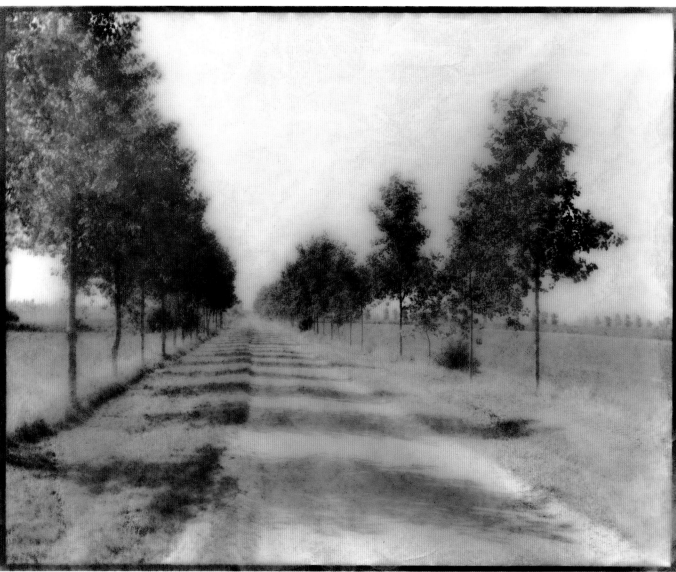

Avenue of trees, Picardy

Here, a sheet of tissue paper was placed directly over the photographic paper during exposure. It is not always desirable for the "filter" to be used for the full duration of the exposure. This print was then strongly toned in thiocarbamide for an old-fashioned feel.

has a significant effect on the end result. Use material anywhere from midway between the lens and the paper to actually making contact.

A good way of accurately controlling the effect is to use a sheet of clear glass supported above the printing paper. The height can be varied, and the diffusing material can be laid on the glass. By using this technique it is easy to create diffusing masks by selectively diffusing different areas of the print—for example the background of a portrait—by cutting the diffusing material to shape.

Contact with glass spacer

Contact printing was originally the only way to produce a print from a negative, and the size of the final print was dependent upon the size of the negative. Even after the invention of techniques for producing enlargements, many photographers continued to use the contact print as being truer to the original and providing the best quality. The range of tones and degree of sharpness in contact prints reflects as truthfully as possible the unmanipulated negative.

Some printing processes, such as platinum, salt, or cyanotype, are only produced by the contact process. However, even contact prints can be manipulated and softened. Burning and dodging techniques can still be used by employing masks, shading with pencil, and other processes. Contact prints by their very nature are as sharp as the original negative, but only if they are in close contact.

Lifting the negative from the printing paper will cause softening of the image. This is easy to do by placing some sort of spacer, such as a piece of glass, between the negative and the printing paper. This produces a softening effect, not only by virtue of the fact that the image is not in contact but also by the diffusion of light from shadow to highlight areas.

Digital

Digital manipulation techniques are extremely powerful, not least in respect to the amount of sharpness or blur in an image. One great

Small farm, Normandy
The top image was shot on infrared film and is the straight, unfiltered, black-and-white print. The blurring in the second image was created by holding a soft-focus filter directly under the lens during the printing stage. The big advantage of doing it in this way is that you can determine precisely how much blur the image requires—in this example, the filter was used for only 60 percent of the total exposure.

advantage of digital is that it allows major changes in focus to occur after the image has been taken. Another is that the positioning of sharp and out-of-focus areas in an image can produce effects that are normally impossible at the taking stage with conventional photographic techniques.

Photoshop has many ways of affecting sharpness, including smudge, blur and sharpness tools, and a range of sharpening and unsharpening filters. The most useful for producing controlled blur is the Gaussian Blur filter. This is highly controllable, and by use of selections, masks, and layers you can achieve very subtle effects. Radial and reflected gradient masks produce effective differential focusing.

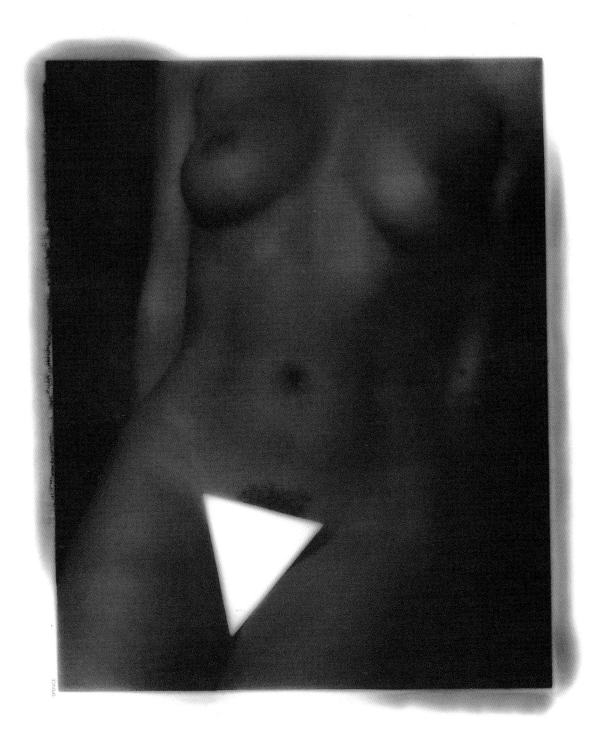

Torn Curtain (OPPOSITE)
A new carpet was wrapped in semitranslucent paper. Taking this into the studio, it was selectively torn and backlit with a single 500W bulb. The model standing behind this screen formed an out-of-focus silhouette except where her breasts touched the paper. By varying the distance between the subject and the paper, more or less focus can be introduced.

Torso after Kertesz

A sharp negative on Ilford FP4 4-by-5-inch film normally contact-printed would produce a perfectly sharp print. To soften it, a piece of glass was placed between the negative and the printing paper and given slight overexposure. The light diffused to cause some fogging. The white triangle is a piece of mirror, which, though it conceals the pubic area, also draws attention to it. It was inspired by the censoring of some of Andre Kertesz' early nude work.

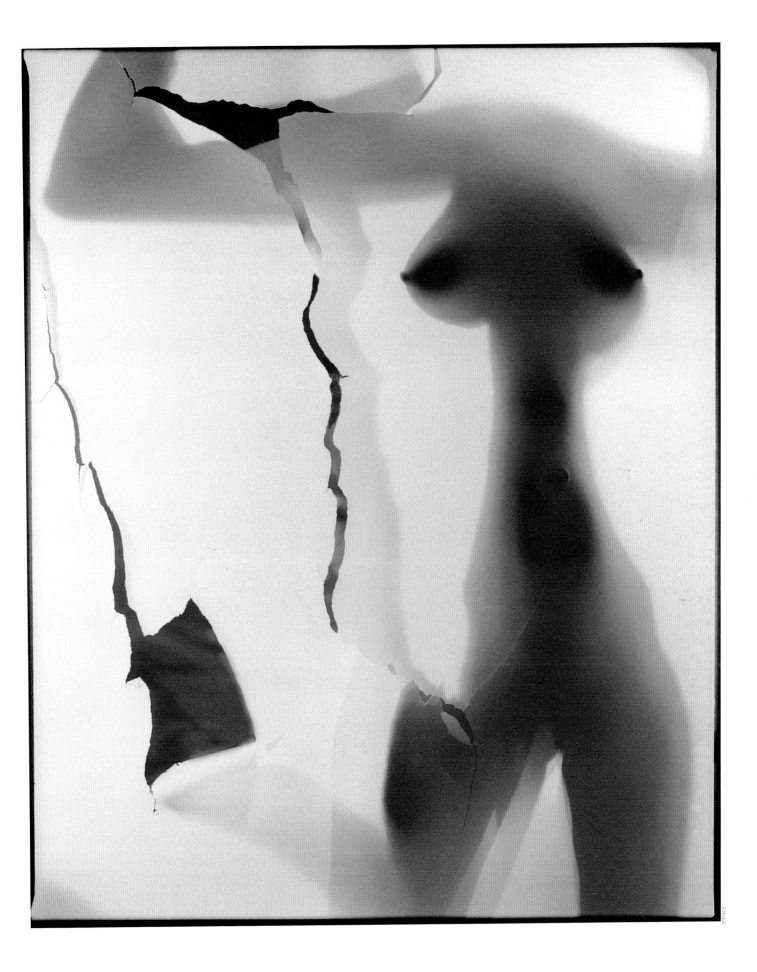

Alternative Methods of Toning

Many books dealing with darkroom techniques cover the classic toning processes of sepia, selenium, gold, copper, and iron-blue toning, but now there are some interesting alternatives that can be achieved either chemically or digitally, ranging from subtle, natural shades to colors more powerful and provocative.

Chemical toning

FSA toners (formamidine sulphinic acid)

If you are seeking an interesting alternative to the standard sepia, copper, and selenium toners, then this process may well be of interest to you—although to refer to FSA as a toner is not strictly true. What this process does is to bleach and then redevelop the print as silver. The secret lies in the bleach—when using FSA, you have the option of using one of three bleaches, a bromide, a chloride, or an iodide bleach. The print is bleached in one of these three and then redeveloped in the FSA universal toner. The various colors are achieved because the

Composition of toners	
FSA developer	
Thiourea dioxide	0.35oz
Sodium carbonate	0.35oz
Water	35fl oz
Bromide bleach (sepia style)	
Potassium ferricyanide	0.35oz
Potassium bromide	0.17oz
Water	35fl oz
Chloride bleach (cold-style toner)	
Copper sulphate	0.8oz
Sulphuric acid 10%	2cu in
Sodium chloride	0.8oz
Water	35fl oz
Iodide bleach (red/orange toner)	
Potassium iodide	0.32oz
Potassium ferricyanide	0.6oz
Water	17fl oz

redeveloped emulsions are of a different particle size, which changes their light reflectivity and therefore the apparent color of the image.

FSA chemicals can be bought directly from suppliers or in kit form. If you wish to make your own solutions, try the formulae set out in the sidebar (bottom left).

Using bromide bleach (sepia style)

While there are undoubted similarities between bromide bleach and a conventional sepia toner, you need to appreciate that the basic chemistry is quite different. You can achieve a very positive biscuit/sepia hue using this method, and also a great deal more. With a standard sepia toner, it is the solution strength that ultimately determines the final color—the weaker the solution, the lighter the hue; the stronger the solution, the darker the hue. You make that decision as you mix up your solutions.

With FSA, the color changes the longer you leave it in the toner, and you are therefore able to achieve anything from a delicate sepia color to a rich pink/brown (not unlike a lith print) from the same solution. The other beautiful advantage is that while your blacks retain their depth, highlights can assume a wonderful grey/blue hue.

The process

It is important to appreciate that the FSA toner deteriorates quickly once mixed, so you can only produce a limited number of prints in any session. Moreover, because it is important to give the toner and bleach an hour to mature immediately after they are mixed, you are reduced to a "window of opportunity" of just several hours. It may seem like a nuisance, but it must be emphasized that this process is well worth trying.

In order to avoid patchiness, it is very important that you presoak your print prior to

WOROBIEC

bleaching. Make sure you agitate your print during the bleaching stage, and remember that it is not always necessary to bleach to completion. At this stage, your print will have turned a weak yellow/brown. Wash your print thoroughly (for at least ten minutes if you are using FB paper), and then place it in the toner. It is important not to pollute any of the toner with bleach. The toning process is moderately slow, giving you ample time to remove your print the moment it reaches the hue you require. Initially, the toner appears to cool the tones, but the longer your print remains in the toner, the warmer the hues become.

Chloride bleach: Illuminated chair

While chloride bleach is referred to as a "cold-style" toner, it is amazing how warm many images can appear, especially if you leave your print in it for an extended period of time.

Bromide bleach: Homestead in field

One of the problems with traditional sepia toning is that the stronger you bleach and tone, the more likely you are to affect shadows. With FSA, however strongly you tone, the blacks remain richly intact.

Using chloride bleach

Otherwise known as cold-style toner, chloride bleach is capable of achieving some wonderfully beautiful hues, ranging from a cool, mushroom color to a very powerful brick-red. It is a process that can easily degrade your blacks and, generally, working from fairly contrasted prints tends to produce the best results. It is important to appreciate that these toners do have a very short working span; you should only expect to put through six to ten 12-by-16 prints.

Place your prints in the bleach. It can work surprisingly quickly, especially in the early stages of a printing session, so always have a water-bath close to hand. Wash your print thoroughly, and then place it in the toner. The final colour will be determined by these factors:

■ How far you have bleached your print.
■ How long you tone it.
■ The density of the print.
■ The printing paper you are using.

Other controls you have over this toner include:

■ Varying the temperature of the toner.
■ Altering the dilution of the toner—the weaker the toner, the lighter, yet redder, the print becomes.
■ Adding a small amount of paper developer to toner to result in darker colors.

Using iodide bleach (red/orange)

One of the interesting features of this technique is the beautiful colors that can be achieved simply by bleaching. For the best result you need to start with a print showing the full range of tones. The bleach appears to attack the darkest tones first, changing them to a deep chocolate brown, while the remainder of the image remains gray.

As with chloride bleach, the effects are determined by the temperature of the toner, the length of the bleach time, and whether you add a small amount of paper developer to your toner.

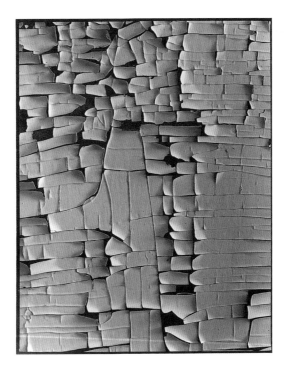

FSA: Peeling paint
Version 1 (left): An untoned black-and-white image, printed slightly darker to accommodate the toning process. Version 2 (above): Compared to a traditional sepia toner, FSA allows you the option of achieving anything between a cool mushroom color to a rich pink/brown.

Porcelain blue

Iron-blue toners are often seen as the obvious means of toning black-and-white prints blue; however, there are other alternatives. One is to use a gold toner, which is an archival process (although it is rather expensive). Speedibrews makes porcelain-blue toner, which is an interesting alternative. This toner has some advantages over the standard iron-blue toners.

■ Because the bleach is separate from the toner, you have more control over the final outcome. You can bleach fully, or partially, and the bleaching process does have a significant effect on the final outcome.

■ Porcelain blue toners are lighter than more conventional iron-blue toners, which allows you to blue-tone high-key prints.

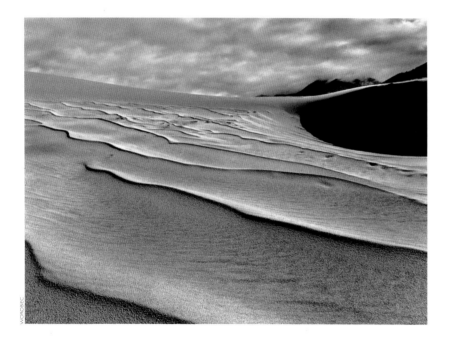

Porcelain blue: Waves

Porcelain-blue toners work equally well on both RC and FB papers. This was printed onto Ilford MG FB without incurring stains in the highlights.

■ The color that is achieved is warmer, more closely resembling a cerulean blue, rather than the Prussian blue one normally associates with blue-toning.

■ The process is slower, so you can exercise far more control.

■ Porcelain-blue toner is much less likely to stain your highlights, letting you tone images where very dark and light areas are in close proximity.

■ Prints toned in porcelain blue are far more robust than those toned in conventional blue toners. They stain less easily, and while you could never describe this as an archival process, they are less vulnerable to "aging."

■ If you bleach only partially, but you positively tone those areas that have been bleached, it is possible to achieve a beautiful chocolate brown in the shadows.

■ This toner works equally well on either RC or FB papers.

The process

After presoaking your print, place it in the bleach. The bleaching process can be quick, especially when fresh; therefore, you should normally add double the recommended amount of water—this is particularly important if you wish to split-tone. Once you have bleached your print, which looks quite brown at this stage, remove it and wash it for at least ten minutes.

The toning process is much slower, thus allowing you far greater scope. Initially your print changes to an olive green, but the longer you tone, the bluer the print becomes. This is one of the strengths of this toner: it allows you to determine the precise hue you require. Some printers have experienced difficulties retaining highlight detail when using this toner, but as with all toning processes, you need to print to accommodate the characteristics of the toner. In this instance, it is important to positively print in your highlights.

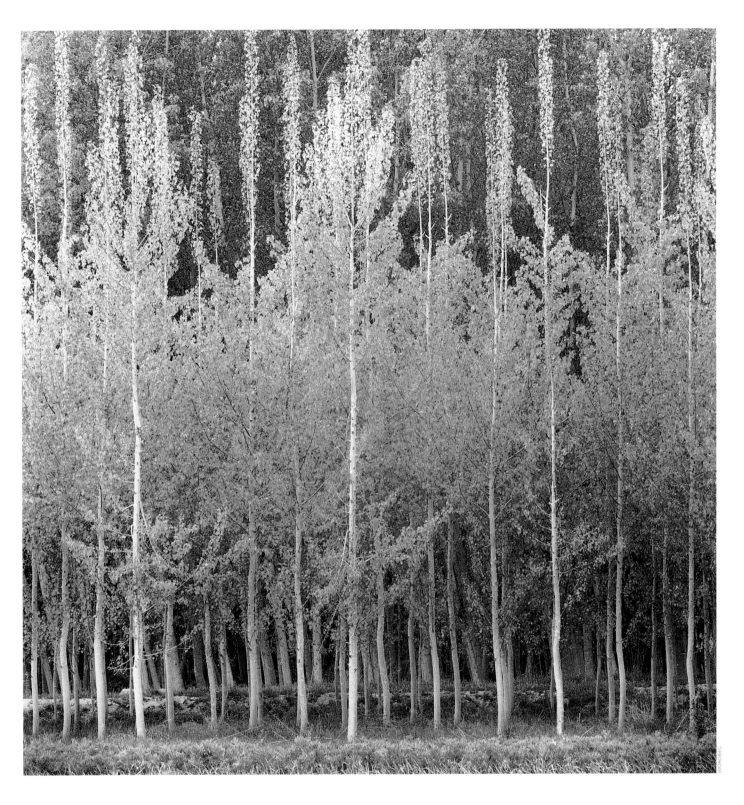

Porcelain blue: Forest edge, Andalusia

Part of the skill of toning is matching the right image with
the process. In order to increase the delicacy of this
image, a porcelain-blue toner was used, which served to
gently lighten the midtones.

Toning digitally

Toning black-and-white prints has become increasingly popular over recent years, but you might be daunted by the process of exposing your beautifully crafted prints to a process that might ultimately stain them. Some workers are concerned that many of the chemicals commonly used in toning are a hazard to the environment or possibly even a hazard to themselves, so as much as they may wish to, they decide not to chemically tone.

One answer is to tone digitally. While working digitally is both convenient and safe, it should be noted that one of the major reasons for toning is to improve the archival permanence of your prints. This is not a noted strength of digitally produced prints, but recent innovations in papers and pigmented inks now give us the ability to produce digital images that could last up to 200 years! While there are still substantial technical differences between chemically and digitally produced prints, longevity need not be the concern it once was. This leads to the main reason for toning prints—namely, improving their aesthetic appeal.

It is ironic, but if you are working from a black-and-white negative, it is very difficult to avoid "toning" your print when working digitally. You can opt to make your final print in black only, but the result will appear rather harsh and gritty. Your other alternative is to use one of the specialty range of black-and-white inks (such as Lyson or Perma Jet), which are produced in gamuts of 4 or 6 pigments and are

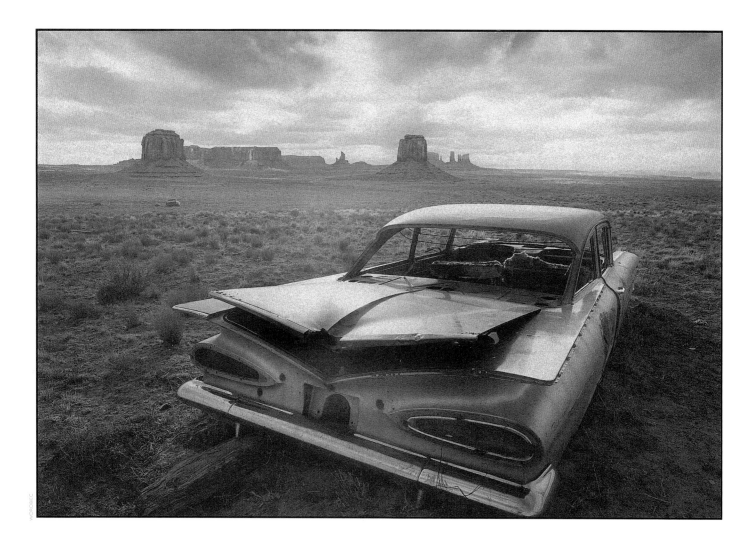

capable of reproducing extremely subtle ranges of tones. They achieve this with a range of gray pigments between the black and white.

If you anticipate doing a lot of black-and-white inkjet prints, then it might be a good idea to buy a dedicated printer to be used exclusively for monochrome work. Switching from color to monochrome can create problems because residue from the color cartridge will pollute many of your prints.

When toning digitally, you should be able to achieve virtually any color combination you want, even when working from a black-and-white negative; experienced darkroom workers are very fond of the beautiful hues that can be achieved with traditional toners. These can easily be reproduced digitally. Moreover, it is a simple task to tone an image from a color negative (if you want) by converting it from color to black and white simply by going to Image>Adjust>Desaturate.

Toning sepia

This toning can be achieved in two ways, first by using Curves.

Convert your image to RGB, and then call up Curves. Initially call up the blue channel, and slightly push the blue into the yellow. Then call up the green channel and very slightly push it toward magenta.

Next call up the red channel to increase the red slightly, though the more you adjust this, the browner your "sepia" will become. Finally, in order to retain positive blacks and whites, return to the RGB channel and peg the lightest and darkest part of the curve.

Digital sepia:

Abandoned car near

Monument Valley

(OPPOSITE)

There are various ways of "sepia toning" digitally, but a reliable method is to convert to RGB and then use Curves. There is a tendency for many digitally "toned" images to appear a little too green once they're printed, but this can be overcome by slightly pushing the green channel toward magenta.

Digital sepia: Sunflower field, North Dakota

An easy way of achieving a sepia effect is to use Duotone. The results can be close to what can be done using chemical toners.

Digital blue:

Forest edge, Andalusia

One of the genuinely exciting things about toning digitally is that you can achieve virtually any hue you care to imagine, particularly if you use Color Balance. In this instance, the slider was pushed toward blue, and then a small amount of magenta was added.

The second way to achieve sepia toning is by using the Duotone capability:

■ Convert your print to Greyscale.
■ Select Image>Mode>Duotone.
■ Select from the Type box whether you want Duotone or Tritone. Sepia is easily achieved by just using Duotone. Establish your black in Ink 1, and choose orange, Pantone 716CVC as Ink 2. If you are not happy with this, it can be changed using Curves.

Blue toning

Without resorting to specialized monochrome inks, it is difficult to avoid some element of color when printing monochrome images digitally. The secret is to control the color to your advantage. There are two principal ways of achieving color digitally:

■ Using the Color Balance
As soon as you access this, you will quickly appreciate the phenomenal diversity a program such as Photoshop offers. You should be able to

achieve virtually any color. Convert your image from Greyscale to RGB, then go to Image>Adjust>Color Balance. Start by clicking on Midtones and Preserve Luminosity, but as you gain experience with toning digitally, you will see that some other options are also worth exploring. To achieve a blue, push the cyan slider toward cyan (try -24, which will give you a greenish blue), and the blue slider slightly toward blue (try +24). You may also need to make a very slight adjustment toward magenta (-5).

Digital blue: Frozen lake on Rannoch Moor

One of the concerns some printers have about toning digitally is that they are unable to gain the archival permanence that can be achieved chemically. The exception is with blue toners—many printers avoid chemically toning their prints, largely because of the blue's unstable nature. It is, however, possible to blue-tone images digitally using archival pigments, which are much more stable than most chemical iron-toners. The blue in this image was achieved using Hue/Saturation.

Digital selenium: Pebble

One of the beautiful features of toning with selenium is
that if you use it fairly dilute, it is possible to achieve a
very attractive split, where the darker tones assume a
rich brown color, while the mid and lighter tones
appear unaffected. This can easily be achieved digitally by
using Duotone.

Using Hue/Saturation

When toning, this facility offers considerable control. Once again you will need to start with RGB. Then go to Image>Adjust> Saturation /Hue. The dialog box has three sliders: Hue, Saturation, and Lightness. The Hue slider is really a complete range of the color spectrum— slide along this to choose the color you want. The Saturation slider determines the strength of the color, while the final slider determines the lightness and darkness of your image. Before you start, make sure that the Colorize and Preview boxes are clicked.

Selenium toning

Selenium produces a very specific and subtle hue that is not easily achieved through the Color Balance control or by using Hue/ Saturation. It is most successfully done through Duotone, which closely parallels most of the traditional chemical toners, such as gold, selenium, and sepia.

First, you will need to ensure that your image has been converted to Greyscale. Then go to Image>Mode>Duotone. Go to Type in the dialog box and select Tritone—very little is achieved when using Quadtone. Ink 1 will always dominate the final hue created, so it is generally best to start with black. In order to achieve a selenium hue, try Pantone 718CVC Orange as Ink 2, and Pantone 634CVC Cyan as Ink 3. If you find that your image is just a little too flat, use Curves and peg the lightest and darkest tones.

Copper toning

Copper toning is a beautiful yet sadly neglected toning process that can greatly enhance a black-and-white print. Its biggest drawback is that it can easily reduce the strength of the shadow, though this does not have to be a problem if working digitally. The easiest way to achieve this is to use Hue/Saturation.

■ Go to Image>Adjust>Hue/Saturation, and move the Hue slider until you have achieved the

Digital selenium: Upstairs banister

Selenium is the most archival of all the toning processes, and while the archival qualities of digital pigments and papers have improved dramatically over recent years, it would be foolish to pretend that working digitally is as good as toning your print traditionally in selenium. But it is possible to achieve the same colors.

Digital copper: Blitz

(OPPOSITE)

While this may look posed, the model in this picture really is a kickboxer and is very good. Achieving a copper tone is easy through the Saturation/Hue facility, but it is important to moderate the effect.

Old Chevy and barn

Compared to working in the darkroom, determining the degree of redness is much easier when working digitally.

required color. In order to reduce its intensity, you can use the Saturation slider.

Sepia then blue

This is possibly one of the most popular—yet at the same time difficult—dual-toning processes to do in the darkroom, but it's one of the easiest to achieve digitally. To gain the best effect, make sure you start with a dramatic and contrasted image.

The first step is to convert the monochrome image into RGB. In order to achieve the blue exclusively in the shadow areas, go to Image>Adjust>Color Balance. If you select Shadows in the Tone Balance, only the shadow areas will be affected. Move your top slider toward cyan (-30) and your bottom slider toward blue (+30) until the right balance is achieved. If the balance is too strong, adjust your sliders accordingly. Select OK.

Digital sepia then blue: Parked truck

Version 1 (above): Untoned print produced in the darkroom.

Version 2 (opposite): A dual-toned, sepia-and-blue print, produced digitally. This process works best with a high-contrast image.

Return to Color Balance, but this time select Highlights in the Tone Balance Box. Move the top slider slightly toward red (-30), then move the bottom slider toward yellow (+30). If on printing you find that your image has a slight green cast, move your middle slider toward magenta. If instead you want to get a copper/blue split, it is a simple process to reduce the amount of yellow you dial in for your highlights.

Sepia then gold toning

This has become a particularly popular toning process, much loved by many darkroom workers. However, gold toners are notoriously expensive. One way around this is to tone digitally. Start with an image that displays positive contrast yet has good highlight detail:

- Start your image in RGB mode.
- You may need to increase the density of your

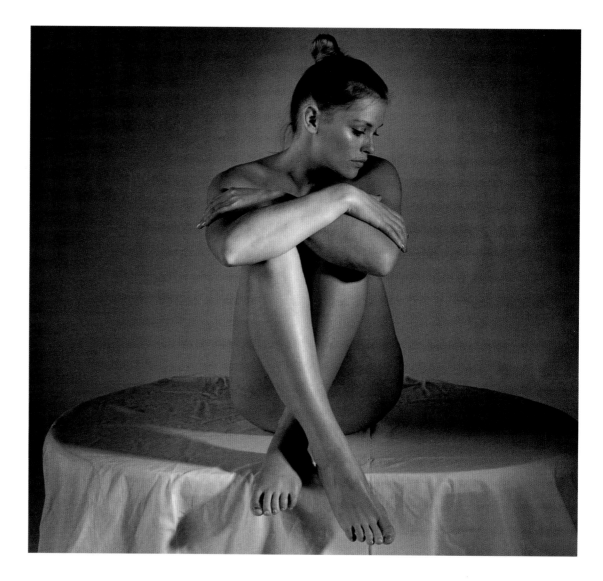

image, as this technique greatly lightens it. To do this you will need to double the exposure.

■ Select Layer>Duplicate, then select Multiply in the Layers palette.

■ At this point, your image will appear darker and a little flatter.

■ Call up Curves and select the blue channel. Push your curve toward yellow, aiming to achieve an input of 41 and an output of 57.

■ Select the red channel, and aim to achieve an input of 52 and an output of 47.

■ Select the green channel, and aim to achieve an input of 48 and an output of 54. At this stage, you should have achieved a rich but rather flat sepia tone. If you have not, then you may be required to make further minor adjustments. Once this is achieved, you will be required to reintroduce the contrast.

■ Call up the RGB curve, and dramatically peg down your highlights, thus encouraging a steep curve toward the shadows. Finally peg the blacks just a little to increase the D max.

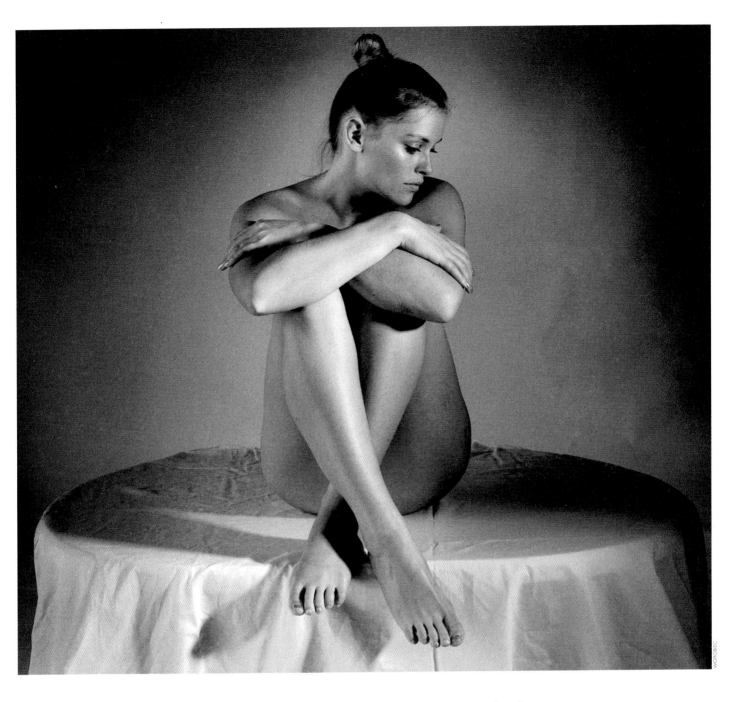

WOROBIEC

Lith effect

This is a darkroom technique that has grown in popularity over recent years. However, because it is a process that is subject to so many variables, it is very difficult to achieve two identical prints. The answer is to do it digitally.

Firstly colorize your scanned negative; this is easily done using Hue/ Saturation. The color you can achieve will depend on the paper you commonly use—ranging from a caramel yellow to a purple-pink hue.

The next task is to mimic the characteristic

Digital sepia then gold: Model on pedestal

Version 1 (opposite): A straight black-and-white image produced in the darkroom.

Version 2 (above): Toned digitally to achieve a sepia/gold colour. In order to achieve this, it is necessary to duplicate the image, to increase density.

tones of a lith print, which shows delicate highlights and flat midtones but also displays deep shadows:

■ Greatly reduce the contrast of the print. This is most easily achieved by using the Contrast slider.

■ It is important to add punch in the shadows in order to give the image that characteristic, "infectious development" appearance. Go to Image>Adjust> Curves. Peg the blacks into the first quarter, then click on the midtones, and then gently pull them up towards the highlights.

Finally, decide which part of your print you wish to appear affected by "infectious development." While viewing the screen, move the shadow point along the baseline, until those areas take on the sooty look that identifies a lith-effect print.

Death Valley

The main characteristics of a lith print are delicate highlights, strong shadow detail, and a very warm color, ranging from caramel brown to brick red. This can be easily mimicked digitally, without having to endure the frustration of pepper-fogging and the other problems that come with lith-printing in the darkroom.

Digital lith: Shake the can (OPPOSITE)

Achieving a lith print in the darkroom can be demanding and time-consuming—moreover, it is virtually impossible to achieve two identical prints. One way around this is to create a lith effect digitally. Some traditional workers might be concerned that they are unable to produce archival prints in this way, but with the advent of pigments and more stable papers, this does not have to be the concern it once was.

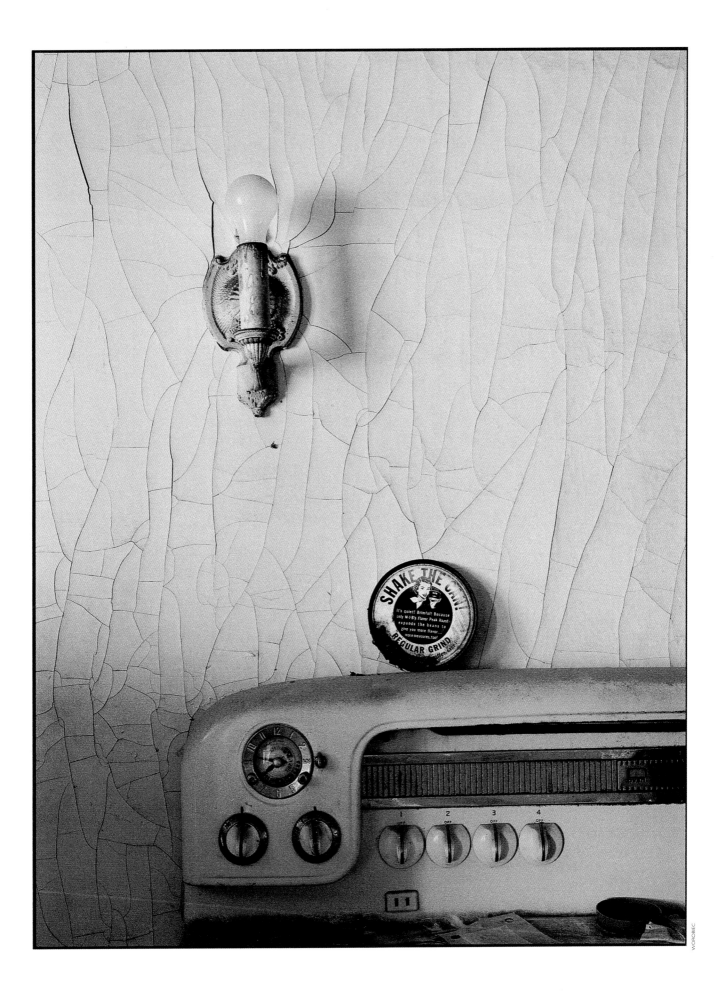

SHAKE THE CAN!

It's quiet! Brimful! Because
only M-J-B's Flavor Peak Roast
expands the beans to
give you more flavor,
more measures, too!

REGULAR GRIND

Selective Toning

Selective toning means toning only a part of your print, leaving other parts untoned. This sounds straightforward, but, as with all techniques, there are interesting variations. Some photographers are turned off by the poor examples you often see, and there is no denying that unless selective toning is done with great care, the results can look extremely artificial.

IN GENERAL, THINGS work out much better when you multiple-tone. This may involve toning the entire print with one toner and then partially toning only selected areas, thus allowing something of the first color to show through the second.

Conversely, selective toning may well involve toning one area and then using another toner to color the other areas. With the many toning processes currently available, the permutations are endless.

Two alternative processes

■ Applying the toner by brush can be done very effectively when selectively toning natural forms or where a more informal approach is required. In general, this process works well when confined to smaller areas and is harder to achieve with larger areas, but of course that depends on the effect you are after. Some workers apply neat toner directly onto their prints, using sponges.

■ Masking techniques. There are two ways of masking your work, with liquid Frisk or masking film.

Still life with forks
Version 1 (left): A straight black-and-white print.
Version 2 (opposite): The holistic quality that is the hallmark of a good monochrome print can be easily lost when selectively toned, unless it is done with care. Initially the entire print was toned in selenium, to preserve the depth of the shadow detail, but then the forks and stone were masked, and the print was placed into a sepia toner. The mask covering the stone was removed, and the entire print was then copper-toned.

Liquid Frisk, also known as masking fluid, can be bought from most art stores. It is applied directly onto your print with a paintbrush.

While it is important to ensure that your print is completely dry, it is a good idea to dampen your brush before applying the liquid frisket because it does have an irritating habit of congealing. Keep a jar of water on hand to keep your brush damp. Also, use a nylon rather than an expensive sable brush—the fluid can easily damage your brush, and nylon brushes are much easier to wash afterwards. Finally, restrict the use of liquid frisket to small, irregular areas.

Masking film (commercially known as Frisk) is a low-tack, transparent, soft-peel product that is easy to apply. It is most often manufactured and sold in rolls, and all you need to do is to cut off what you need. Masking film works best on larger areas.

Applying masking film

It is important to work on a flat surface that is free of debris. Cut off what you need, peel off the backing, and apply the film to your print, working carefully from one end to the other. Once it is in place, hold your print at eye level to ensure that there are no air bubbles in possibly risky areas. If you find any, it is easy to remove the film and reposition it.

Once the film is on, cut the mask using a sharp craft knife or scalpel; with a little practice, this is easy to do. The secret is to use a sharp blade but not to apply excess pressure. If you let the blade do the cutting, there is little risk of nicking the print.

If you are doubtful about your skills, use pearl or matte papers where any nicks are less likely to be seen. Once you have cut your mask, peel away the film—once again, it is worth carefully checking the edges to ensure that there are no air bubbles.

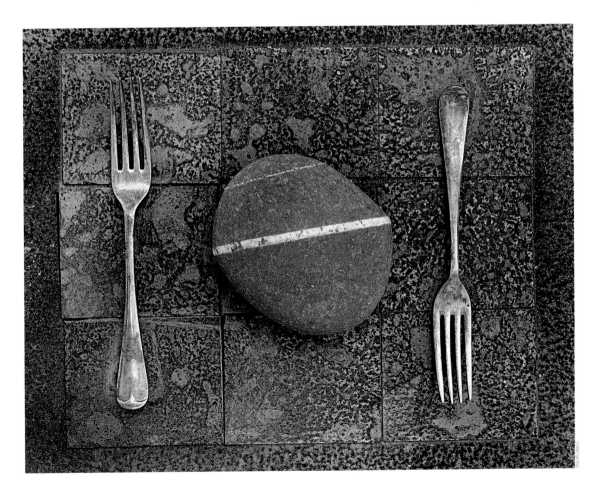

The order in which you tone is important, particularly if you want to use dual-toning. Try out the toning procedure on a test-strip or discarded print just to see if the results are to your liking. As you gain experience with this technique, you will see which toners work well together, how they respond to selective toning, and the various techniques used to apply the toners.

What happens if the toner bleeds?

Obviously, the more toners you use, the more likely it it that one of the toners will seep under the mask and potentially ruin your print. If this happens while using the first toner, it is easily remedied by painting neat paper developer into the affected area. However, once your print is completely toned, it is difficult to retrieve the situation by painting one toner into another. You really have to get into the habit of holding your print at eye level to ensure that there is no opportunity for unwelcome bleeding.

Selective toning digitally

One of the frustrations of selective toning chemically, particularly if you use three toners or more, is that a mistake can occur right at the end of a tricky process, leaving you little alternative but to start again. One way around this is to selectively tone digitally.

The secret here is good selection. There are numerous methods, and the one you choose is often determined by the negative you are working from. The important point is that you do need to be accurate, and an error of just a few pixels can often be very revealing. Once you have an accurate selection, make a quick mask, and that should allow you to make changes.

Assuming that you are working from a black-and-white negative (although this would work equally as well using color), you need to make the decision whether to work RGB or Greyscale. If you work RGB, then you should be able to use Color Balance or Saturation/Hue. If you wish to remain in Greyscale, then the Duotone facility is your best option.

Interior with orange chair (OPPOSITE)
It would be easy to imagine that the chair had been selectively colored—however, it is the only part of this print that retains its original hue. This image was lith-printed onto old Kentmere Kentona paper, which produces a vibrant orange/red colour. Only the chair was masked, while the remainder of the print was strongly toned in selenium mixed in a 1:5 ratio.

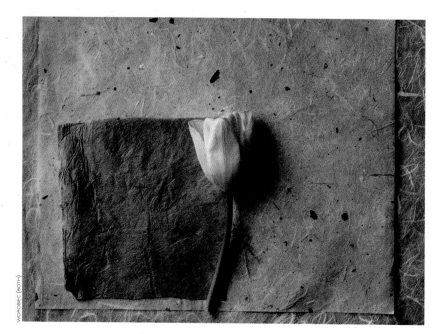

WOROBIEC (BOTH)

Tulip
This image has been selectively toned digitally. The big advantage to working digitally is that you can see your mistakes as you progress and can remedy them before you start printing.

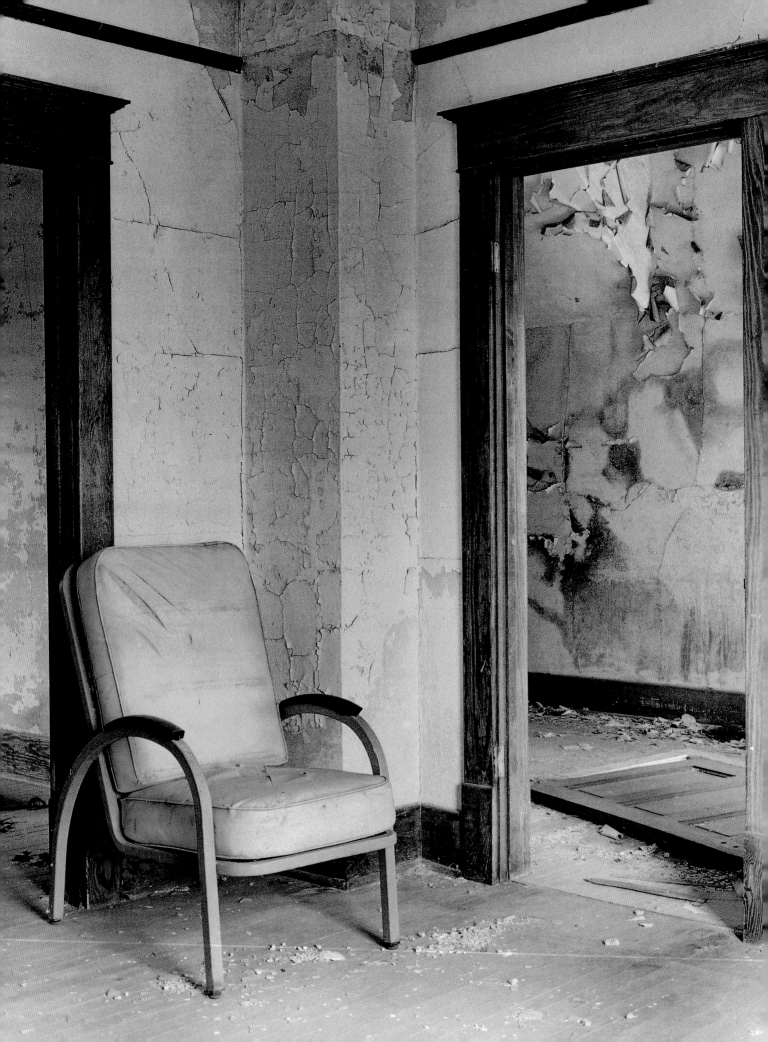

Extending the Boundaries of Photography

Painting with Light

The word photography means "drawing with light," and virtually all photography can be seen as painting with light. One of the first recorded photographs by Nicéphore Niépce, of the buildings outside his window at Gras, France, in 1826, was reputedly an eight-hour exposure, during which time the position of the light source, the sun, had moved considerably. However, in most cases our source of light tends to be fixed.

HOW FRUSTRATING (and at the same time rewarding) is it to be waiting in the landscape for that precise moment when subject matter, composition, and lighting magically come together? In the studio we may spend hours moving flash or tungsten lights into position, using reflectors or masks, poring over

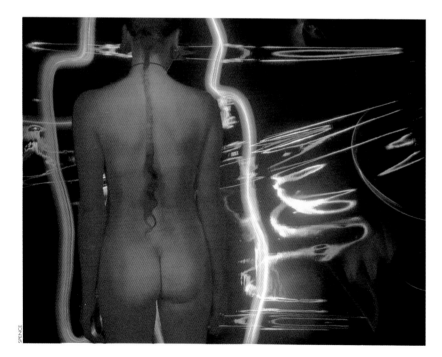

Polaroids, and so on, until we achieve our goal. Maybe because the technology of film has advanced so much—its sensitivity, latitude, and grain structure—we rarely envisage a more considered approach, where an exposure is built up over time, perhaps lit by a light source that can be moved during exposure.

By using light as a movable means of revealing information, we can free ourselves of imposed limitations and manipulate natural lighting. Light can be added to reveal form, detail, and structure. Subject or camera/lens movement can be incorporated as a creative element. Light can envelop a subject, or it can appear from many different directions. Light or the light source can become the subject itself.

Probably one of the most famous examples of painting with light comes from Frank Hurley, photographer on the legendary Sir Ernest Shackleton expedition to cross the Antarctic in 1915. When the *Endurance* became trapped in pack ice in the Weddell Sea in the permanent darkness of the Antarctic winter, Frank Hurley produced his historic photograph of the "spectre ship" by illuminating the ship with twenty separate flash exposures while keeping the shutter on his plate camera open. The resulting image looks eerily like a negative as the ship is outlined against the blackness of the night sky.

Photographing interiors of buildings often leads to problems that can be overcome by painting with light. In most of these cases, ambient sources of light, whether windowlight or existing tungstens and fluorescents by themselves, would inevitably produce some well-lit areas along with dark, featureless corners

Cressida

A flashlight was used to outline the figure by pointing it at the camera and moving rapidly. The flashlight was then directed to the reflective background. Exposure on 100 ISO color negative film was 30 seconds at f/16.

Duo (OPPOSITE)

This mirror image was created by using a silver vinyl sheet, usually used to create garden mirrors. A flashlight was used to light the model and also to reflect light directly from the vinyl surface.

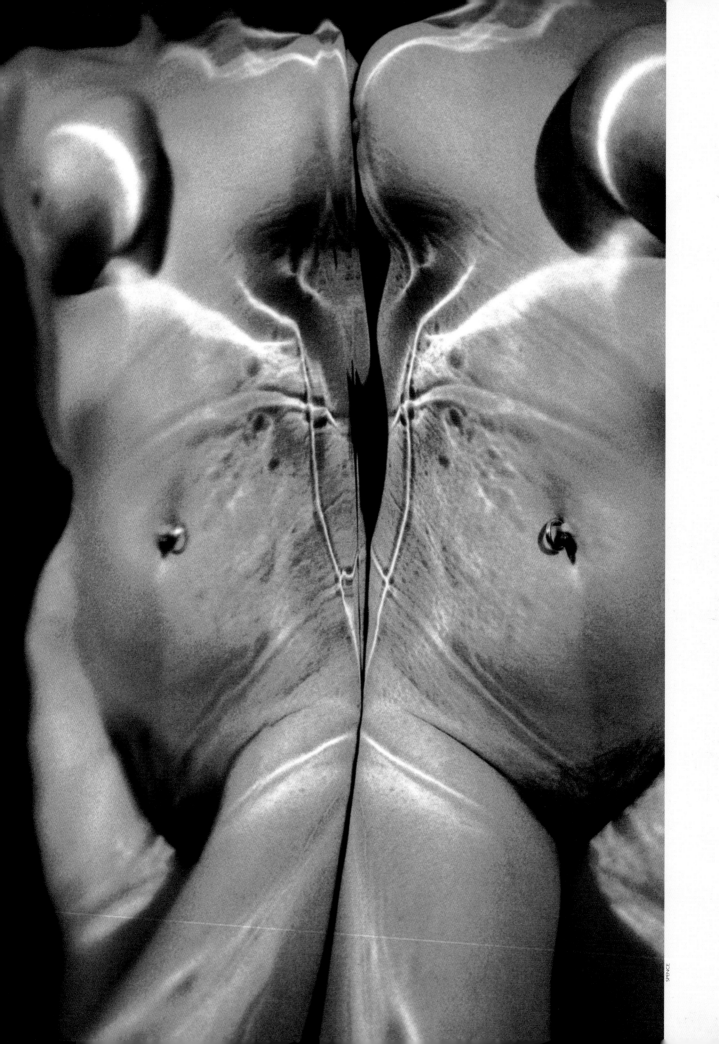

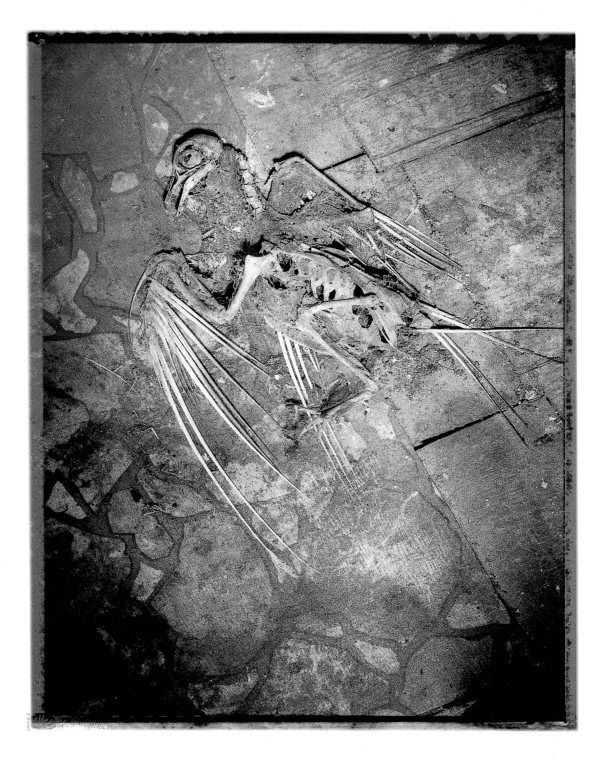

Rhubarb (OPPOSITE)
Still-life shots like this rhubarb leaf and powder may require longer exposures, due to using small apertures to gain adequate depth of field, especially using a 4-by-5 camera. However, a 60-second exposure at f/32 on Ilford FP4 film was used to enable enough time to move a sheet of reflective silver foil in front of the camera to produce an ethereal look.

Pigeon skeleton

This unfortunate animal had fallen between some broken floorboards and could just be glimpsed. Even using a tripod, the light was terrible. The only answer was to add extra illumination. A flashlight was used to "paint" the scene during a 15-second exposure.

RAD.
RHEI PULV.
DOSE 3 to 15 grains

SPENCE

that needed illumination. Of course the whole interior could be relit by using artificial lights—tungsten or flash—but generally it is better to retain the original atmosphere as much as possible.

The answer is to use available light as the primary overall exposure, and then add to it using a movable light source to fill in the gaps. The type of light used to do this is determined by the medium being used, color or monochrome. For the monochrome user, the various solutions do not raise too many problems. Color workers have to beware—long exposures and different sources of light will lead to reciprocity and color temperature shifts.

Take a typical scenario: a windowlit interior. An overall exposure of $f/16$ at 5 seconds is perfect for the general view, but an awkward corner will not even register on your light meter.

Abstract

Light itself has become the subject in this image. Illumination, shadow, reflection, and diffraction all played their part as light was passed through glass prisms and blocks to produce a more abstract composition.

Heads (OPPOSITE)

The shadows cast and light reflections caused by passing a light source through some glass heads were captured here by photographing the background, rather than the objects themselves.

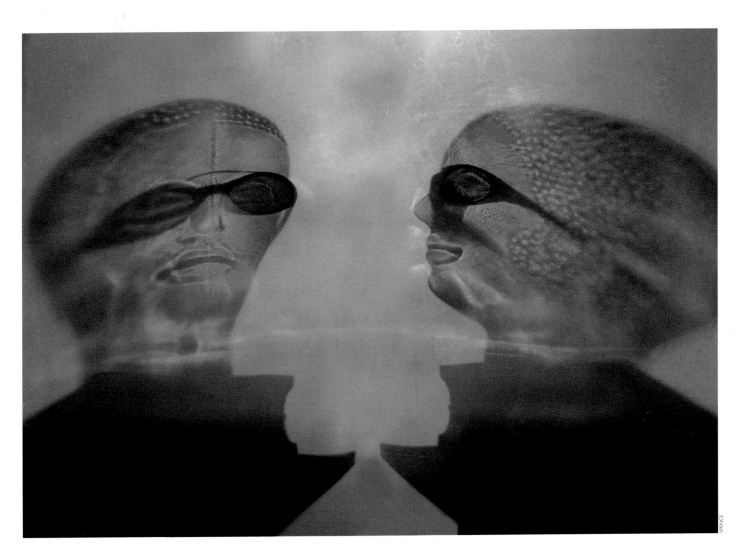

There are two solutions. If the corner is close enough to the window, and you can put yourself out of shot and use a reflector, this always looks natural. This often won't be possible, in which case you can point a handheld flash unit (daylight balanced) towards the gloom. If you can position yourself out of shot, fine. With a 5-second exposure, you don't even have to rely on a synch lead, as it can be fired manually.

What sort of exposure is required? Polaroid is a wonderful thing and allows almost instant feedback, but as a starting point, one to two stops less exposure than would be required to light the whole room will be about right.

Though you want some detail in the shadows, it is important that they are still a little darker than the main body of the room to retain a natural feeling. This can be achieved with a single flash, but more control is available if the power of the flash is reduced. This is built up in stages, maybe with slight movements in position to prevent any telltale shadows. It may also be necessary to place yourself in the frame while firing the flash. Direct the flash away from your body, and shield the flash from the camera with a black card or your body.

This technique works even better if you use a multiple flash and move between each one. In the example given, you may be able to move and fire at least two flashes in the 5-second exposure. You could also break it down to five separate exposures of 1 second (with one extra for lucky reciprocity), with the flash fired from different positions each time.

An alternative approach, especially if the interior is lit by an artificial source, is to use a directional tungsten light. Portable lights can be purchased, but often a good flashlight can

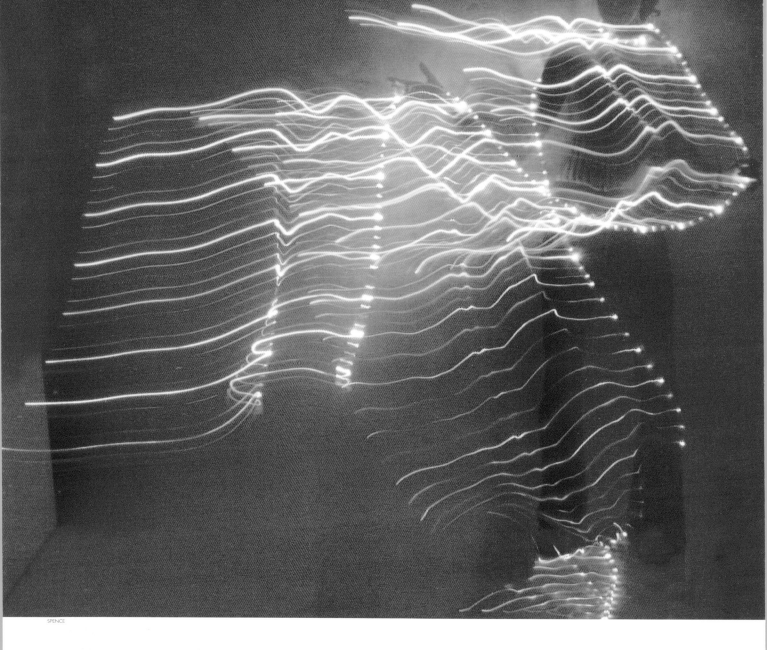

SPENCE

Light trail

This was a 5-second exposure in the studio. The figure was draped with a string of Christmas tree lights, and walked from right to left. The background coloration was due to a reciprocity shift caused by a long exposure on a Fuji digital camera. The saturation of the color was slightly enhanced in Photoshop.

suffice. Aesthetically, the directional light is often preferable to this flash. Light can be caressed and coerced into position. The major consideration in both of these cases is to determine the direction and intensity of light. To achieve a natural result, it should feel as though the light has been reflected from some interior surface. The intensity should again be considerably less than the main source of light—about two stops.

Awareness of photography as painting with light has come to the fore with its use in the commercial field, particularly with studio still life and the use of light wands. Though commercially available to the professional, mere mortals can use low-tech technology to achieve similar ends. In this case, rather than using an additional source of light to "fill in" dark spaces, the light wand becomes the primary source of light. This can lead to very interesting results.

The main effect of moving the light source is to confuse or lose the normal perception of direction of light. We produce an image that is simultaneously lit from left and right, from above and below. This makes the light envelop the subject and therefore produces an image that our eyes normally cannot perceive. This has proved particularly seductive in both commercial work and portraiture. Linked with unusual films like infrared, it can produce a unique image.

Very often such images are produced using a light source with a limited angle so the image is built up in sections. Exposures are therefore relatively long—typically 30 seconds or more. During exposure, the light wand, tungsten light, or flashlight is moved in a gradual motion over the subject. This gives enormous control by giving more or less exposure in terms of time, to emphasize certain features of the subject.

Another factor is the subject. If your subject remains still, it will be sharp. But of course it is possible to move the subject during exposure, move the camera, or change the focal length or focus of the lens during exposure. This can lead to some very exciting images. Multi-exposure is

also an obvious extension of this technique. Color images can be built up using different light sources or color filters on the light source, like simple color gels on a flashlight.

Moving light can also become the subject of your photograph (or a part of it). Heulsmann's image of Picasso is a classic example. The photographer combined a flashlit image of Picasso with a timed exposure of the painter moving a light to recreate one of his famous bull motifs, in the way we draw in the night sky with sparklers. Our persistence of vision allows us to "see" the lines and shapes drawn. In this case, the camera and film formed a more permanent record.

Scott Morgan has a contemporary approach, particularly in his *Shiva* portfolio, where he paints images directly onto film using swirling and spinning Christmas tree lights. The Swiss photographer Thomas Flechtner produced intriguing images of contours of the Swiss mountain slopes by attaching lights to his skis in the dead of night and recording his own progress over periods of many hours.

RPS collection

The Royal Photographic Society was being moved from the Octagon in Bath, Somerset, and the historic cameras were stored under polythene. A straight photograph (top) reveals problems with shadows, and the polythene makes it difficult to use a flash without harsh reflections. The lower image shows how, with a slight change of viewpoint and the illumination with a moving flashlight over a 10-second exposure, the details of the collection can be seen.

Series and Sequences

A single photograph is usually the capture of a discrete instant in time. It shows what we want to show at that precise moment. We can then study that moment preserved in its silver solitude. What we cannot see is what happened just before or just after the image was conceived. What is beyond the edge of the photograph?

WE CAN EXTEND our photographic vision and provide more information by thinking in terms not just of a single image, but of sequences of images. Many photographers have worked in sequences. Some, like Duane Michals, have used the sequence in the form of a narrative. Most of Duane Michals' sequences consist of five to eight individual pictures, which run as a linear sequence like stills from a film. Like any narrative medium, the content can be factual, or a total fiction, or a mixture of the two. Michals sums up his attitude towards sequence images:

"Sequences are to me like haiku. Just moments. I was dissatisfied with the single photo since I was unable to bend it into a further statement. In a sequence, it is the sum of the pictures which implies what a single photo cannot say. There is no sense in making a sequence, if the sequence makes no sense. Otherwise it becomes a mere exercise of skills. It has to go beyond this."

Duane Michals, *Photography and Reality*

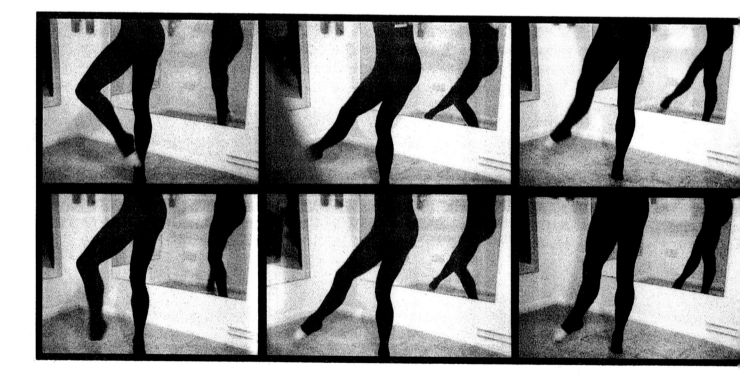

Dance

Many sophisticated cameras and attachments have been used to record sequences over time. Fast action usually involves some sort of auto advance built in or attached to the camera. Less sophisticated technology can be used to novel effect. Here, a cheap plastic camera that cost less than $15 was used to take four images on a single 35mm frame in just under 1 second. The resulting negative is a sequence of four images that are reminiscent of the frames of a moving film. The camera

The analogy with haiku is an apt one. The most successful sequences seem to have a balance of rhythm and economy. As in haiku, there is no superfluous use of words; in a good sequence, every image is vital to the whole story.

One of the most poignant narrative sequences was by Ralph Eugene Meatyard just before his death. Discovered after his death, the photographs show Meatyard disappearing from sight over the brow of a hill. He knew that death was imminent and created a visual representation of his departure from this earth.

However, narrative or linear storytelling sequences are just one way to approach sequence photography. The juxtaposition of two or more images can provoke a variety of reactions and readings due to their content or form. Spaces between images can become important, determining the flow of information and ideas. The work of Ray Metzker, for example, makes use of juxtaposed images taken in both different places and at different times. Yet elements of subject matter and composition seem to unite the images to create a new meaning.

Alice Wells, using the same methods of juxtaposition, describes the effect as not being a combination of two moments, but the production of a new moment—a multilayered reality that we experience.

The use of photographs in sequence has a long history, probably the most famous being those of human and animal locomotion by Edweard Muybridge, taken between 1872 and 1884. By using anywhere between twelve and twenty-four cameras, individual moments in time in the movement of animals and people were recorded. Conducted against a scientific, gridded background, these were primarily seen as providing objective information and used to analyse movement for scientists and artists.

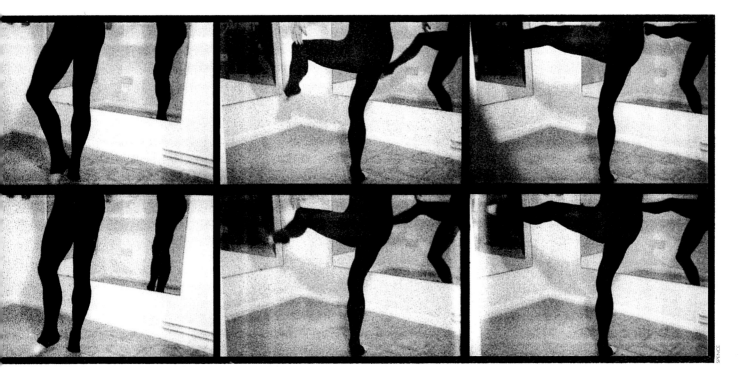

works on a fixed shutter speed and aperture, so the ISO of the film was selected for the intensity of the prevailing light conditions. The shutter speed is only 1/125 second, so with active movement there is a slight blurring that adds to the mood. In this case, a rather grainy Kodak T-max 3200 film was used: combined with the plastic lens, this enhances the rather filmic feel.

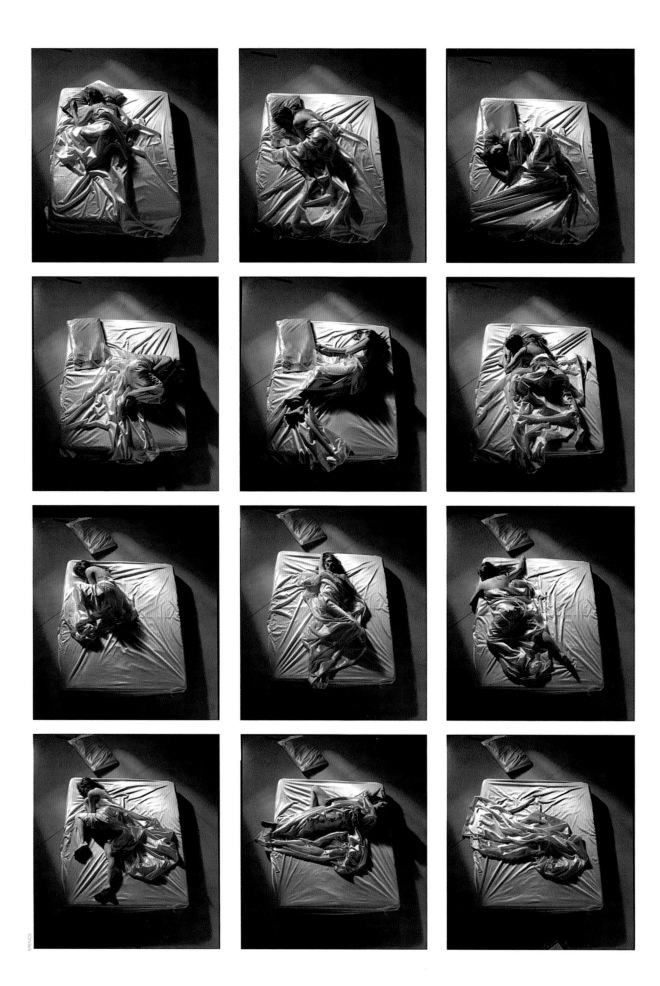

Sleep sequence

<small>(OPPOSITE)</small>

Science has often used time-lapse sequences to understand activities that occur over an extended time. In this sequence, sleep is seen as a somewhat frenetic activity.

Pink Elephants

Created as a bit of fun, these pink elephant plastic ice cubes were scanned on a cheap flat-bed scanner with a plastic bag as a background. The effect is a modern interpretation of the absurdity of seeing pink elephants when inebriated. Producing the grid, and using the same image flipped, were easy working in Photoshop.

Flow patterns

On the edge of Loch Lomond in Scotland, a strange scum is sometimes found on the surface of the water, which then defines the currents and the flow of water beneath. Combining four images in a sequence emphasizes the movement and flow of the water.

In the 1960s and early 1970s Bernhard and Hilda Becher took objective sequence recording of everyday objects and buildings to an extreme. Their images of functional buildings, such as winding towers, gas holders, bunkers, framework houses, and water towers, were photographed full-on and full-frame. Each building was photographed in an identical way, and the individual images were presented in a gridlike formation. At first sight such repetition may seem banal, but the more we looks at these observations, the more we see of the individuality of each building and the sculptural and textural forms within.

Normally we would record a scene or object in a single frame of film, but breaking away from this convention and making a mosaic can lead to fascinating questions concerning time and space. An ordered approach might be to photograph each part of a scene in sections and contact-print the entire film to produce an image. Changes in viewpoint or scale may also be produced between each frame of film, and also movement in the subject can create a sense of time.

Sequence photography, by its very nature, requires prior planning. That is not to say that a body of work cannot be sequenced at a later date, particularly in reference to development of ideas or themes, but for smaller projects, particularly those involving narrative, it is essential to organize ideas and determine how images will work together. Such previsualization is not in every photographer's nature, but the analysis of your images is essential for personal development and can only improve the integrity of your work.

Some factions of photography, particularly the pictorialists, see the final print as an entity in its own right. The interpretation of the negative, by printing techniques and presentation, adds to the value of the image. Others are more interested in what an image "says" and how a series of images can tell the story in a more complete way. Sequences fall between these two camps of thought and might very well be an apt meeting point. If you have never tried working in sequence, it should prove an interesting departure in your approach to the single image and the limitations it imposes.

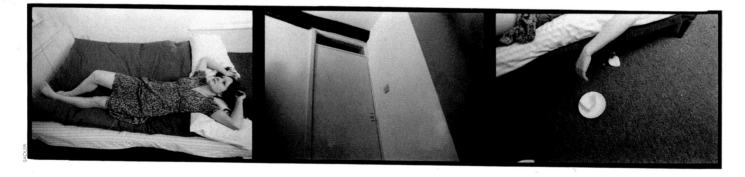

"Things will never be the same again,"
sequence by Richard Sadler
This image allows the viewer to make his or her own interpretation of events that have happened, or are happening. The broken cup, the position of the woman's hand, and the raising of the dress on her leg provide a very uneasy feeling.

Pebbles on rock (OPPOSITE)
This is a sequence of shots taken while exploring the rocky coastline of North Devon one afternoon. Because each picture was, in part, a replication of the previous one, it seemed appropriate to present them as a series.

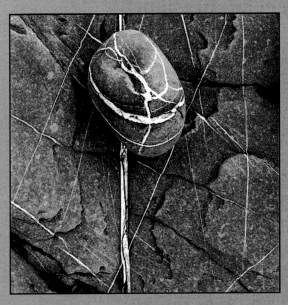

Scanner as a Camera

If fifteen years ago you had asked photographers to imagine taking a photograph without using a camera or even film, and told them that the equipment required would cost no more than a very basic SLR camera, but that the results could rival what can be achieved using a large-format camera, then they could have been forgiven for appearing just a little sceptical. This is a measure of how quickly technology has moved on.

ONE OF THE advantages of working with a flatbed scanner is that there is no messy darkroom work—no worrying about film processing and then using negatives to produce prints. Obviously you are restricted by the size of the subject you wish to capture, but with careful scanning, you should be able to achieve stunningly sharp and detailed images. But possibly the most exciting aspect of this process is that you are then able to access sophisticated software that gives you enormous control over the final image. This may well be limited to the software provided with the scanner, or you may wish to use other more dedicated packages, such as PaintShop Pro or Photoshop, that can open up endless creative possibilities.

There are, of course, great limitations to using your scanner as a camera but the secret of any technique is to creatively exploit what you have.

The most obvious problem is that you are limited by the size of your scanner. If it is standard size (A4), you will be unable to scan objects much larger than 12 inches—yet it is extraordinary how many interesting subjects are smaller than this.

Prints are also governed by the size of your printer—however, this applies to all digitally produced prints. If size is a constraint, it is relatively easy to construct joiners digitally.

The process

Because you have to place the objects you want to scan directly onto the platen, it is a good idea to protect the platen with a thin clear sheet of acetate—try OHP transparencies. Initially, it is worthwhile composing away from your scanner. Once your composition is resolved, place each element carefully face down onto the platen.

It is not necessary to use the scanner cover. If this is inconvenient, the cover can be easily removed—the scanner is unlikely to pick up much light from the room unless it is very strongly illuminated. If you wish to keep a very tight control of the background, you can use a light piece of paper or card over a still life. Once you have made an initial scan, it is a simple task to change the composition and rescan.

Feather
This high-key image was created by scanning the feather on a flatbed scanner, using a white box 2in (5cm) deep as a background. This produced a shadowless, light background.

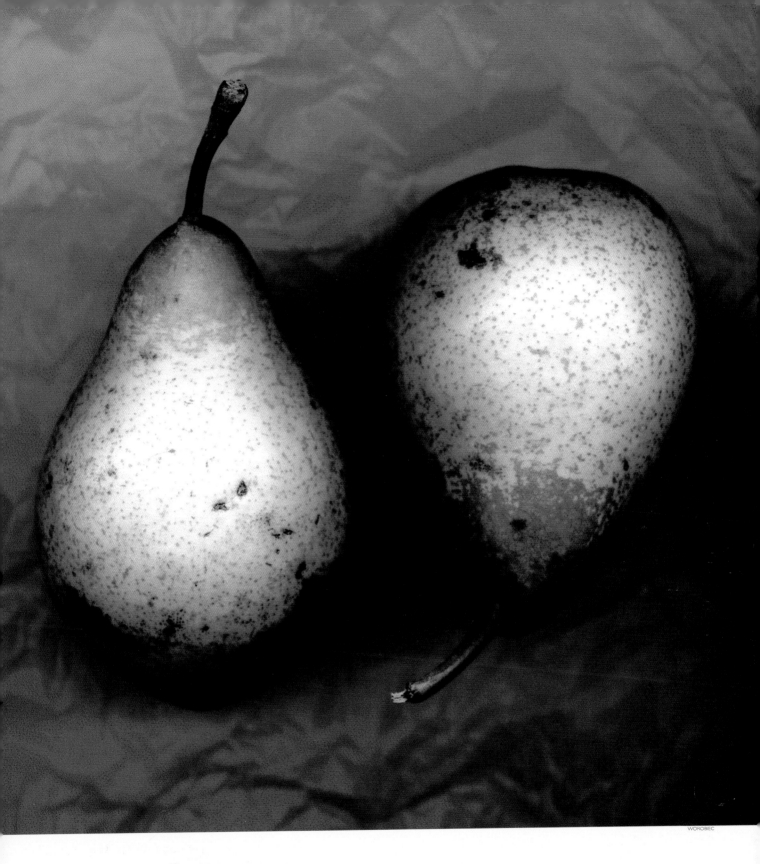

WOROBIEC

Two pears

All techniques have their unique characteristics, and working
from a flatbed scanner is no exception. Because the source of
light is constant, the highlights will invariably appear at the
point which is nearest—or in contact with the glass platen.
This can be corrected digitally.

Skeletal leaf and fossil

Very small and seemingly uninteresting objects can be successfully scanned, but they can appear more interesting when grouped together. Scanning such small objects can often reveal intricate detail, which is difficult to show using more conventional photographic means.

Some newcomers to this technique are put off by the limited source of light , which appears in the image always to come from above. This is caused by the strips of light in the scanner, which travel along the bed. While it is always from one source, the lighting is relatively soft, and it produces images that can be digitally manipulated subsequently.

What kind of depth of field can I expect with a scanner?

Unlike a camera, depth of field is something you have no control over. Those of you who have tried something like this with photocopiers will be surprised by the relatively good depth of field that can be achieved: you can expect a depth of field of several inches. If you compare this to an expensive macro lens working at a magnification of, say, 1:3, the scanner compares very well.

Constructing backgrounds

The background of any still life is always important, and using a flatbed scanner does not alter that. A light background can be created by either using the scanner cover, or by placing a light-colored material over the still life—light tissue paper is a particularly effective foil. If you want to create a seamless black background, it is worth constructing a black box that sits on the scanner. Make it reasonably deep (6 inches or so) to ensure that it will always be out of focus. You can also try lining it with black velvet. The material might attract white specks, but these can be removed using a piece of cellophane tape.

Using low resolution when scanning

While there is a natural inclination to get the very best out of any equipment, we can also be too demanding. Be aware of how much memory your computer holds. If you are not familiar with a flatbed scanner, you should know that it works quite differently from a purpose-made film scanner. In effect, the flat-bed scanner scans the entire platen (unless otherwise instructed). It can therefore record an astonishing amount of information, even when set at a relatively low

Physalis
Small, light, and delicate subjects, such as physalis, are ideal for scanning, because they are less likely to damage the glass platen. If in doubt, use a sheet of clear acetate as a protective film.

resolution—sort of like using large-format film.

If you set the resolution too high, scanning and any further modification will seem to take an eternity, and you might not have sufficient memory in your computer to handle it. The best approach is to start with your lowest resolution, and if that proves to be unsatisfactory, you can increase it a little by little.

Debris on the platen

If you are scanning organic material, it is very easy to litter the platen with unwanted debris. Try to anticipate where the debris is likely to come from, and remove it before you place the subject on the platen. Once you have placed your material, check the glass very carefully, and if necessary use a blower brush. If after scanning your work you still find bits of debris, these can be dealt with using your Cloning tool.

Choosing subject matter

Clearly this is determined by size, weight, and the appropriateness of placing objects on your platen. One approach is to use elements that are difficult to photograph with a lens. Close-

Thistle and honeycomb (OPPOSITE)
Once you gain confidence with creating layers, you may
become quite ambitious. In this example, the honeycomb
and thistle were scanned separately, resized, and then
pasted onto a new background. A final layer was added to
create the informal border.

WOROBIEC

Discarded Tulip 1
When scanning objects, such as these discarded tulips,
think carefully about the background. This example used
tissue and rice papers.

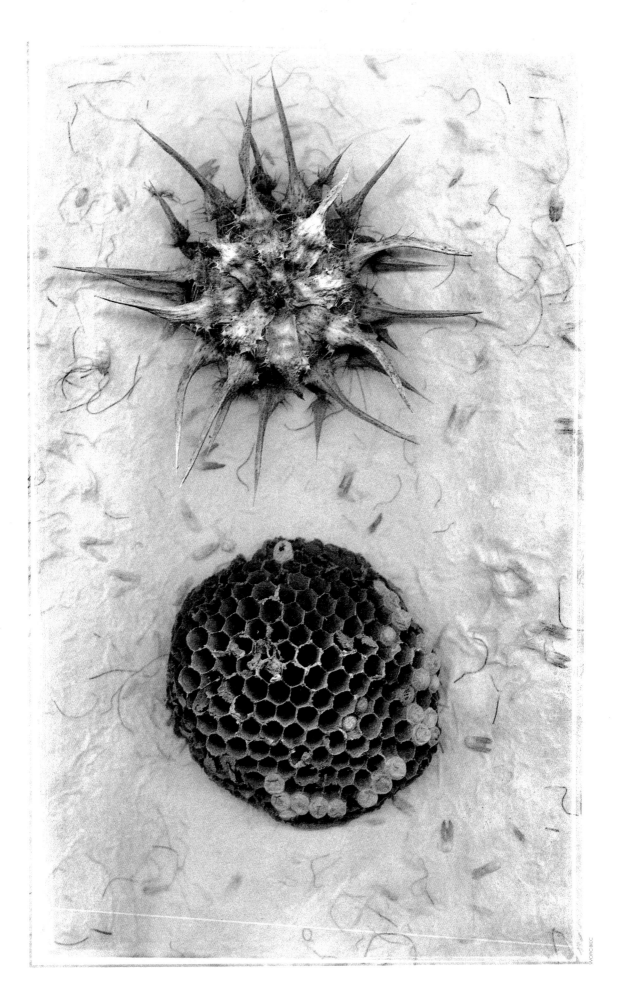

SCANNER AS A CAMERA

ups of organic forms work wonderfully—fruit, vegetables, flowers, shells, and pine cones, can be easily scanned, but because of their size they can prove difficult to photograph conventionally.

But that is only half the story. By accessing programs such as Photoshop, you are immediately able to introduce the exciting prospect of layers, which opens up new opportunities, particularly if you are prepared to work more unconventionally.

Flatbed scanners are superb for producing interesting montages or joiners. Look for the potential in discarded or damaged negatives, stained photographs, old letters, pieces of fabric, or any other material that appears visually interesting. After composing these elements together, try scanning them—it is amazing how

Artichokes

While you can never expect to get significant depth of field when using a flatbed scanner, it does nevertheless compare quite favorably to many conventional macro lenses, bearing in mind the magnification you are able to achieve.

Tulip in bloom

A black background be achieved in one of two ways. First, allow the light from the scanner to fall away naturally. Providing there is no light source immediately above the scanner, the background will appear black. The other alternative it to construct a black box to sit over your scanner.

easily these once disparate materials can come together. If discordant colors pose a problem, it is relatively easy to convert everything to Greyscale, and then reintroduce color through Curves or Duotone.

Constructing supports

One of the problems with using a flatbed scanner is that if you are photographing a relatively soft object, such as a flower, it will distort if you just lay it on the platen. One way around this problem is to construct a simple support system.

For flowers you can construct a simple block system, with holes for the stems, and place it on the side of the scanner. But support systems can also be made by using something as simple as removable adhesive mounting pads.

Porcupine quills

These quills are an ideal subject for this technique because they lie flat. Even so, the depth of field of the scanner is remarkably good. Scanning an 8-by-12-inch (A4) bed at 360 dpi gives a photographic-quality print of the same size. It is important to match the scanning resolution with the output resolution.

Pinhole Photography

Pinhole photography is a type of lensless photography. Basically, a pinhole camera is a lightproof box with a small hole in one end and a photographic emulsion film, or paper, in the other. Light passing through the hole projects an image onto the film. The ability to form an image using a small aperture and darkened space has been a phenomenon known for centuries—in fact, we have references as far back as fourth- and fifth-century BC in China and Greece.

IT IS WELL-documented that artists from the Renaissance onward used projected pinhole images on which they based their sketches and drawings. Astronomers have used pinhole technology from at least the fifteenth century. Even today, pinhole cameras are used by astronomers to photograph the stars using otherwise invisible X rays and gamma rays. In 1544, Gemma Frisius used a pinhole and a darkened room to view a solar eclipse. Over 450 years later, thousands of people viewed the 1999 solar eclipse using pieces of card in which a small hole was drilled, projecting an image of the sun.

Almost any space that can be lightproofed can be turned into a pinhole camera—anything from a village hall to an egg is potentially a camera. Thomas Bachler showed that even the human body could be made into a camera. By placing a piece of film in his mouth, he was able to slightly open his lips and photograph his own reflection in a mirror. Put simply, light rays passing through a small aperture in a pinhole camera form an inverted image. If film or paper is placed inside, it will record the image.

Commercially made pinhole cameras were available in the nineteenth century, and manufacturers are producing them today as we see a resurgence of interest in this most basic of image-forming devices. Their simplicity is superficial. Though a camera can be created easily out of almost any cheap materials or recycled objects, the design and use of these cameras can produce in aesthetic terms, images of great sophistication.

Technically speaking, you can produce relatively high-quality images that approach those formed by lens cameras. However, this almost defeats the purpose of using a pinhole camera. The very qualities of soft focus, long exposure, diffraction, reflection, and chromatic aberration are part of the characteristic and fun of pinhole photography. Photographs are not reality—though many people accept them as such. Pinhole cameras are able to see the world in an alien way—changed perspective, multiple and panoramic views, and compression of time.

Making a pinhole camera

These are all pinhole cameras. They all have the following features in common:

■ They are lightproof.

■ They have one or more pinhole apertures that can be opened and closed. Other than that, everything else is individual to the object in question, such as minor modifications.

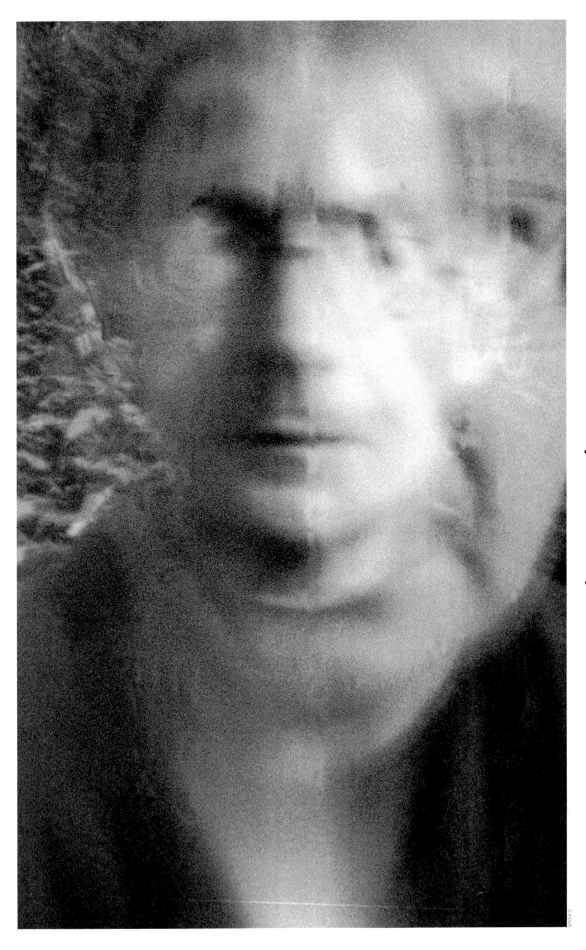

Multi-exposure

This self-portrait is the result of a 30-second exposure on a pinhole camera. During the last 15 seconds the photographer moved closer to the camera, resulting in a double image.

Self-portrait

This was produced on a roll of test film in a converted Voigtlander twin-lens reflex camera. During a 30-second exposure movement occurred, a good way of obscuring complexion defects. The negative was scanned on an Epson flatbed scanner, and the edges of the film holder were included as a frame.

The lens of a Canon A1 35mm camera was replaced by a pinhole fitted into a body cap. This allowed thirty-six images to be taken. Using 400 ISO film in the landscape, exposures ranged between 20 seconds and 1 minute. The angle of view was similar to the 50mm lens and showed little sign of vignetting. Here, the subject is moving water and a 30-second exposure produced an abstract image showing the direction of flow.

Lightproofing

Objects or materials used to make a camera should be totally opaque to light—black insulating, masking, or duct tape is great for covering any leaks at joins or corners.

The inside of the camera should be black to prevent internal reflection (unless this is desired). This can be achieved by using black sugar paper, matte black paint, or, best, self-adhesive black felt to line the camera. Felt is quick to apply, and the film or paper inside the camera is less likely to move.

Before using a camera, always test it for light leaks. Place a piece of fresh black-and-white printing paper in the camera in the darkroom, then leave the camera in sunlight for about ten minutes without opening the pinhole aperture. If your camera is lightproof, the paper will still be the original base white when developed.

Lightweight cameras can be subject to movement, especially with longer exposures. Usually you can use any available heavy object, such as a brick, to prevent movement, but if you don't want to trust to luck, a well-filled bean bag

or sandbag can be carried in case. When placed on top of the camera, it will mold to whatever shape is required. An alternative is to secure an appropriately threaded nut (usually 1/4-inch) to the base of the camera to act as a tripod bush.

Pinhole

This is best created from a soft, thin, metal sheet—brass, tin, or silver. It must be thin enough to create a pinhole, rather than a short tube, but still opaque to light. Metal foil from pie dishes, soft drink cans, and so on can all be brought into action. The hole can be machine-drilled or pierced using a needle.

Mapping pins or sewing-machine needles are easiest to hold. Using a cutting mat or other base, the pinhole is made by carefully pushing and turning the needle until it just pierces the foil. Pushing the needle point further in, as it is tapered, can vary the size. The underside of the foil should then be gently rubbed with fine-grade sandpaper to remove any untidy edges. The needle can be reinserted from the other side to create a round hole. The hole can be observed either by using a loupe or projecting with an enlarger to ensure it is clean. Its size can also be measured. The size of the hole needed will depend on the focal length of the camera, and the sharpness required in the final image.

A rough guide for optimum sharpness is shown below. The measurements of pinhole diameter are given in millimeters due to the tiny variations.

Sizing a pinhole

A rough guide for optimum sharpness		
Focal Length (mm)	Pinhole diameter (mm)	Approximate f-stop
50	0.26	192
100	0.45	220
200	0.63	320
300	0.77	390
400	0.89	450
500	1.00	500

The f-stop of your pinhole = focal length/diameter.

Garden ornaments

These garden ornaments were photographed using a converted 6-by-6 twin-lens reflex camera. The lens was replaced by a pinhole. This allows the use of roll film, so a number of images can be taken on one roll of film. The angle of view is roughly equivalent to an 80mm lens, and some vignetting is apparent towards the edges of the frame.

Pinhole negative
This is a paper negative produced by a "book pinhole camera." Characteristically, the tones are reversed, and the fogging around the edge is due to light leak caused by the design of the camera.

Pinhole positive print
A positive image is made by contacting an original negative onto a second piece of paper. Keep emulsion to emulsion to ensure optimum sharpness. In this case, the positive print has been scanned and colorized in Photoshop.

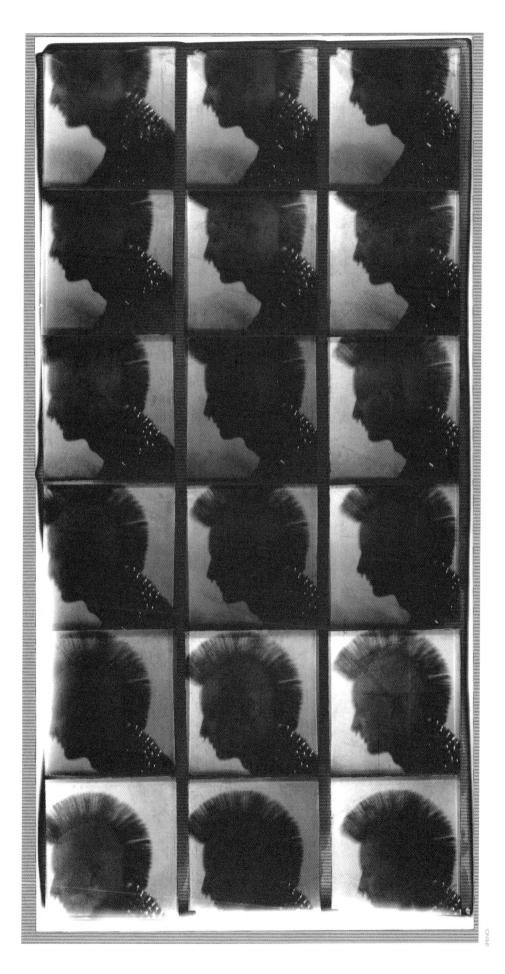

Malakai

This portrait was created using an eighteen-pinhole camera made from a plastic penholder unit. Each unit was able to record a slightly different viewpoint. Ilford MG paper was used to produce the negative, which was then scanned into a computer using a flatbed scanner. Some color was added in Photoshop, using Hue and Saturation, and then it was printed. The printer was low on ink, creating a rather unusual color shift and banding on the edges.

By deliberately deviating from such a guide, interesting effects can be achieved. A larger-than-normal pinhole will produce softer images, and is particularly effective for giving more ethereal effects, particularly in color.

To determine the size and shape of a pinhole, a good technique is to use a flatbed scanner. Scan at the highest resolution, and open the image in an image-manipulation program such as Adobe Photoshop. The measure tool can then be used to accurately measure diameter, and by zooming in on the pinhole you can easily check for irregularities.

Focal length

The focal length of the camera is purely the distance between the pinhole and the film/paper surface. In fact, there is no true focal length with pinhole cameras, as all points are equally focused. This is a unique characteristic of pinhole cameras, meaning that everything from the front of the camera to infinity is in focus. The diameter of the image circle is roughly 3.5 times the focal length, so a 4-inch focal length will produce an image about 14-inch across.

Wide-angle cameras can be made by keeping the distance between the pinhole and the photographic emulsion relatively small. Generally speaking, the light intensity at the edges of the image will be significantly less as the distance from the pinhole becomes greater. This leads to a typical darkening of the positive image—usually in a circular edge—typical of pinhole work. Using greater distance produces telephoto effects—a drainpipe could make a very effective telephoto camera. In this case, exposure tends to be more even, and the light falloff at the edges is less significant. The greater the focal length, the less light will reach the film, and therefore exposures tend to be much longer.

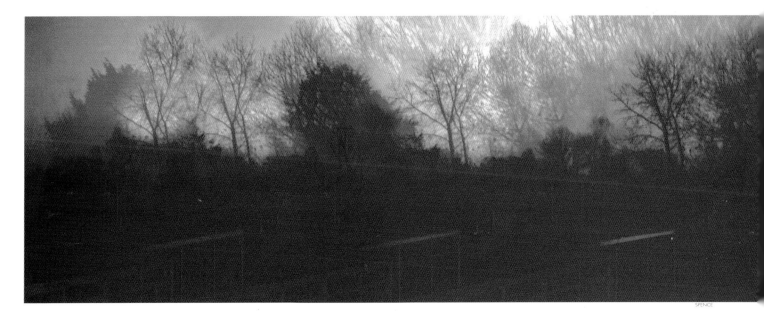

SPENCE

Barbie doll (OPPOSITE)

The doll was photographed using a pinhole camera made from an old book. Having hollowed out the book, a pinhole was set in the front cover, and a piece of photographic paper was placed inside the back cover. A single 500W floodlight illuminated the doll during a 3-minute exposure. The ragged edge is due to light penetrating the edges of the cut pages.

Treescape

Using a triple pinhole camera in landscape format, the trees are seen to overlap, providing an extended landscape. The paper negative was then scanned and colored in Photoshop.

Simple viewfinders can be made to determine the image area, but instinct seems to take over after a while, and the slight unknown can lead to less restrictive compositions.

Camera design

Pinhole cameras can be bought, home-manufactured, or "redesignated." It is astounding how many Web sites are devoted to pinhole photography, and there is a thriving industry supplying cameras, exposure meters, and mechanically engineered pinholes. These are great for serious workers who want the best in engineering and design. However, the home manufacture of pinhole devices is an integral part of the culture of this often-hidden side of photography.

Thick card is an ideal starting point for making a camera, and boxes used for packaging can be brought into service. A simple two-box construction is a versatile starting point. The front end contains the pinhole, and the back end holds the paper or film. Slide the two boxes over each other as snugly as possible. This makes them easy to load, light-tight, and allows a variable focal length.

Curved containers—cans, film canisters, and so on—produce interesting distortion, and if designed correctly can overcome image fall-off by keeping the pinhole-to-image plane relatively constant.

Multiple exposure is easy, as there is generally no movement of the film. By using more than one pinhole in the same camera, you can easily produce multiple images. By varying the distance between pinholes, more or less overlap occurs. Creating a 360-degree panoramic camera can be achieved by surrounding a central drum with paper or film and using six pinholes arranged in a circle around the edge. English photographer Andrew Kemp has produced some magnificent work using this kind of homemade camera. Working directly onto color reversal paper, he photographs communal spaces over long periods, from 2 minutes to 10 hours.

"I choose to work with the 360° panoramic format as it allows the spectator freedom of movement within the image, rather than being led to a specific point. The images succeed by diffusion as opposed to a concentration of interest. As a photographer, I am very aware that time is a commodity. You always seem to be waiting for something. Waiting generates thinking."

Andrew Kemp

Mannequin

This image was taken using a triple-pinhole camera. A drawer file previously housing CDs was converted by fitting three equally spaced pinholes along the longer side of the box. Each pinhole produces its own image of the mannequin, and the spacing between the pinholes allows overlapping of the images.

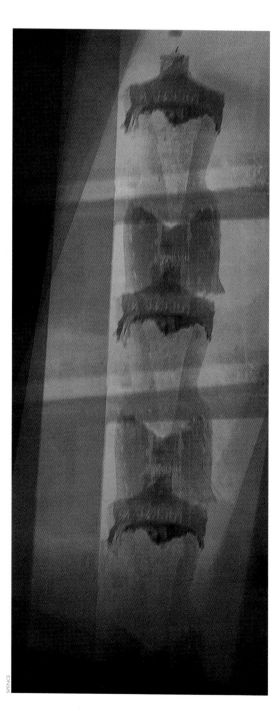

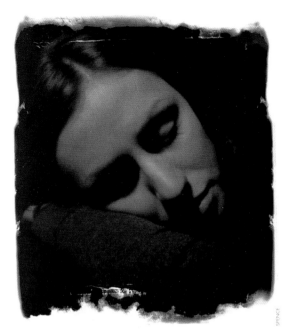

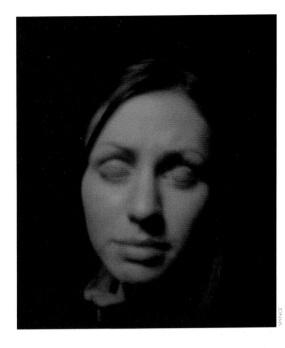

SPENCE

Ruth 1 and 2

These two portraits were studio shot using a single 500W bulb. The first image, using a pinhole camera made from a hollowed-out book, is a 30-second exposure with a still pose. The second image, taken with a converted twin lens reflex camera, was again taken during a 30-second exposure, but this time the model closed her eyes for half the exposure, resulting in a disconcerting image.

Mobile cameras have been made out of cars, garbage cans, suitcases, old books, and watering cans. Many people cannibalize old or broken film cameras, from Polaroid to disposables. An easy starting point to make a pinhole camera that uses 35mm film is to replace the standard lens on a basic SLR with a body cap that has a pinhole in the middle.

Materials

Virtually any photographic material can be used in pinhole cameras to produce a direct image. To begin with, any black-and-white paper will produce a negative image. This in itself can be interesting, but these negative images can also be easily printed as positives by the contact process. RC black-and-white papers are a good starting point as they stay flat and are quick to process. Glossy papers can cause some internal reflection, so matte papers are recommended. Papers that have no product markings are the best for contact printing to a positive. As a general guide, speed rating will be about 5 ISO.

Color-reversal materials will produce a direct positive. If copies or enlargements are to be made, film is a better choice. It can range through all types and formats. Remember that the exposure is generally fairly long, however, and that reciprocity effects will occur. More unusual materials, such as liquid emulsion, can also be used, but very slow materials like cyanotype, platinum, and salt are not suitable. Large-format negatives are easily made using a pinhole camera, and are ideal for producing contact prints using any of the "alternative" printing processes.

Exposure

If you develop a way of working with one camera and one film, exposure tables can be developed, but in most cases experimentation is the key—it is best to try each film/camera combination under differing light conditions. Once you are happy with a camera, don't be tempted to change the pinhole—it will be almost impossible to reproduce. Remember that reciprocity problems occur with very long or very short exposures.

Exposure meters can be used as a guide, but a compensation table will need to be developed. The chart below gives a starting point.

Exposure meters				
Light	f stop	B&W Paper ISO 5	Film ISO 125	Film ISO 400
Bright sunshine	300	30 seconds	2 seconds	0.5 second
Hazy sunshine	300	3.5 minutes	5 seconds	1.4 seconds
Cloudy bright	300	10 minutes	30 seconds	6 seconds
Overcast	300	25 minutes	2 minutes	15 seconds

Photograms

Imagine a glowing suntan, interrupted only by the white outline where the bathing suit covered the skin. This is a photogram. The bathing suit prevents light from reaching the photosensitive surface—the skin, under the suit. The rest of the skin has reacted to ultraviolet radiation, leaving a mark. Conventional photographic materials such as film and photographic paper, achieve the same effect by covering them with objects and exposing the paper to light to produce a direct image without the intervention of a photographic negative.

IN THE 1800s, Thomas Wedgwood used leaves and other objects placed in contact with paper soaked in silver nitrate or silver chloride to produce photograms. On exposure to light an imprint of the object was produced. Wedgwood was not aware of the fixing properties of hypo, so unfortunately these were transient images.

In the 1840s, Anna Atkins used the cyanotype process to create photograms of a variety of plant forms. This technique was used in a purely illustrative way. The plant recreated its own outline and form. This use of photography to directly represent reality lost its favour as pictorialism took hold, but in the early part of the twentieth century, a return to objectivity and purity was prevalent on many fronts.

Dada artists used the photogram as a rejection of idealized beauty and representation of the bourgeoisie. Closely allied to the use of objects directly in collages, photograms were used effectively by such workers as Christian Schad.

The process has endured, and it is still used by many contemporary photographers and artists. British artist Susan Derges placed petri dishes containing developing tadpoles directly onto photographic paper, and subsequent exposure to light revealed different stage of their life cycle to form a distinct series. She has also created a special process for producing photograms of swirling waters in rivers in both monochrome and color. The German photographer Manuela Hofer used disposable packaging items, such as teabags and sandwich containers.

Using the enlarger

Photograms can be created from any photosensitive material—black-and-white paper or film, color negative or positive paper, photolinen, cyanotype, and so on. The basic process involves laying objects in contact with the surface of the paper and exposing the composition to light. This will produce a negative image in most cases, unless a reversal material is used. Negative images have a unique quality in their own right, but can easily be converted to a positive by contact printing.

The object you choose to work with will affect both the result and required exposure time. Opaque objects will produce an outline only, but translucent objects will reveal variations in density. These are often more interesting. Complete contact with the printing

Leaf skeleton

This is a positive photogram produced by simply laying a leaf skeleton on the surface of Ilford RC paper. The technique is ideal for capturing the delicate venation of the dried leaf.

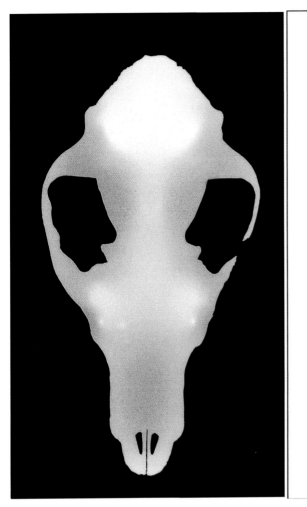

Skull

Version 1: This is a direct photogram created by placing the animal skull onto the photographic paper and using the enlarger bulb to provide illumination. It has produced a typical negative image, and interestingly, the different thicknesses of the skull are revealed.

Version 2: The original negative photogram can be converted to a positive image simply by placing the negative face down onto a new sheet of photographic paper under a piece of glass to maintain even contact. The positive is produced by projecting light through the negative print, using the enlarger or any other light source. Remember, however, that this will produce a mirror image.

paper is usually required for perfectly sharp results. Covering the subject with a sheet of plate glass is often necessary. Allowing parts of the object, such as a dried leaf, to lift from the surface will introduce some softness. Extended exposure will also lead to light diffracting at the edges of three-dimensional objects, leading to some fogging, which increases the feeling of form. It sometimes comes as a surprise just how much light seemingly "opaque" objects can be made to transmit.

A single exposure under the enlarger is fine, but try breaking the exposure down into discrete sections, moving, adding, or subtracting objects at each exposure. Be careful, however, when an object is removed and the paper is re-exposed to light; it quickly darkens. Tests are necessary to determine the correct times for each exposure. The introduction of text or illustration is also easy at this stage. A sheet of acetate can be drawn or written on with black pigment ink and laid on the paper during exposure, producing white text or drawing.

Projection

Small, thin objects can be placed in the negative carrier, either directly or sandwiched in glass or acetate, and an image can be projected in the same way as a negative. This can reveal some remarkable detail in natural fibers, leaf skeletons, insect wings, and so on. Depth of field is very narrow, so unless the object is perfectly flat, some areas will be out of focus. Again, this can be used to good creative effect, and different images are created by moving through the focusing.

Even liquids can be placed in a sandwich of acetate or polythene, although care must be taken to ensure an adequate seal. By mixing liquids, allowing crystallization, or introducing

air bubbles, a variety of abstract shapes can be produced. The edges of bubbles, where there is an interface between air and liquid, produce dark outlines due to the diffraction of light. Color materials reveal subtle diffraction colors produced even in clear liquids.

Other light sources

An enlarger is an ideal light source because it is easily controlled, but its major disadvantage is that the source of light is always directly above the baseboard. By dispensing with the enlarger, movable light sources such as flashlights can be used. These can be angled to cast shadows or even moved during exposure. This works well with three-dimensional objects, or diffracting objects such as glass, bottles, prisms, and so on. Generally it is best to use a very low-power light, and using a homemade snoot is a good idea for directing the light source.

Moth

Here, the deceased body of a moth was combined with a broken glass slide to produce a direct photogram that has a slightly ghostly feel.

SPENCE

Sunlight might seem to be too bright for photogram work, but some materials are less sensitive and therefore worth experimenting with. The cyanotype process is particularly suitable, printing-out paper is ideal, but even conventional printing papers can be used. If conventional enlarging papers are exposed to light, they will change color. Subsequent fixing without development retains some of the color, though much is bleached out.

By using massive overexposure (30–60 minutes) in bright sunlight, photograms can be produced that exhibit a variety of colors, depending upon the paper being used. It is good to experiment, and this is a wonderful way of using up all of your old, stale paper.

Portable flash units are great sources of light when working with "transient" objects. For example, the eddies and flows of moving water can be revealed by placing photographic paper

Ink

Ink was placed in a small plastic bag that was then sealed and used directly as a negative in the enlarger to produce this projection photogram. Small details have been revealed by the enlargement, creating a rather ambiguous composition. The resulting image was then blue toned.

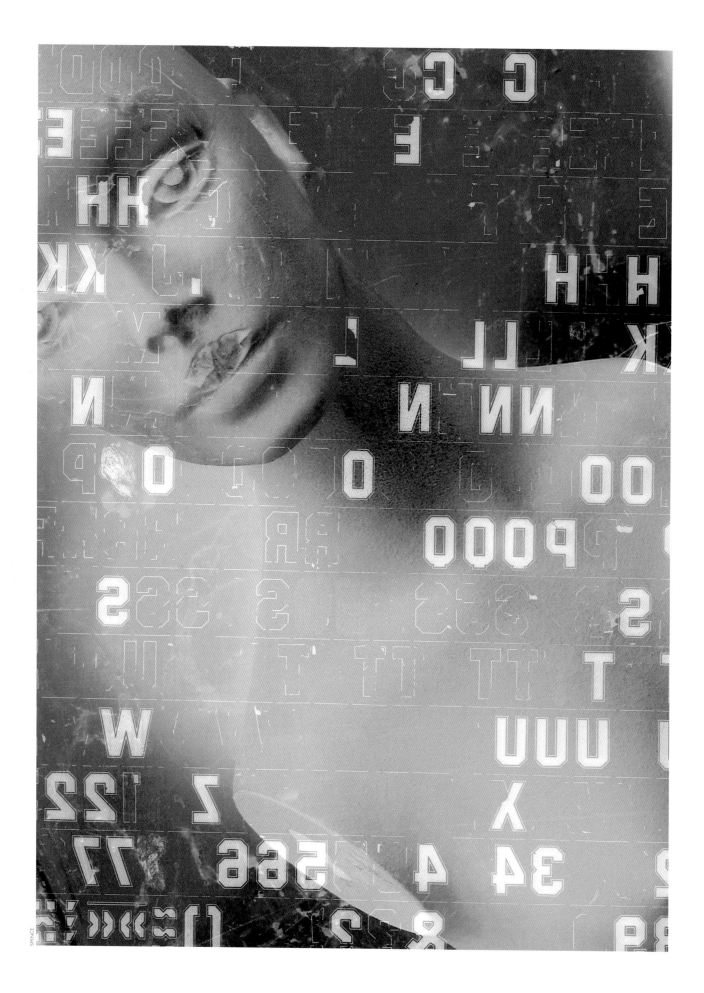

EXTENDING THE BOUNDARIES OF PHOTOGRAPHY

Mannequin (OPPOSITE)

What most people would discard as garbage sometimes finds a new use. An old sheet of partly used Letraset was put over the photographic paper, and a negative image projected by the enlarger created this multiple image. The resulting print was then scanned and colorized in Photoshop.

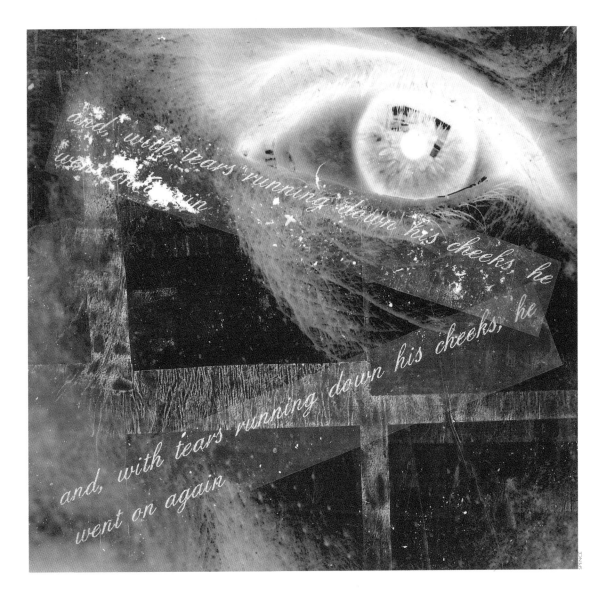

Tears

Text photocopied onto acetate was laid over a black-and-white print of the face. This was then contacted to produce a negative image.

underwater in a flowing river at night and firing a flash or series of flashes above the water to freeze the surface textures.

The same principle applies to using smoke and other ethereal components. Paper or film can be placed in old 4-by-5 or 8-by-10 dark slides to transport them to and from the location. Alternatively, two sheets of glass sandwiching the paper and covered with a black plastic bag from a box of printing paper will do the job just as well. The artist Susan Derges uses specially made dark slides that enable her to produce large scale photograms of moving water.

Photobatik

Though not strictly producing a photogram, the process of photobatik is worthy of mention at this point. With a photogram, an object prevents light from reaching photographic paper, thus creating its own image. Photobatik works by using an object to prevent parts of the paper from being sensitized or processed, thus creating an image. For the most part, this works on the principle of the inability of oil-based and water-based materials to mix.

If an object is thinly coated with Vaseline and pressed onto the surface of black-and-white photographic paper, it will leave a clear Vaseline impression. If the paper is then exposed to light and developed, the developer, being water-based, will not be able to penetrate the Vaseline, so the paper only darkens in the areas not affected by the Vaseline. The result is a white imprint against a black background. If the print is washed in mildly soapy water to remove the Vaseline, rinsed, and fixed, it will leave a permanent impression.

Variations on this theme can also be produced. For example, inadequate washing prevents the paper from fixing completely, and colors can be introduced, albeit transiently in the impression, due to fogging of the remaining silver salts. You can also "print" onto ordinary art papers by using Vaseline before coating with sensitizers such as cyanotype or argyrotype,

which, being water-based, will repel the sensitizer. Exposure to UV light and subsequent clearing will again produce a direct batik print.

Natural pigments

The natural world is full of examples of light-sensitive materials. Animals and plants are directly affected by the presence or absence of light. The cells of the retina in the eye are temporarily bleached by light: it used to be common folklore that an image was imprinted on the retina of the last thing a person had seen at the time of death. Unfortunately, this is not true, as otherwise forensic science could have been revolutionized. However, some changes caused by light can be seen and used to produce images. The tanning of the human skin is an obvious example, and it is quite possible to use the body as a living canvas for photogram images. This is, of course, less permanent than a tattoo, but not so painful.

Artists Heather Ackroyd and Dan Harvey have worked for over ten years with grass as a photographic medium. When green grass is deprived of light, it turns yellow due to the loss of the chlorophyll pigment. By covering grass with opaque barriers or large photographic negatives, an image is eventually produced. The grass images are grown in a giant darkroom using artificial light. Large trays are sown with a specially selected strain of grass and covered with a giant photographic negative. The resulting work is often large-scale and needs to be viewed from a distance. Even so, the amount of detail and subtlety of tone is amazing. Over time, as it is exhibited in the light, the image disappears. The transience adds to the fascination.

The same principle can be applied to many other plant forms, such as leaves or even developing fruit.

All of the above processes can be used by themselves or in combination to create an infinite variety of image-making opportunities, with or without a camera negative. Be warned, though—you may never use a camera again.

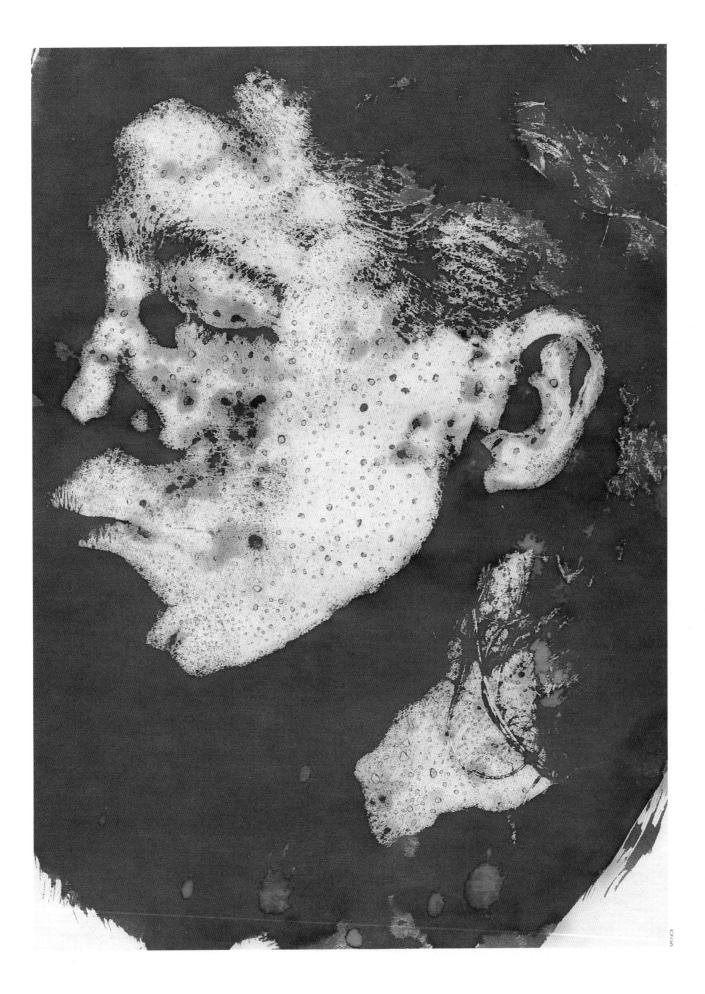

SPENCE

Distressed Images

Generally we take photos that we want to last. The print is seen as a purely mechanical or chemical process subject to almost infinite duplication. It seems a matter of heresy to suggest that deliberate destruction—defacing, tearing, or chemical breakdown of a print—can be a desirable characteristic. However, destructive processes can be used to great effect. Marcel Duchamp's *The Bride Stripped Bare* is the classic example.

MISTAKES CAN ALSO be useful. Unfixed and stained prints can take on some magnificent hues, and partial solarization can totally transform an image. These are usually chance finds that are subject to continual change. Rephotographing or scanning with a flatbed scanner can preserve even transitory images

Biological decay

Film and fiber-based papers contain materials, such as paper and gelatin, that are of biological origin. As such, they are materials that decompose and act as food for micro-organisms. These processes cause changes in both the materials and any latent or developed images. Usually photographs and negatives are kept in cool, dry conditions to prevent any such changes, but to encourage the effects of micro-organisms, warm, humid conditions are ideal. Changes that do occur are not predictable, of course. Time, experiment, and close observation are necessary.

To work on prints, choose well-washed fiber-based materials. Resin-coated papers are protected by their outer coating, which is difficult to penetrate. An easy way to create a humid environment for decay micro-organisms is to enclose a print with organic material inside a plastic portfolio sleeve. As the micro-organisms grow, they will start to physically break down the gelatin and paper fibers, causing damage to the image on the print. Waste products are produced that further enhance the changes, and the micro-organisms themselves will probably cause distinct color changes. Once started, these processes are irreversible and tend to continue.

It is worth keeping a close eye on developments. To preserve these changes, rephotograph or scan the print at frequent intervals. Film negatives or transparencies are open to the same actions of decomposition, and the effects become more pronounced if the negative is enlarged, as it normally is. Soil is a suitable environment for the action of microbes—just remember where you buried your film.

Scratching emulsions

Most photographers confronted with a scratch on their film would probably throw away the ruined negative. Alternatively, many hours could be spent spotting the offending mark out. With modern digital technology, scanners and photo-manipulation software are provided with sophisticated dust and scratches filters, and even if you do find marks on your images, cloning them out in Photoshop is relatively easy.

However, some photographers choose to remind us that the photographic image on paper has substance, depth, and texture, and that the negative can not only be formed by the action of light but also by the hand of man.

The controversial photographer Joel Peter Witkin trained as a sculptor at the Cooper Union School of Art in New York. He brings this background to his work, both in the arrangement of his tableaux and in the treatment of his negatives. He uses implements to scratch on both sides of his negatives, introducing elements of destruction, concealment, and design. This, combined with his use of toners, chemicals, and selective

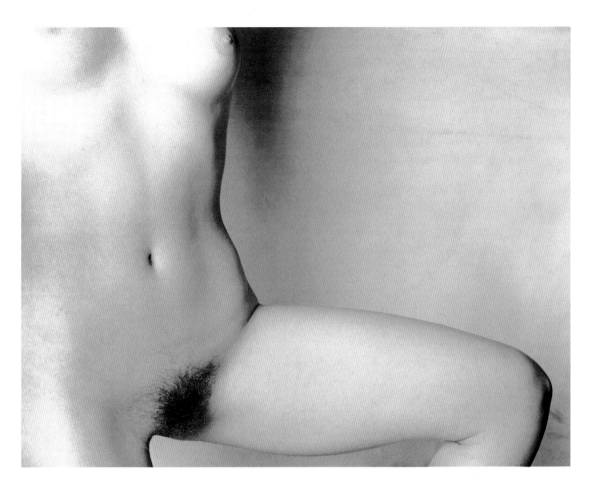

Chemical staining

This is the straight contact print from a 4-by-5 negative on Ilford FP4. It was printed on Ilford MG fiber-based warm-tone paper. The aim was to achieve a classic form reminiscent of Edward Weston, using very simple, straight-forward lighting, and careful cropping.

Stained print

As usual, a number of test prints were produced that inevitably ended up in the trash with inadequate washing, and still wet. Weeks later test strips and prints were rescued from the trash, and fixer stains, creases, and so on were apparent. This is a matter of chance—some images took on a new appearance, which added a different dimension to the original vision that is probably as far from Weston's concept of photography as it is possible to get.

Decay process

Stage 1:

This was a test print in the development of the decay process. It is a straight print on Ilford FB multigrade paper.

The next stage in the process was to seal the test prints in a plastic portfolio sleeve with a number of fresh leaves. The leaves have natural colonies of bacteria and fungi that, under warm, humid conditions, rapidly multiply and use the paper and the gelatin of the print as a food source and start its decay.

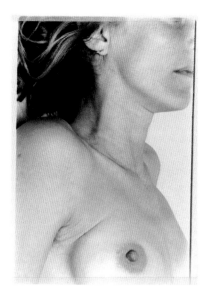

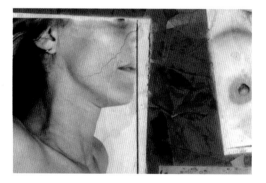

Stage 2:

Here, we see the beginnings of the decay process. Staining and color change have begun.

Stage 3:

After a few weeks, the image became discolored, and signs of microbial growth were much more apparent. From these tests it was possible to determine the effects of different types of leaves and time on the decay process. Different papers will also produce different effects—resin-coated papers do not break down easily and are best avoided.

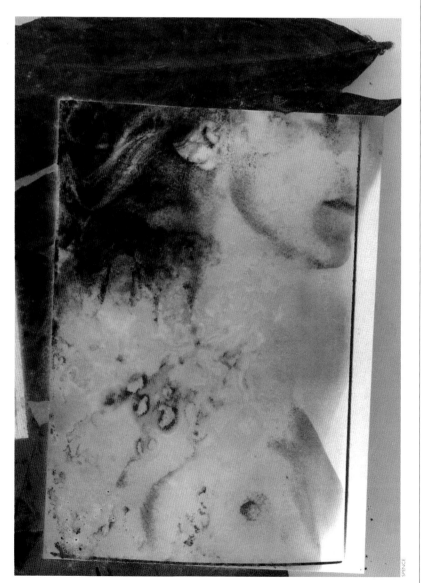

diffusion of the images, produces unique works of art whose aesthetic qualities are often contradictory to the underlying subject matter.

Scratching into the film base or emulsion of monochrome materials will result in white or black marks. Careful scratching into the emulsion of color transparencies will reveal the underlying color layers.

Damaging negatives is risky, unless you have a backup. An ideal solution is to sandwich your negative with a discarded piece of film that has been been distressed. Not only does this protect the negative, but you are able to move the distressed piece of film in order to produce a varied outcome. You will need to give your print extra exposure at the processing stage, as even clear film can cut out some light.

Chemicals

The effect of chemicals on prints and negatives is determined by a number of variables. Not the least of these is the type of photographic emulsion used, its age, whether a hardening agent has been used, and so on. It is probably best to start experiments on copy prints or to produce multiple negatives especially for the purpose. Bleaches such as potassium ferricyanide have traditionally been used for the removal of silver images, but any corrosive materials can be tried. Standard household bleach is easily obtainable and can be used both to fade and manipulate images.

Remember that chemical reactions are faster with warmer solutions, but also remember that a chemical that corrodes your images will probably corrode you, so take the usual precautions—rubber gloves, goggles, and plenty of running water to douse accidental spills. Sodium carbonate, which can also be obtained in crystal form, can be dissolved to form a solution that either causes reticulation of negatives or, in extreme cases, can strip away the negative from the base.

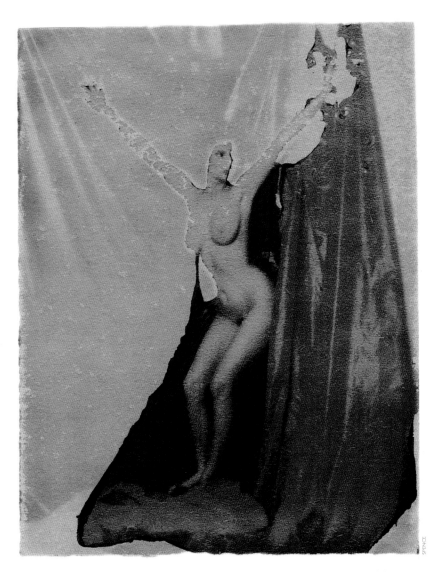

Nude

The production of a normal color Polaroid print relies upon the migration of color dyes onto a receptor surface. Peeling apart the Polaroid then reveals a fully processed colour print. If the Polaroid is pulled apart about 10 seconds into the development time and pressed onto the surface of a fine art paper, the migration of dyes carries on to the paper surface. This is the basis of "Polaroid transfer." When pulling the transfer apart, some of the image, particularly the dense image areas, may lift off, as shown here.

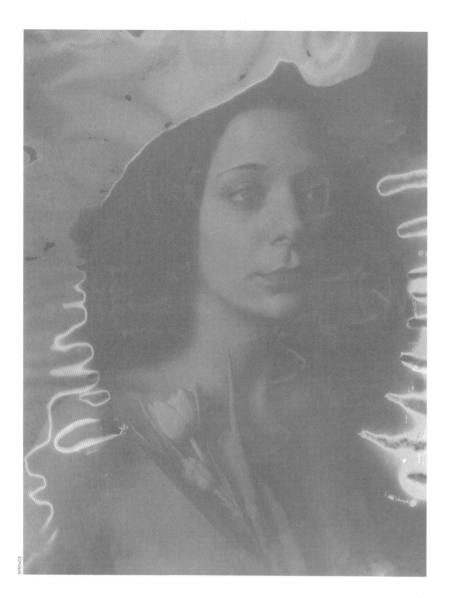

SPENCE

Sue

The surface of photographic prints can be attacked by a variety of chemicals. This works particularly well in large areas of even density, like the dark background in this image. The print was immersed in household bleach, and then the edges were selectively treated with stronger solutions while protecting the central area.

Negative reticulation

Modern black-and-white films have made reticulation almost redundant, but the effect can be achieved chemically with some of the faster emulsions, such as Kodak Tri-X—even if a hardener has been used at the fixing stage. Try a solution of 0.08 oz (60g) of sodium carbonate to 35 oz (1l) of water at 140 °F (60 °C). Immerse the negative for 5–20 minutes, and then rinse with cold water.

Using a weaker solution of sodium carbonate (0.04 oz/30g per 35 oz/1l) for a longer time will produce even greater reticulation. If left for too long, the emulsion may lift completely, so care has to be taken. If this is controlled, some parts of the image can be selectively removed or manipulated by using a soft brush. If some areas

of the negative are painted with rubber liquid frisket before treatment, any action of chemicals can be prevented selectively.

Collage and tearing

Creases or tears in photographs are usually associated with mishandling or the ravages of time. Well-loved and well-thumbed prints bear such imperfections as the patina of age, and this adds to their charm. It also reminds us that the artifact of the print is an image printed on a surface such as paper, and this surface can be as much part of the aesthetic as the image itself. The portrait photographer Arnold Newman is well-known for his meticulously planned images of the famous and infamous. Usually his prints follow the conventional, fine-art tradition of archival printing, quality, and presentation.

On one famous occasion Newman deviated from this route. Producing a somewhat serious-looking image of Claes Oldenburg, Newman decided that the straight print was not working. His solution was to tear the print, introducing a white lightning fork from the top of the image that just pierced the head of Oldenburg. This echoed the humor and whimsy of much of Oldenburg's work—Oldenburg was famous for metamorphosing everyday objects such as clothes pegs into monumental sculptures. By tearing the print, Newman produced an analogous metamorphosis.

Taking such an act of vandalism to its logical conclusion, Mike and Doug Starn have, since 1985, been producing large-scale works by creasing, tearing, and reassembling prints with tape to produce images where the surface qualities and structure of the materials are almost as important as the subject matter. In fact, some images are akin to modern abstract paintings, where no image exists other than fogged paper, as in *Black Piece 1986*. In the Starn twins' work, we see the acquisition of photographic materials as a legitimate medium for the creation of works of art, with roots firmly based in the traditions of the Modernist movement of the 1920s and 1930s.

Combination negative with decayed lantern slide

Siren negative

For a series of images based around the theme of mermaids and sirens, the idea was to produce work that had the appearance of age—almost as if created in a bygone age, when such mythical creatures were said to inhabit our seas and estuaries. A number of old glass lantern slides were damaged and were suffering from being kept under poor conditions. They were coming apart, the paper masks were torn, and some had developed growths of mold. By taking the slides apart and sandwiching some combination negatives, it was possible to impart these characteristics of decay to the printed image. It did mean that the ultimate sandwich was rather thick, and the negative carrier had to be dismantled to get it in the enlarger.

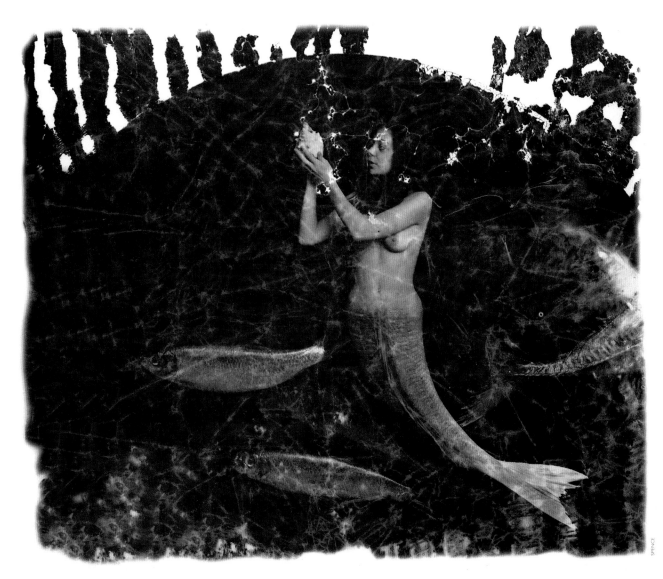

Final image

This is one of four that was eventually produced. A set of these were printed on to fine-art paper using liquid emulsion, which took the images a step further from photographic reality.

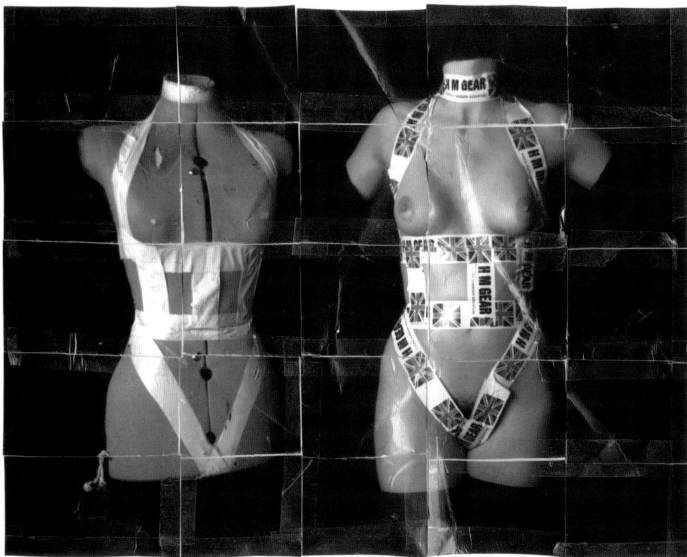

SPENCE

Taped torsos

The original version of the taped torsos was printed in
sections on Ilford RC glossy paper and selenium toned.
The sections were taped together with cellophane tape
and deliberately creased. The sectioning and the tape
reflect the subject, and the creasing of the paper reminds
us that this is an image on a surface, rather than the
subject itself.

Body series

This is the final image produced as part of a series in which the images of the body, photographed in sections and printed onto 12-by-16 Ilford FB MG paper, were decayed over a period of twelve months. The stages were photographed regularly, and the sections were combined to produce life-size images. This was also repeated with a male torso, and the result was an installation in which both bodies were shown in various stages of decay.

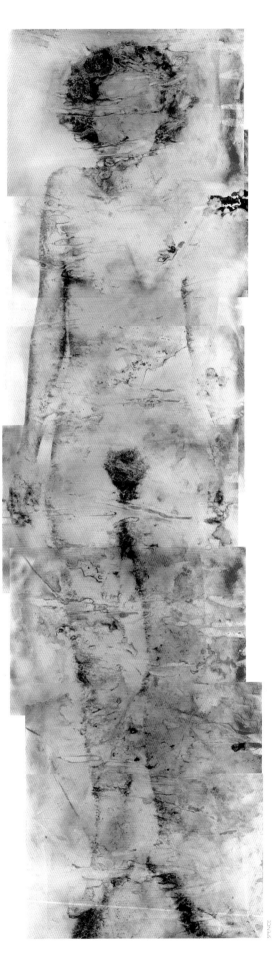

Store window dummies 1 and 2

This image is disquieting, if only because on first glance it has the appearance of a butcher's shop. In order to heighten this, the negative was deliberately "distressed" in order to remove it from its more mundane context. The edges were roughened by painting photo-opaque liquid directly onto the negative, and the surface of the negative was then scored using sandpaper and a scalpel.

Working with Mixed Media

Is it always essential that your print is sharp and rich in detail? Surely there are occasions when a perfectly processed photograph is just a little too real and fails to engender the mood you were trying to capture in the first place. Sometimes you may find that a more subtle and alternative approach to image-making is required.

T HE NOTION OF the photograph as an entity in its own right, measuring a certain size and produced from a negative, is a conservative one, and numerous artists and photographers have discovered that image-making can be far more interesting than this. This is not solely a contemporary view—the methods of hand-tinting, silk-screen printing, gum bichromate, and bromoil have been practised for many decades.

Parallels with the world of art are always interesting, yet it is difficult to name many contemporary painters who choose to work exclusively in just one medium—most recognize that there are enormous advantages in employing a variety of mediums within the one image. They understand that all media have their own characteristics, and while it is important to respect the uniqueness of each of these, often images can appear far richer and visually more exciting when a variety are used.

Making the ordinary extraordinary
A compelling argument for working in mixed media is that it can introduce layers of meaning

Applying photo dyes and oils to a toned print

Stanford, Montana

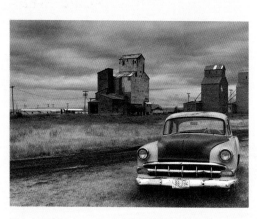

Version 1:

Straight black-and-white print.

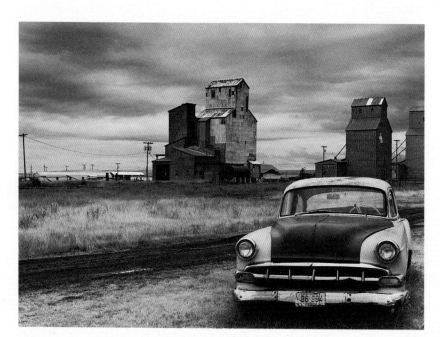

Version 2:

This print was sepia-toned to give the image a warm color base.

that cannot possibly be achieved using purely photographic means. Examine your negatives, and then decide how many of them truly represent significant events. If yours are like ours, then you probably have precious few. But does that mean that we have been wasting our time? Are our images simply too mundane? The answer is, of course, no. But when others view our pictures, they have very little information to go on, and consequently they are often unable to empathize with what we were experiencing when we first took our photographs.

Ironically, some of the most potentially interesting pictures are of the "mundane," because they are a genuine reflection of our lives. But, almost by definition, we have become so accustomed to seeing the commonplace that we can sometimes fail to recognize its significance. The experiences of "ordinary people" are often both interesting and those that we can easily relate to, which is often why contemporary photographers specifically feature "ordinary" situations. By introducing new layers into our photography, not only are we able to make the ordinary appear extraordinary, but we are more able to accurately relay our thoughts and emotions and therefore to communicate to a wider audience.

Once you accept that other mediums can be introduced into your photography, it should be easy enough to accept that your images need not necessarily be rectangular. Why can't your images be irregular in shape, or perhaps presented three-dimensionally? As photographers, we are seeking an individual way of responding to the visual world, and this is not always easily done through the conventional photographic processes. By looking outside of photography, we are capable of achieving images that are highly imaginative and individual, potentially a much richer reflection of our personal vision.

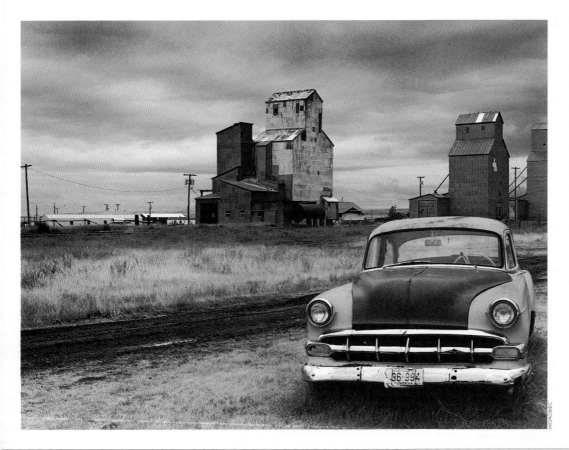

Version 3:

Marshalls oils and spot-pens each have their own unique characteristics. Photo dyes were initially used to hand-color this print, but then photo oils were worked over them in order to create a depth of color that is difficult to achieve in any other way.

Hand-tinting photographs

Possibly the most direct way of introducing another medium into your print is by hand-tinting. Hand-tinting is a long-established tradition that has grown in popularity in recent years, largely because so many photographers want to invest something of themselves in their print-making. There are a number of options you may wish to consider without having to change the intrinsic character of your image.

Photo dyes are an easy and effective way of hand-tinting photographs. They can be bought from most photographic stores. They usually come in kit form and are designed to soak directly into the emulsion. If you are inexperienced at hand-tinting, start with very thin washes, and then build up the intensity of your color in layers. Try one of the following:

■ Fotodyes come in kit form, comprising twelve bottles of light-fast dyes that are easily diluted with water.
■ Photocolor's Color Dye Sets are designed for spotting color transparencies and print. They are also an excellent medium for hand-tinting.
■ Patersons Retouching Kit comes in a package with eleven colors, plus white, although it is not recommended that you use the white.
■ Jessops Mastertouch Pic-Fix is the only one that comes as solid tablets.

Finally, if you are unconvinced about spending your hard-earned cash on such dyes (which are reasonably expensive), then you might wish to try food dyes instead. They are ludicrously cheap and can be bought in any food store, but they, of course, lack lightfastness.

Tetenal Spot-pens resemble felt-tipped pens and are particularly easy to apply. They can be used blatantly or with great subtlety. Because the colors are predetermined within the pen, they are not as easily mixed. If you do overwork them, especially on FB papers, it is possible to damage the surface of the emulsion. Before you start applying the color, it is important that you presoak your paper. It is also necessary to rub the tip of the pen for 20 seconds or so, to make the dye flow evenly.

Marshall Photo oils and oil pencils are the preferred option for most photographers serious about hand-coloring, not only because of the ease of use but also because of the luminosity of the colors that can be achieved. The translucent pigments are designed specifically for photographs and are able to introduce exquisite colors without masking subtle photographic detail. While these kits are quite expensive, they are an exceptionally beautiful means of hand-coloring your work.

There are some wonderful examples of hand-coloring where a foundation color is established using photo dyes but is then added to using photo oils. You can achieve colors of incredible depth and permanence using this method and these materials.

Neither watercolor or gouache paint work particularly well on conventional glossy photographic papers, although acceptable results can be achieved when using FB matte papers. For best results, use art-based photographic papers, such as CCR (Kentmere Art Classic) or Art (Kentmere Document Art). The joy of using watercolor on photographs is that the two mediums are not designed to work together, and so you will introduce a certain informality into your work, which is part of the appeal.

Using oil paints

When using conventional hand-tinting media such as photo dyes and Marshall oils, you do not expect to lose critical photographic detail, precisely because they have been designed to remain translucent.

However, once you begin to apply conventional oil paints, you are seriously beginning to extend the possibilities of photography and mixed media, as your image will reveal elements both of photography and of paint. It is pointless to pretend that oil paints are photographic oils, therefore you might as well

Row of pears

Version 1: A straight black and white print. Keeping in mind that color was to be added both above and below the pears, these areas were held back at the printing stage.

Version 2: The print was copper-toned, and then a mixture of Marshall Oils and oil pencils was used to hand-color the pears. Finally, opaque oil paints were applied both below and above the row of pears.

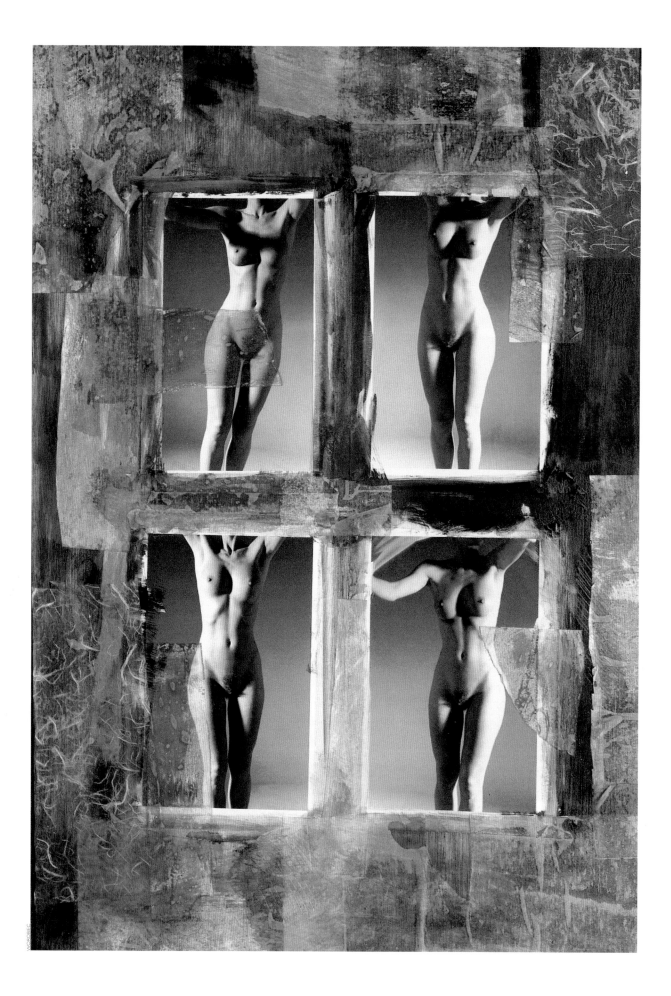

adopt a cavalier approach to their application. Try applying the paint in a deliberate and unrestrained manner, and you might be pleased by the outcome. If you prefer a more cautious approach, try adding Marshall oils in some parts of the photograph while using conventional oil-paints in others—the two media happen to be highly compatible.

Liquid photographic emulsions

If you want your work to appear unconventional, you will need to start working with unconventional materials. Normal photographic papers are generally of a very high quality, are available in standard sizes, and offer a consistency that makes printing relatively easy. There are rarely any surprises.

If you decide to use a liquid photographic emulsion instead, your results are going to be a little less predictable, but you are also going to encounter fresh opportunities. First, you are able to determine the scale of your work, because liquid emulsion can be applied to surfaces of any size. Second, you do not necessarily need to be restricted to working on paper, as liquid emulsions can be successfully applied to a variety of materials, including wood, glass, metal, and ceramics.

Third, the images printed onto liquid emulsions are rarely perfect. They often reveal marks and blemishes that would be unacceptable with conventional photographic papers, but this is the charm of liquid emulsion. Finally, and perhaps most interestingly, because they can be applied to a variety of materials, they can also be used in conjunction with other mediums, which once again opens new opportunities.

Commercially produced emulsions

A variety of emulsions are available, and as much as these things can be standardized, they are classified into three grades—SE1, SE2, and SE3. SE1 is a normal-contrast bromide emulsion, giving a neutral to warm black. SE2 is a high-contrast emulsion, while SE3 is a chloro-bromide emulsion that produces very warm tones. Most commercially produced emulsions including Fotospeed LE30, Tetenal Work Photo Emulsion, and Luminos Silverprint, which are all SE1 emulsions.

Using liquid emulsion on paper

Liquid emulsion works on all heavy-duty papers, but it works particularly well on high-quality art papers such as Bockingford and Fabriano. Once processed, these images can be toned like any other photographic images, but they can then be further enhanced by applying watercolor, gouache, acrylic, or oil paints.

Using liquid emulsion on wood

This offers enormous scope, though there are practical problems to be resolved. First, you need to appreciate that the wood will need to be processed just like a normal piece of photographic paper, requiring the same fixing and washing cycles. If size is a problem, you will need to come up with some imaginative

Fish fingers
This image was created by applying liquid emulsion onto Bockingford art paper. The subsequent print was then dual-toned, first in selenium, then thiocarbamide. The big advantage of using liquid emulsion on conventional art papers is that it is receptive to so many color pigments.

Nude Study I

(OPPOSITE)

Four prints were split-toned sepia and copper. The photographs were then attached to a panel to which layers of shellac and rice paper had been added.

Sarah (OPPOSITE)
You may feel unsure about painting directly onto a print for fear of ruining it. One way of overcoming this fear is to do it digitally. Here, the model was photographed using black-and-white film against a simple background. An abstract painting was created with loosely applied paints. The painting was photographed and the two images were fused using Layers in Photoshop. A discarded Polaroid print made the informal edge.

solutions, such as applying neat developer and fix directly onto the sensitized surface. The problem is that it is difficult to wash out the fix from wood; therefore, you will need to create a barrier by painting the surface with varnish or white primer prior to applying the emulsion. But once you have your image, the creative potential is enormous, as you are easily able to add further elements, including wood, fabric, paper, card, metal, and virtually any pigment you care to use.

Liquid emulsions can also be successfully used on fabrics, glass, ceramics, plastics, stone, and so on, though in most cases you will need to ensure that the surface to be coated is clean, and in many cases you are well advised to abrade it as well. You will need to experiment to establish whether some form of primer is required in order to gain the best results. Liquid emulsions are so flexible that you can work two-dimensionally or three-dimensionally. The photographic element can play a dominant or a nominal role within the piece, thus encouraging you to explore the area between photography and fine art.

Making marks on photographic prints

We can color our images using conventional dyes, but it is also possible to use less conventional materials, such as oil pastels, Conté crayons, pencil crayons, felt-tipped pens, and colored inks. For the most part these materials work better on Art or FB matte papers, but again this is an area that is clearly worth experimenting with.

The essential principle underpinning this approach is that none of these materials is designed for coloring photographs, therefore there is little point in trying to adopt a conventional approach. If you are a bit wary, make a few photocopies of your work, and then try out a variety of markers to see what can be achieved.

Collages and assemblages

These effects offer possibly the greatest potential for mixed media, as virtually anything can be added—the problem is recognizing it.

Consider the work of some of the early twentieth-century painters, particularly the Cubists and Surrealists, although the collage/assemblage tradition was possibly most eloquently developed by the Dadaists. These artists experimented with paint and photographs, discarded letters, used railway tickets, maps, text, diagrams, in fact any source that helped to develop their ideas. They frequently discarded perspective, choosing instead to employ an openness of spirit that is rarely seen in conventional photography. If you are uncertain about how to develop your ideas, start with photocopies of your own prints that you are happy to cut up and spoil, it will allow you a greater sense of freedom.

Finally, if you wish to work in this way, you will need to question what you should and should not throw away. The Pop artist Joseph Cornell was an endless collector of what on the surface might have appeared worthless trash, but he was later able to synthesize these disparate elements into stunningly beautiful collages and assemblages.

Using a flatbed scanner

Artists are often the first to identify the potential of new technologies, and with the advent of flat-bed scanners all kinds of new opportunities have opened up. Allied to sophisticated software packages such as Photoshop, it is now reasonably easy to scan elements separately, and then fuse them together within an entirely new context using Layers.

It should be possible to merge entire photographs with paintings, drawings, collages, prints, doodles, maps, letters, leaves, shells—anything that can be placed within the scanner. The key to this and any other related work is to retain your sense of design, and never allow your aesthetic judgment to be compromised.

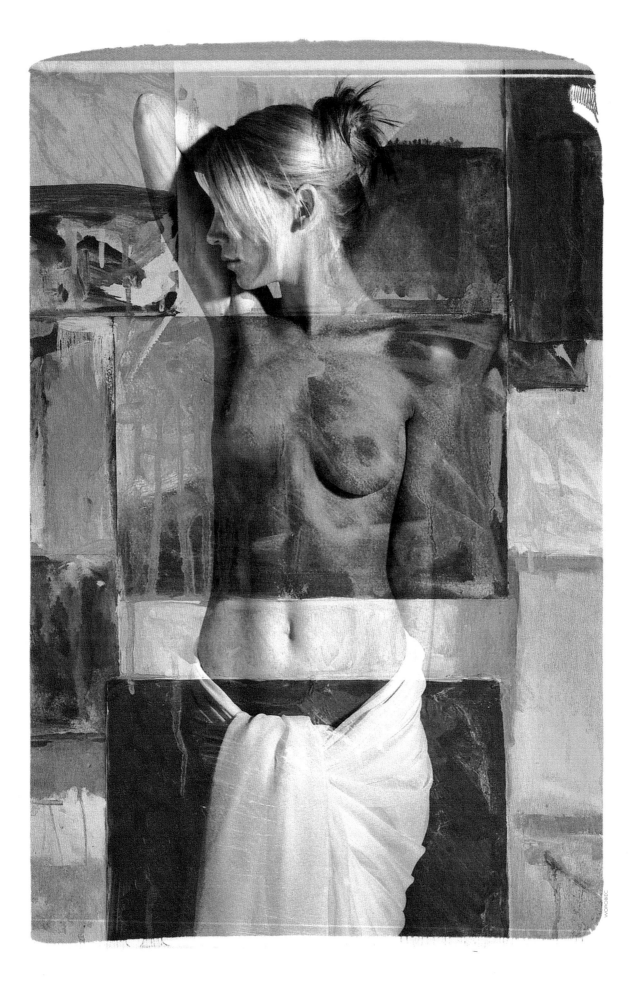

Collaborative Work

If photography is an art form, there must be ample opportunity for the practitioner to be able to make valuable judgements and choices throughout the entire process. What are the choices?

YOU CAN OPT to work in color or black and white, use a rectangular format, or choose to work square, but this is often determined by the format of the camera. Cropping is an option, but even then it is still amazing just how similar all photographs are. Comparisons are often made between photography and painting, largely because the rules relating to composition emanate from painting, yet it is surprising how painting has developed since the advent of photography. Individuality, the hallmark of twentieth-century painting, emerged because artists were prepared to ditch the conventional ways of working. Creating a style is one way of achieving individuality, but other factors are as important.

Portrait 1

A closeup sequence of black-and-white prints of the model was scanned and then colored green. The images were printed onto T-shirt transfer film, and pressed onto a fine cotton fabric. Each element was then reassembled to make a joiner and then stitched together, adding elements of fabric very much in the appliqué genre.

Change the scale of your work

The vast majority of photographs conform to the size of papers available—10-by-8-inch, 12-by-16-inch and 16-by-20-inch. We are limited by what photographic paper manufacturers produce, but the scale of a piece of work can be very important. Currently there is a fashion for very small photographs, and we rarely see oversized ones. However, some images have a presence that is lost when seen small.

It is possible to buy rolls of paper that allow you to work on large pieces—Ilford, for example, still produces rolls of printing paper 30 inches wide and up to 65 feet long. Working on these scales can create problems in the darkroom, but these can be overcome by projecting your image onto the floor, and sponging on chemicals. Another rather novel way of working big is to work in multiples. Artists such as David Hockney and Noel Myles produce photocollages, or "joiners," that can often extend beyond 10 feet. If you have the will to work big, there will always be a solution.

Be prepared to work multimedia

One of the more interesting things to emerge from twentieth-century painting is artists' willingness to work with materials other than paint. It started with the Cubists at the beginning of the century, who experimented with notions of the real and the apparent. They collaged real elements, such as scraps of newspaper, letters, and pieces of cloth, alongside painted illusions. This tradition was enthusiastically developed by the Dada artists, who saw that it offered a fresh dimension to their work.

Such willingness to work multimedia continues today, if somewhat controversially, through the work of the 1998 British Turner

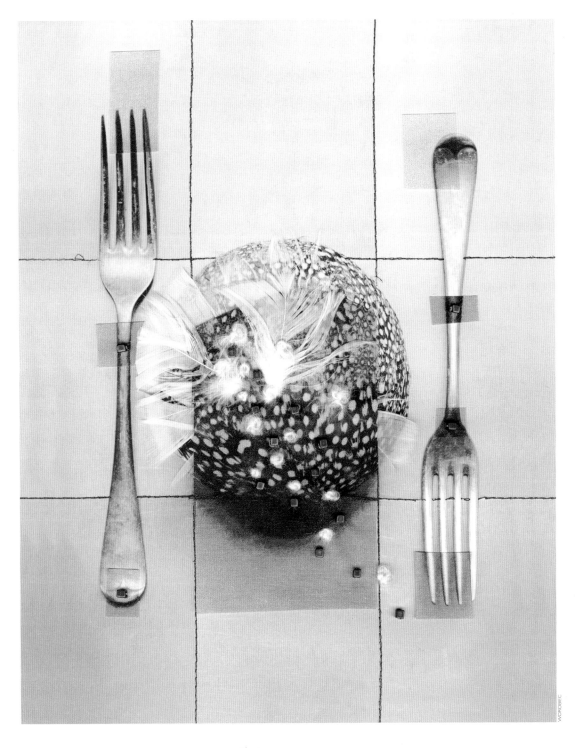

Fork

The feathered Christmas decoration was included because it is precisely the kind of image that easily lends itself to the technique of appliqué. This example sticks to the general composition offered by the original print. A second copy was made onto fabric, then elements from the second copy were carefully positioned back onto the first. Finally, stitching, beads, and feathers were added.

Prize-winner, Chris Ofili, who incorporated elephant dung into his paintings. While this is not necessarily recommended as a medium to use with your photographs, it is nevertheless surprising how quickly people's prejudices melt away once they have seen his work. The point is that we can still be highly creative about how we introduce other elements into our photographs, without going to excess.

Working jointly with another artist

Another interesting way of introducing multi-media is to work with another artist trained in a discipline completely different from your own. When I saw the beautiful appliqué images created by the artist Louise Hesketh I realised that they would combine perfectly with photography. "Portrait 1" (p.146) and "Fork" (p.147) were a combination of my images and Louise's appliqué, and for "Model with globe 2" (below) I employed Louise's ideas to create a piece of work on my own.

The key is not to be too controlling about your own input and to respect the contribution made by the other person. Because appliqué is an art form in which fabric is applied to, or laid

Working with fabric

Appliqué: Model with globe 2

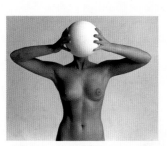

Version 1:

A conventional black-and-white print.

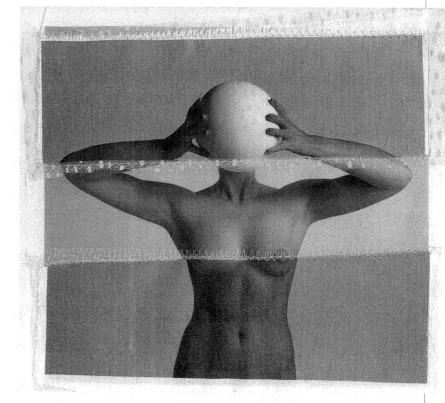

Version 2:

This was the first result. Keeping it simple seemed the best policy—and the hardest bit was getting up the courage to enter a fabric store, not normally a photographer's domain.

Version 3:

The images were digitally produced and printed onto fabric using T-shirt transfer film. A section was removed from the middle of the gray/blue image, and it was placed over the other so that the image was complete again. Additional pieces of fabric were also arranged beneath the gray strips before the entire montage was finally machine-stitched.

onto, another material, it was recognized that it might help if the photos produced could be done on material. There were two convenient ways of doing this. The first method is to print onto Fotospeed's Fotolinen. The alternative is to scan a photograph onto a T-shirt transfer film, which can then be pressed onto a suitable material of your choice.

Fotolinen

Fotolinen comes in various sizes—8-by-10-inch, 12-by-16-inch, or rolls 4 feet wide and 8 feet long, so your options are varied. The smaller sizes can be processed like any standard photographic paper—when you remove it from the packaging, you should be able to detect a rough side and a slightly smoother side. The emulsion is on the rougher side. If you have difficulties with this, stroke both sides of the linen with your finger—the silent side is the back, while the surface giving a "rasping" sound is the emulsion side.

Fotolinen is a fixed grade 2½, using a conventional chlorobromide emulsion, so it should be used with a red safelight. You can use it in any paper developer, and in every way it behaves like printing paper. Once developed, fix as normal, and then wash for at least ten minutes. When wet, it does not easily slide into a print washer, so consider washing it in a tray. It tones well in most toners, which can give a color base for further work.

If you are brave enough to work large-scale, it has been suggested that one way of overcoming size problems is to process your work in a child's inflatable wading pool. If you are really ambitious, it might be useful to construct a tray using the plastic lining for a pond garden.

Once processed, the easiest way to dry your print is to hang it on the line. It will appear rather crumpled, but it can be pressed—take care only to press on the reverse side using a moderately warm iron. Start with the Rayon/Silk setting.

T-shirt transfer film

A interesting alternative is to scan the image on a flatbed scanner and then print it onto T-shirt transfer film, which can be purchased from most office or computer supply stores. Obviously any color manipulation should be done prior to printing. Take the printed film and press it onto any suitable fabric, though as a fairly high temperature setting is required, you are largely restricted to cotton or linen.

Other possible uses of Fotolinen

■ Making a larger tableau by stitching various elements together. Try producing a sequence of photographs onto sheets of Fotospeed Fotolinen, then stitching them together to make a large wall hanging. The final construction could have added tassels, or you might wish to stretch your work onto a stretcher in the same way as an oil painting.

■ As a sculpture. Fabric is a particularly pliable material and can easily be attached to a wooden or metal structure. When you consider that you are also manipulating photographic images, all sorts of exciting opportunities begin to present themselves.

■ As the basis for an oil painting. There is no reason why you cannot use this as a method of producing a photo-realistic painting on "canvas." You can use Fotolinen, which allows you to work very large, but restricts you to working in monochrome, or conversely you can use T-shirt transfer film, which does allow you to work in color, but of course restricts the size you can use. If you want to produce a joiner oil painting, this may be one way to achieve it.

If you feel that painting over a photograph is a little like cheating, it is worth noting that in a recent exhibition by artist Michael Andrews, some of his work involves silk-screening photographs onto canvas, which are then painted. It is a legitimate means to an end.

Exploring Time

While much of what has been covered so far deals with techniques, this is not the only way of exploring the potential of photography. It is also a process that can very effectively explore concepts.

Concepts, however, are difficult to develop because they require us to think independently, and often we need to work in ways we are unaccustomed to. A concept such as "time" is interesting because photography freezes time, though often when it is addressed it is usually done symbolically, featuring such time-honored cliches as clocks, hour-glasses, and sundials.

So what is time? If you consult any dictionary, you will not be able to find a clear-cut definition, merely a sequence of examples—a point at which, or period during which, things happen; an appropriate season or movement, and so on. In essence time is infinite, which really does set up a challenge, but that is not to suggest that we cannot look for exciting visual examples of time.

Your camera offers many shutter speed options, though most of us generally use speeds of between $1/60$ and $1/250$ second. How many of us regularly use $1/2000$ second, or even $1/8000$ second? While such speeds are still immense when compared to the theoretical shortest span of time, they are nevertheless quick enough to

Shooting the same subject over a period of time

Eight images of Factory Butte

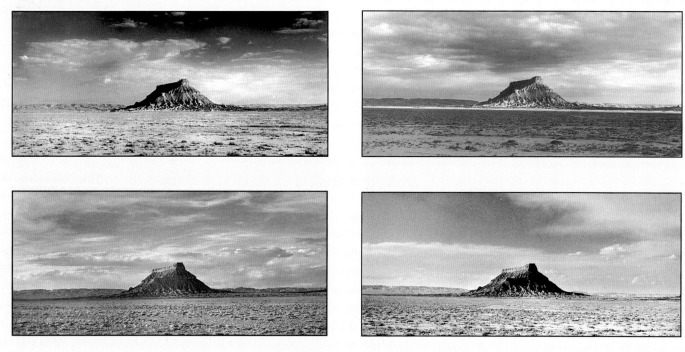

Many artists, including the great French Impressionist Claude Monet, have recognized that a landscape is never the same—it is constantly changing.

illustrate a world that cannot possibly be seen with the human eye.

At the other extreme, many cameras are designed to give automatic exposures of 30 seconds or more, but they also allow manual exposures of an indeterminate length of time. If you are experienced in night photography, it is not uncommon to use exposures of up to 1 hour. But how do you photograph a day, a week, or a year? Of course you can't if you are only prepared to produce just one image, but if you are able to be a little more creative in the presentation of your work, then it is possible to explore this concept in an intelligent and interesting way.

Single images suggesting time passing

The moment you take any photograph it becomes history—some photographs will be of dubious interest, but it is possible to take single images that immediately appear to encapsulate time. As photographers, we frequently visit particularly evocative places that present us with evidence of the past in sufficient detail to stir our imaginations. Images of such places invite us to scrutinize detail, identify the marks left by man, and, where possible, relate them to our own lives.

Take, for example, "Edith McBride's Telephone" (see page 153). This is an image taken from an extended project on abandoned properties in North and South Dakota and was photographed in August 2001. The scene looks ordinary enough, except that there are numerous clues surrounding the telephone to suggest that this home has been abandoned for twenty years or more. The planner below the telephone is filled in up until Tuesday, September 13, 1977, while the little note to the left of the telephone reminds Edith that she has

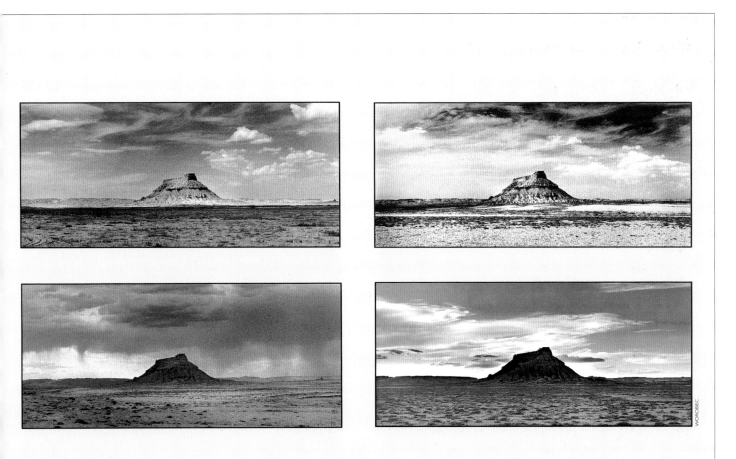

These images of Factory Butte were taken over twenty-four-hours. Each black-and-white image was toned in Photoshop to heighten the sense of time.

a doctor's appointment on that day. There are other scraps of information littered around the phone that have only a very limited significance, but to Edith McBride these were clearly of great importance. Such images furnish us with a very detailed and personal insight into a life, which has remained undisturbed for two decades.

While we frequently encounter evidence of how people lived, particularly at more established historic sites, it is quite unusual to encounter something quite so ephemeral, yet untouched.

Exploring time with long exposures

One of the great assets of photography is that it allows the observer to view the world in an entirely new way, such as when a photograph has been subjected to a long exposure. Our brain is programmed to see in milliseconds and it is not capable of viewing a moving scene accumulatively. A camera set on a long exposure can record layers of movement that the brain simply cannot comprehend. This is most popularly exploited when photographing moving water—however, this need not be the only application of such a technique.

Night photography offers boundless opportunities for long exposures. No matter how little light there seems to be, if you give your film sufficient exposure, it will record. Obviously there are technical problems to be overcome, the most serious being reciprocity failure. Most films will accurately record the lighting conditions up to a 1-second exposure—beyond that and the film will begin to underexpose incremental to the length of the exposure. All film manufacturers provide a scale

Avoiding reciprocity failure		
For black-and-white film, try the following corrections		
When your meter reads	1 sec	try 2 secs
When your meter reads	2 secs	try 5 secs
When your meter reads	4 secs	try 11 secs
When your meter reads	8 secs	try 35 secs
When your meter reads	15 secs	try 1¼ min
When your meter reads	30 secs	try 3 min
When your meter reads	1 min	try 10 min

indicating the compensating exposures required, but as a crude rule of thumb you can use the chart below.

Color film generally requires less compensation. You have the added problem of a shift in color balance, though tungsten film is more resistant to this. Some color workers add filters to try and overcome the problem, but others like the color shifts that can be achieved.

Revisiting areas previously photographed

Some landscape workers adopt a very cavalier approach to their work—"been there, done that"—however, returning to a previously photographed scenario may well reveal an entirely different mood. In fact it is almost impossible to photograph identically the same landscape, particularly if you also include some cloud detail.

One of the best ways to illustrate time is to methodically record a scene either hour by hour, day by day, or month by month, depending on the issues you consider to be important.

Comparison can be made with moving film. Most people are fascinated by slow-frame video footage that illustrates growing plants, disappearing ice, mushrooming clouds, and the like. We can achieve similar affects with still photography, except that in this form we are able to scrutinize at will, re-examine, and cross-reference, making it a far superior way of understanding the world than a medium that is presented in a purely linear fashion.

Most people in the West are familiar with Claude Monet's *Water Lilies*, though some may not be aware that he painted not one, but an extended series of canvasses in which he was able to record the changing light of the seasons, and how this affected his beloved garden at Giverny. He had previously completed various versions of *Rouen Cathedral* and *Haystacks*. In themselves, each of these were relatively inane themes; however, Monet recognized that nothing remains the same and diligently recorded the subtle color and tonal variations as the lighting changed.

Six images of Buachaille Etive Mor, Scotland, from November to April

This is a scene familiar to countless photographers, and it is easy to assume that it never changes—but it does! This sequence of shots was taken over a period of six months, and while at first glance they all look very similar, on further scrutiny one discovers that each moment in time is unique.

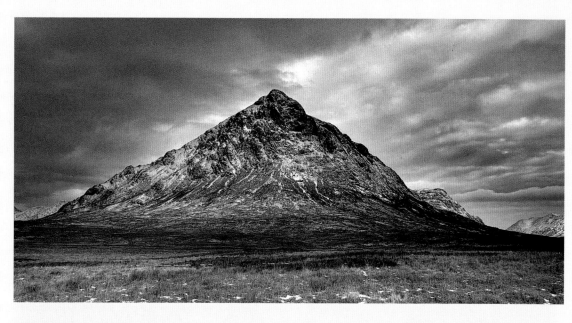

We can achieve this much more easily using photography, but it is important that we learn the lesson set by Monet and only use simple and direct subject matter.

An interesting alternative to this is to revisit a site you have photographed several years, or even decades, ago. You will, of course, appreciate that nothing stands still. In the series of photographs documenting the depopulation of areas within North and South Dakota (for an example, see "Edith McBride's Telephone," page 153) it is surprising just how little has changed in those years, and yet when the photographs are re-examined, it is obvious that subtle changes have occurred.

Constructing a narrative

Brief stories can often be created using storyboard sequences in which the photographer stages a dramatic situation. Such work is most eloquently exemplified by the American photographer Duane Michals. Within a sequence of photographs, he was able to create strange and enigmatic narratives, most notably *The Young Girl's Dream* and *Death Comes to the Old Lady*. The work takes the form of five or six prints, not unlike a very brief cinematic presentation, except that the viewer is able to dwell and re-examine each shot at leisure.

Constructing your own narrative should be relatively easy, and this is an interesting way of

Palm tree

These are two images of the same palm tree, though on first glance one looks like the negative of the other. They are both positive images, graphically illustrating how greatly the appearance of an object can be determined by the time of day. The image on the left was photographed at dawn (with the moon still apparent in the sky), and because of the poor light, an exposure of several seconds was required. The image opposite was photographed late in the evening, illuminated by a nearby street lamp, hence its ghostly, negativized appearance.

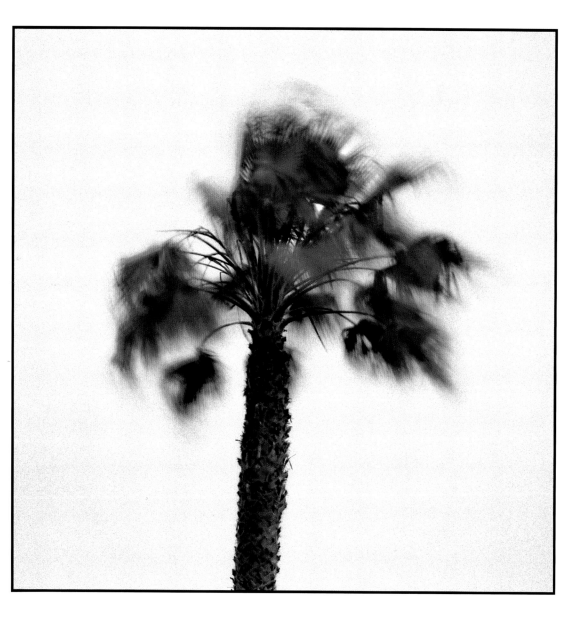

exploring the theme of "time." It is important to start with a clear idea, and then construct each shot so that the changing aspect of the story is clearly illustrated. Always consider it from the viewer's standpoint—each shot must have something valuable to say, yet not appear superfluous. If you doubt your ability to do like this, sketch out your sequences beforehand.

Using fill-in flash

An interesting feature of time can also be explored by using fill-in flash when the very brief exposure from the flash (just $^1/_{2000}$ second) overlaps a much longer exposure, possibly several seconds. This works particularly well with moving subjects. In a sense, what you will achieve is a double exposure, one superimposed over the other. The first will freeze a split moment in time, while the second exposure will illustrate movement over an extended period of time. Sometimes the mix can prove hauntingly beautiful.

In order to achieve a satisfactory result, it is important that you balance out the exposure between the flash and the longer exposure. However, even with detailed calculations it can be a rather hit-or-miss technique, therefore if you are able to, it is worth trying various combinations of shutter and aperture.

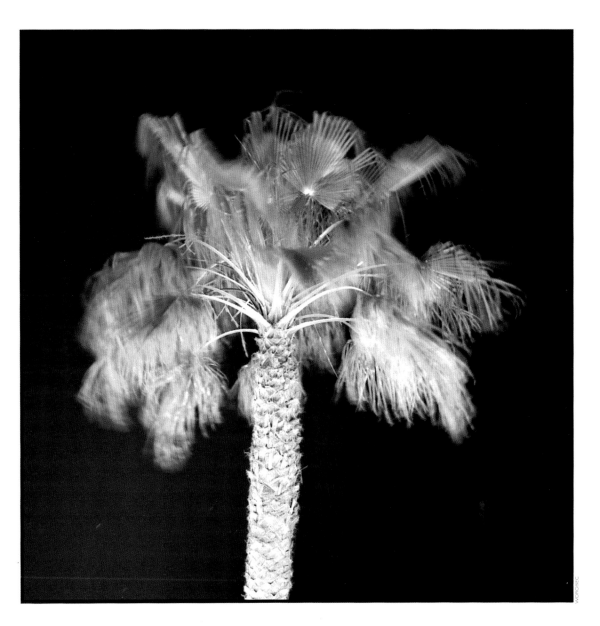

Index

Suppliers

USA

B & H Photo
420 9th Avenue,
New York, NY
Tel: +1 (212) 444-6600
Toll free: +1 (800) 947-9970
www.bhphotovideo.com

Film, photographic paper, darkroom supplies, Marshall's Photo Oils. Also mail order —call for catalog.

Calumet Photographic, Inc.
16 West 19th Street,
New York, NY 10011
Tel: +1 (212) 989-8500
Mail order: +1 (800) CALUMET
www.calumetphoto.com

Photographic supplies, Marshall's Photo Oils. Mail order and retail outlets in New York, California, Illinois, London, Belfast, Edinburgh and other locations— call or see website for complete listings.

Dick Blick Art Materials
P.O. Box 1267,
Galesburg, IL 61402-1267
Tel: +1 (800) 828-4548
www.dickblick.com

Marshalls Oils, and other art materials. 35 retail stores nationwide and mail order —call or see website for catalog and list of stores.

Ilford Imaging USA
West 70 Century Road,
Paramus, NJ 07653
Tel: +1 (201) 265-6000
www.ilford.com

Kodak Ltd USA
Tel: +1 (800) 242-2424
(information center)
Fax: +1 (800) 755-6993
www.kodak.com

Luminos Photo Corp.
P.O. Box 158,
Yonkers, NY 10705
Tel: +1 (800) LUMINOS
www.luminos.com

Suppliers of Fotospeed toners, developers and photographic papers. Suppliers of Kentmere papers including Art and Document.

Marshall's
www.marshallcolors.com

UK

Calumet Direct
93-103 Drummond Street
London, NW1 2HJ
Tel: +44 (0800) 964396 (sales)
www.calumetphoto.com

Daler Rowney Ltd
P.O. Box 10, Bracknell,
Berkshire, RG12 8ST
Tel: +44 (01344) 424621
Fax: +44 (01344) 486511
www.daler-rowney.com

Suppliers of art materials.

Fotospeed
Fiveways House, Westwells Road,
Rudloe, Corsham,
Wiltshire, SN13 9RG
Tel: +44 (01225) 810596
Fax: +44 (01225) 811801
www.fotospeed.com

Suppliers of Perma Jet papers and inks.

Ilford Imaging UK
Town Lane, Moberley,
Knutford, Cheshire, WA16 7JL
Tel: +44 (01565) 684000
www.ilford.com

Manufacturers of an extensive range of black and white printing papers.

Kentmere Ltd
Staveley, Kendal,
Cumbria, LA8 9PB
Tel: +44 (01539) 822322
Fax: +44 (01539) 821399
www.kentmere.co.uk

Manufacturers of speciality black and white papers including Document Art, Art Classic.

Kodak Ltd.
Kodak House, Station Road,
Hemel Hempstead,
Hertfordshire, HP1 1JU
Tel: +44 (01442) 261122
www.kodak.co.uk

Rayco Chemical Co.
199 King Street, Hoyland,
Barnsley, S74 9LJ
Tel: +44 (01226) 744594
www.rayco-chemicals.co.uk

Suppliers of chemicals for toning.

Silverprint
12 Valentine Place
London, SE1 8QH
Tel: +44 (020) 7620-0844
Fax: +44 (020) 7620-0129
www.silverprint.co.uk

Suppliers of chemicals, toners and specialty papers.

Speedibrew
54 Lovelace Drive, Pyrford,
Woking, Surrey, GU22 8QY
Tel: +44 (01932) 346942
www.speedibrews.freeonline.co.uk

Manufacturers of Speedibrews chemicals including porcelain blue and FSA toners.

AUSTRALIA

Fotospeed Australia PTY
32 Commercial Road,
Fortitude Valley,
Brisbane, QLD, 4006
Tel: +61 (7) 3252-4466
Fax: +61 (7) 3252-4771
www.fotospeed.com.au

Suppliers of Perma Jet papers and inks.

Acknowledgements

PHOTO ART has proven to be a particularly enjoyable book to work on, and inevitably the support we have received from others has proven to be invaluable. We are especially grateful to Roger Bristow for commissioning this, to Emma Baxter for her professional guidance and to Roger Hammond for his excellent design work.

We are appreciative of the assistance we have received from John Herlinger of Fotospeed, particularly with regards to our digital work; we are also grateful to Michael Maunder for supplying the excellent Speedibrew toners. The additional work by Louise Hesketh has undoubtedly added an interesting dimension to this publication, and shows that working in collaboration has great value.

We would also like to thank the models: Jeni, Jo, Sue, Alicia, Sarah and Cressida, Permajet and The Pinhole Factory.